D1202499

SEEING THE INVISIBLE

Also available from Continuum:

SEEING THE INVISIBLE

On Kandinsky

Michel Henry

Translated by Scott Davidson

continuum

Continuum

Continuum International Publishing Group
The Tower Building 80 Maiden Lane
11 York Road Suite 704
London SE1 7NX New York NY 10038
www.continuumbooks.com

Originally published in French as *Voir l'invisible* © Éditions François Bourin 1988.
Reissued © Presses Universitaires de France 2005

Liberté • Égalité • Fraternité
RÉPUBLIQUE FRANÇAISE

This book is supported by the French Ministry of Foreign Affairs, as part of the Burgess
programme run by the Cultural Department of the French Embassy in London.
(http://www.frenchbooknews.com/)

This English translation © Continuum 2009

British Library Cataloguing-in-Publication Data
A catalogue record for this book is available from the British Library.

ISBN-10: HB: 1–84706–446–9
ISBN-10: PB: 1–84706–447–7
ISBN-13: HB: 978–1–84706–446–2
ISBN-13: PB: 978–1–84706–447–9

Typeset by RefineCatch Limited, Bungay, Suffolk

Contents

Translator's introduction

Michel Henry (1922–2002) was a leading French philosopher in the latter half of the twentieth century whose work addressed issues in areas such as metaphysics, theology, political theory, economics, psychoanalysis and aesthetics.[1] Looking back on a century plagued with war, genocide and oppression, Henry was highly critical of the political and social developments of the twentieth century and deeply concerned about their implications for the twenty-first century. The underlying cause of those developments, on his view, was a widespread devaluation of life whose roots could be traced back to the rise of the modern worldview first formulated by Galileo and then developed philosophically by Descartes.[2] One significant feature of the modern worldview is its elimination of sensible qualities from the external world and the subsequent reduction of reality to what can be measured and quantified. By reducing all reality to the external world, the modern worldview leads the true reality and value of life to fall into oblivion. For, life in its truest sense, according to Henry, has nothing to do with the external world or the forms of life studied in biology; instead, its sense resides within subjective experience as an immediate pathos and awareness of one's own living. Through this reawakening of the true sense of life and its value, Henry's philosophy calls for a critical re-examination and elaboration of its profound implications in all domains of inquiry.

Born in 1922 in Haiphong (Vietnam), Michel Henry's father, a military officer, was killed in an automobile accident when Henry was only 17 days old.[3] His mother, trained as a concert pianist, was compelled shortly thereafter to return to France and eventually settled in Paris. Henry's

philosophical studies began at the Lycée Henri IV in Paris, and he went on to study philosophy at the Sorbonne. His master's thesis, *Le Bonheur de Spinoza* (*The Happiness of Spinoza*), was completed in the winter of 1943 under the direction of Jean Grenier.[4] Although Henry distances himself from Spinoza's metaphysical speculations, Spinoza's influence is evident in the later development of Henry's own philosophy, viz. their shared commitment to a philosophy of immanence. Henry's commitment to a philosophy of immanence is evident in his view that all phenomena are the manifestations of a single source, namely, life.

During the summer of 1943, Henry followed the example of his older brother who was a member of the 'Free French' resistance group stationed in England. He joined a resistance group located in the Haut Jura and operated in Lyon as an undercover agent. Fittingly, his codename in the group was 'Kant' because *The Critique of Pure Reason* was the only item in his backpack when he showed up to join the group. His wartime experience exercised a deep influence over his philosophy. Through his participation in the resistance, Henry gained an appreciation of the clandestine dimension of life. Unable to say what he truly thought or who he truly was, it was in the resistance that Henry came to the realization that the true life is invisible. The clandestine sense of life, as a pathos that can only be experienced within oneself, remains a constant preoccupation throughout all of Henry's writings.[5]

After defending his dissertation thesis in front of a distinguished dissertation committee, consisting of Jean Hyppolite, Jean Wahl, Paul Ricoeur, Ferdinand Alquié and Henri Gouhier, Henry eschewed repeated offers to teach in Paris at the Sorbonne. Instead, Henry opted to lead a quieter, provincial life where he could concentrate on his work without the distraction of Parisian intellectual life and the heavy teaching demands of the Sorbonne. In 1960, he accepted a post at the Université de Montpelier, located in the south of France on the Mediterranean coast, and settled there with his partner Anne, a noted Proust scholar, whom he married in 1958. There he was able to balance lighter teaching demands with an ambitious writing schedule. Henry remained at Montpelier up to his retirement in 1982, but retirement did not slow him down. Quite the contrary, the decade immediately following his 'retirement' was an especially prolific period for Henry, including the publication of *Genealogy of Psychoanalysis* (1985), *Barbarism* (1987), *Seeing the Invisible* (1988) and *Material Phenomenology* (1990).[6] While *Material Phenomenology* articulates the phenomenological foundation of his understanding of life as a radical immanence, the

other works of this period examine its implications within the domains of psychoanalysis, political theory, and aesthetics, respectively.

In his spare time, Henry was an active art enthusiast and collector. He was especially interested in art prior to the eighteenth century as well as twentieth century abstract art, which he regarded as the renewal of art's spiritual mission from earlier times. The present volume, *Seeing the Invisible*, was inspired by Henry's passion for the work of Wassily Kandinsky.[7] Kandinsky is rare among painters, because in addition to making art, he developed a profound aesthetic theory in a series of theoretical writings, most notably, *On the Spiritual in Art* (1911) and *From Point and Line to Plane* (1926). These writings, which are the Rosetta stone to Kandinsky's abstract art, were revisited by Henry shortly after a large Kandinsky exhibit at the Beaubourg (Paris) in 1984–85. The Paris exhibit gathered together paintings from all of the different periods of the artist's life. Henry reportedly visited the Paris exhibit over a dozen times and later went to New York City to study the Kandinsky collection at the Guggenheim.[8] Inspired by his study of Kandinsky's paintings and theoretical writings, Henry's explicit aim in writing *Seeing the Invisible* (1988) is to elucidate the significance of Kandinsky's discovery of abstract painting.

Henry's fascination with the master of abstraction can be explained through the deep underlying connection between the ambitions of the two thinkers. Kandinsky, much like Henry, regarded the modern era to be in a state of crisis, and he sought to provide a renewal of humanity through the development of abstract art. Kandinsky's departure from figurative art resembles Henry's own critique of the modern worldview, with its emphasis on the external world and objectivity. Rejecting the preoccupation with the external world in eighteenth and nineteenth century art, the spiritual mission of Kandinsky's abstract art is to restore the value of the inner life. In *Seeing the Invisible*, Henry's central thesis is that Kandinsky's abstraction is more than just a particular movement in painting; instead, it reveals the deep truth of all art. All art is really 'abstract', which is to say that it is freed from any adherence to the external, visible world. In order to develop the significance of this thesis, I will now briefly sketch out Henry's philosophical elucidation of Kandinsky's revolution in painting.

By understanding painting in terms of the seemingly obvious connection between vision and the visible world, aesthetic theory has followed its Greek inspiration and reduced the task of painting to a depiction of the visible. Traditionally, painting especially has been associated with the activity of *mimesis*, which signifies an imitation or copy of objects in the external

world. Its problems are those associated with the representation of the visible world, such as the depiction of light or perspective. What is revolutionary in Kandinskian abstraction is that the apparent connection between the painting, the eye, and the visible is undone.

In his theoretical works, painting is freed from the visible though a fundamental principle concerning the nature of all phenomena:

> Every phenomenon can be experienced in two ways. These two ways are not random, but bound up with the phenomena—they are derived from the nature of the phenomena, from two characteristics of the same: External/Internal.[9]

In recognizing the dual nature of all phenomena—as both external and internal—Kandinsky emphasizes the radical split between these two modes of appearing. While the external appearance of a phenomenon refers to how the phenomenon is seen, the internal refers to the invisible tonality of a phenomenon, or how it is felt. Kandinsky's abstract art overturns our conceptions about painting and art in general, because it seeks to express the internal aspect of phenomena, in other words, to paint the invisible. Freed from all mimetic activities, its central preoccupation is the question of how to paint the invisible, instead. That is, how can the visible artistic means of painting—graphic forms and colours—be used to depict a wholly different, invisible reality? Kandinsky's response to this question is altogether surprising and ingenious.

According to Kandinsky, the means and the content of painting are unified, because the means of painting—graphic forms and colours—are themselves invisible. This seemingly paradoxical claim is supported by the fundamental principle cited above that every phenomenon has both an external and internal aspect. Applied to forms and colours, this principle implies that they have both a visible and invisible way of appearing. While the visible aspect of forms and colours is obvious and commonly taken for granted, the invisible aspect of forms and colours typically goes unnoticed even though it is actually essential to the composition of a painting and indeed to all art.

Consider, for example, the artist's choice of colour. Understood as an activity of mimesis, the artist's choice would be based on the nature of the object under consideration. Such an explanation, however, falls short with respect to almost all paintings, since the overwhelming majority of paintings concern events that the artist did not witness. Take the example of the countless paintings of the Adoration of the Magi. It is clear that none of the

artists ever witnessed this event. If they were engaged in a mimetic activity, these artists would have no reason to represent a Magi in one colour or pose rather than another one, because these artists do not possess any knowledge about what they might have worn or how they might have stood. Hence, the choice of colours can only be explained on the basis of another source, and Kandinsky helps us to appreciate that this basis resides in the invisible aspect of colours.

The invisible aspect of a colour refers to its dynamic and emotional power. In his theoretical writings, Kandinsky painstakingly examines the various dynamic and emotional powers of each colour. For example, yellow moves towards the spectator and gives the impression of attacking, while blue moves away from the spectator and gives the impression of calm. In so doing, Kandinsky tears the laws of composition away from the objective world and situates them in the pathos of subjective experience. Colours are selected not on the basis of their resemblance to the external world but their internal emotional power.

The same analysis can be extended to graphic forms as well. A form—such as a point or a line—is not primarily the outline of an external body, instead each form is the expression of a specific type of force. For example, the point is stationary and expresses a feeling of calm, whereas a zigzag line is mobile and conveys a feeling of discontinuity. The theory of graphic forms refers primarily to the forces experienced within our bodies. Instead of imitating the visible contours of the human body, graphic forms reveal the various invisible forces pulsating within our bodies, that is, the bodily powers of moving, feeling and desiring. Kandinsky's artistic genius derives from his understanding of the invisible aspect of forms and colours as well as their various combinations. In addition to providing philosophical insight into Kandinsky's art and theoretical writings, *Seeing the Invisible* is also a gateway to Henry's own philosophy of life.

Within Kandinsky's theoretical writings, Henry discovers an implicit material phenomenology. By bracketing the representation of the visible world, Kandinsky's theory of colours and forms performs a sort of phenomenological reduction. This reduction leads us back to the pure impression as such. That is to say that the impression of a colour or form is no longer understood in terms of what it represents, instead the impression is described on its own terms, solely as an impression. Kandinsky's theory of colours and forms thus provides a phenomenological description of the various tonalities and forces produced by the pure impressions of colours and forms. Insofar as these pure tonalities and forces are not disclosed

through a representation of the visible world, this implicit phenomenology could rightly be described as a phenomenology of the invisible. The invisible tonalities and forces belonging to colours and forms, according to Henry, are the material of life. In expressing these tonalities and forces, art is thus the expression of life, awakening new and intensified possibilities for life.

To highlight just one of the many implications of *Seeing the Invisible* for Henry's philosophy of life, its account of aesthetic communication provides a possible response to a common objection to Henry's philosophy. Put briefly, with its heavy emphasis on the radical interiority of the experience of life, one common objection to Henry's philosophy is that it cannot establish an intersubjective community. The account of aesthetic communication in this work, however, provides a vivid example of Henry's conception of community as a community of the living.[10] The artist, through the combination of the tonalities of invisible colours and forms, communicates a feeling of life to the spectator. Borrowing from Kierkegaard, Henry understands this communication in terms of contemporaneity, where the spectator repeats the feeling that was originally felt and expressed by the artist on the canvas. This account of aesthetic communication provides insight into the community of the living in general. The community of the living, established through a shared feeling, can extend beyond the limits of geographical location, historical period or group membership, perhaps even beyond death. While a full account of Henry's understanding of community would require much more detailed work, it has been evoked here in order to provide one example of the many insights to be found in this remarkable text.

While the above remarks provide an initial orientation for readers approaching this text for the first time, I will conclude with a few technical remarks about the translation. This text was originally written for a general audience, and I have sought to remain faithful to that original intention. Since French style generally (and especially Henry's style) is much more elliptical than English, a literal transcription of the text was not possible. Wherever it was possible to do so without sacrificing meaning, I have shortened sentences and reformulated them to conform with the standards of conventional English. Whenever it helped to clarify Henry's meaning, I have also opted to replace pronouns with the nouns to which they refer. The result, I hope, is a text that will be more clear, accessible and enjoyable to the English-speaking audience. Second, there are a number of differences between the French and English translations of Kandinsky's

writings. I have followed the English translation of Kandinsky in most cases, although I was forced to modify a few quotations in which a relevant phrase or concept in the French translation differed from the English one. Those modifications are indicated in the text. Finally, the reader should take note of the unique philosophical significance of Henry's use of the term 'pathétique', which I have rendered by the English 'pathetic'. While the English sense of the term is derogatory, Henry's use of the term is derived from the Greek notion of 'pathos', which can refer to a feeling, a passion, or broadly, to anything that is undergone. So, when Henry employs the term 'pathetic', it is not to be taken in its conventional English sense; instead, the reader should take it to convey the way in which life is a feeling or a passion undergone in subjective life.

Introduction

Kandinsky is the inventor of abstract painting, the one who sought to overturn the traditional conceptions of aesthetic representation and to define a new era in this domain—the era of modernity. In this regard, he appears as the 'Usher' or the 'Pioneer', to borrow the words of Tinguely. To understand Kandinsky's painting is to understand an art so new and unusual that in its beginnings it only aroused scoffs, if not anger or spit. At the time of his death in 1944 in Paris, Kandinsky was still unknown to the French public, and misunderstood by the 'critics'. Today, one might wonder whether this situation has really changed.

The solitude of one of the greatest creators of all time at the moment when French painting affirmed its primacy, and concentrating all attention on itself, regarded itself as the world's main centre of discovery has at least one merit—it shows us that abstract painting differs entirely from that with which it is commonly confused, namely, the historical sequence which leads from Cézanne to cubism, including impressionism and most of the other 'movements' that define 'modern painting' in the eyes of the public. The big names of this period are in fact strangers to 'abstraction'. For example, in addition to his academicism, Picasso is a figurative artist. Even those painters whom one would not hesitate to group among the 'non-figurative' painters—Mondrian with his pure geometrical lines, Malevich's Suprematism, the Constructivists with their bare planes, Arp with his free forms, and Klee himself with his magical signs—pursue their work within the pictorial tradition of the West, outside of the field opened by Kandinsky's radically innovative presuppositions. Is his painting thus unique in its genre?

1

Kandinsky's singularity is due, moreover, to a circumstance that is vital for our project. The 'Pioneer' did not just produce a body of work whose sensuous magnificence and rich inventiveness eclipse even the most remarkable of his contemporaries. He also provided an explicit theory of abstract painting, exposing its principles with the utmost precision and clarity. So, the painted work is accompanied with a group of texts that at the same time clarify his work and make Kandinsky one of the main theorists of art. Facing the hieroglyphs of the last canvases of the Parisian period (which are said to be the most difficult), they provide the Rosetta stone on which the meaning of these mysterious figures is inscribed.

In order to understand works of art, the cultivated person already used the main classical aesthetic theories, those of Plato and Aristotle, and more recently, those of Kant, Schelling, Hegel, Schopenhauer and even Heidegger. Unfortunately, the common trait of all these thinkers was that they really expect nothing from painting. This renders their analyses of little use for those who would like beauty to increase their ability to feel and to enrich their personal existence. Kandinsky's analyses provide an infinitely more sure and effective guide to the amateur, because they pertain to colour, point, line, plane, the layout of the painting, and the material on which it is painted with exemplary simplicity, and because these are unequivocally both the means and the ends of art. A small number of painters among the greatest ones—such as Dürer or da Vinci—and the more modest ones—such as Vasari—have sought to clarify what they did and, at the same time, to communicate this to others. No one has accomplished this objective better than Kandinsky. That is why we are proposing a study of his theoretical writings as a privileged means of access to the understanding of the essence of painting—or better—as a way to enter into the expanded life of aesthetic experience.

Is it not paradoxical, however, to choose the 'most difficult' painting as an initiation to painting in general? Is it best, in the presence of a historical development extending over centuries and even millennia, to begin with the most recent and sophisticated works, in a sense, to begin at the end? Does our world—the world of European nihilism in which all values are undone and self-destruct—provide the most appropriate site for disclosing the source of all values, especially aesthetic values? After the gestures of Dada and the empty attempts of surrealism, in the whirlwind of styles, manifestos and schools launched thanks to the whims of the marketplace and the media, how can we recognize the true principle of authentic works of art?

Another objection presents itself. Can the rigorous discovery of the principles of abstract painting, resulting from Kandinsky's extraordinary work of elaboration, help us to penetrate the nature of painting in general, if, as we have indicated, abstraction differs radically from the traditional products of Western art? Or, to the contrary, should we affirm that, in spite of its revolutionary character, abstract painting leads us back to the source of all paintings, and moreover, that it alone discloses the possibility of painting and allows us to understand it? The fact that abstract painting comes late in the history of culture and even at its decline, at the time of its division and self-negation, does not prevent it from leading us, by a huge leap backward, to its origin. This, of course, is not its historical origin, which is lost in oblivion, but its ever-present and active foundation: the eternal source of all creation.

If the rationality of the principles of abstract painting is the rationality of all paintings—since it is the rationality of painting's own possibility and since *all painting is abstract*—then its power of clarification is not limited to Kandinsky's work, however well it may clarify his work. It sheds light on painting's entire development and all of the painted works—mosaics, frescos, engravings, and 'paintings' in the strict sense—that have been passed down to us. And this holds not only for paintings but for every conceivable art form: music, sculpture, architecture, poetry and dance. The great syntheses between the different arts, such as in Wagner's operas, fall under the jurisdiction of the principles of abstract painting, and we know that they were one of the privileged themes of Kandinsky's reflections.

What is this *possibility* of painting to which abstract painting offers the key? Consider a pebble on a path. One can indeed draw and paint it, but it will never paint anything. The possibility of painting does not dwell within it. Only the human being is potentially, perhaps even necessarily, a painter and an artist. One must, therefore, ask: 'What is the human being? What must a human being be in order for an activity like painting to surface as one of its abilities?' Yet, human beings did not create themselves. The human ability to paint is thus due to the nature of the human being, such as this nature has been given to humans, and this is due to the nature of Being as such.

What the greatest minds have ultimately sought from art is knowledge, a true or 'metaphysical' knowledge, capable of reaching beyond the external appearance of phenomena in order to lead us to their intimate essence. How can painting bring about this ultimate revelation? We already have an inkling that it is not by giving us something to see or by representing the

3

ultimate essence of a thing to us; instead, we identify with it through the initiation ritual of art, to the extent that this ritual draws its own possibility from and is tied to the structure of Being. What, then, is the nature of Being implied by painting and to which painting gives us access, making us contemporary with the Absolute and, in a certain sense, staking a claim to it?

Internal/external: the invisible and the visible

If one reads Kandinsky's theoretical works attentively, one notices that two terms continually arise there and that the entire weight of the analysis is concentrated on them. These terms are 'internal' and 'external'. The second great theoretical writing, *Point and Line to Plane* (1926), which appeared in the Bauhaus era, begins as follows:

> Every phenomenon can be experienced in two ways. These two ways are not random, but bound up with the phenomena—they are derived from the nature of the phenomena, from two characteristics of the same: External/Internal (532).

This claim must be elucidated, because it holds the fate of abstract painting. That is to say that with this claim we will establish the fate of all painting, and moreover, the fate of all art whatsoever. At any rate, we constantly experience the fact that every phenomenon can be lived in two ways—externally and internally—with respect to one phenomenon that never leaves us, that is, our own body. For, on the one hand, I live this body internally, coinciding with the exercise of each one of its powers—I see, I hear, I feel, I move my hands and eyes, I am hungry, I am cold—in such a way that *I am this seeing*, this hearing, this feeling, this movement or this hunger. I fall completely into their pure subjectivity to the point of being unable to differentiate myself from this hunger, this suffering, etc. On the other hand, I also live this same body externally, because I am able to see it, touch it, and represent it as one represents an object, in general, as an external reality more or less analogous with other objects.

Kandinsky affirms this extraordinary property—whereby my body is given to me in two different ways: 'internally' insofar as it is identical to my most profound being and 'externally' insofar as it is also offered to me as an object—for all phenomena. Thus, it is possible to distinguish these 'two sides' with respect to everything that is shown to us and is called a phenomenon. These two sides [*diese zwei Arten*] do not pertain to the content of the phenomenon but precisely to the manner in which this content is shown to us and appears. The 'two sides' are two modes of appearing. They are what Kandinsky calls 'External' and 'Internal'. For him, the External thus does not refer primarily to something that is external but to the way in which this something manifests itself to us. This manner consists in the fact of being placed in the exterior and being positioned before our regard, such that it is the fact of being placed before and in the exterior. Here exteriority as such constitutes manifestation and visibility. The exteriority in which every thing and every content becomes visible, becomes a phenomenon in terms of an external phenomenon, is the exteriority of the world. The world is the visible world, because the world means exteriority and because exteriority constitutes visibility. An external phenomenon is never seen or known in virtue of its particular properties—because it is big or small, structured or formless, etc.—but because it is external and for this reason alone. Since belonging to the 'world' signifies exteriority, it is manifested in exteriority and exteriority is equivalent to manifestation. Kandinsky says that the 'way' is not bound up with the phenomenon at random, because it is in this way—exteriority—that it can become a phenomenon and can be shown.

In contrast with being shown as an external phenomenon—in exteriority and the visibility of the world—Kandinsky presents another 'way': the Internal. The Internal is, in some sense, a more ancient and more radical way of being given. Like the External, the Internal does not refer to some particular thing that would be revealed inwardly; instead, interiority refers to the very fact of being revealed in this way. What does this most original 'way' of being given and 'being lived' consist of? This is an inescapable question, even though 'being lived internally'—the 'way' on which Kandinsky will construct his aesthetics—cannot be stated simplistically. It would then fall prey to a critique seeking to deny its existence—'Nothing of this sort exists!', 'Interiority is a myth!' In other words, the External provided proof of itself and this proof, it seems, is itself. It is the world appearing in its undeniable visibility, which does not cease to offer itself as a spectacle and to which, even when I close my eyes, I still belong through

the directedness of my senses towards it. Likewise, if the Internal must be taken as the basis of our analysis, it also must provide proof of itself. To prove itself is to show itself, but in its own way and no longer that of the world. For example, it would be absurd for the savant to demand the Internal to appear in the same way as the world of external phenomena that one might see with the eyes of the body or at least with those of the mind. The Internal will never be shown in this way, as something which can be seen because it is right there in front of us. It is the invisible—that which can never be seen in a world or in the manner of a world. There is no 'inner world'. The Internal is not the fold turned inward of a first Outside. In the Internal, there is no putting at a distance and no putting into a world—there is nothing external, because there is no exteriority in it.

In what way, then, can the Internal be revealed, if it is not in or as a world? It is revealed in the way of life. Life feels and experiences itself immediately such that it coincides with itself at each point of its being. Wholly immersed in itself and drawn from this feeling of itself, it is carried out as a pathos. Prior to and independently from every regard, affectivity is the 'way' in which the Internal is revealed to itself, in which life lives itself, in which the impression immediately imprints itself and in which feeling affects itself. This is how we arrive at a first formulation of the major equation supporting Kandinsky's work as well as his theoretical research:

Internal = interiority = life = invisible = pathos

Being is thus not a univocal concept. Two dimensions traverse it and tear apart its primal unity (to the extent that it would ever have one):

1. The dimension of the visible where things are given to us in the light of the world and are lived by us as external phenomena, and
2. The dimension of the invisible where, without the light of this world, even before the emergence of this horizon of exteriority that puts every thing at a distance from ourselves and offers it as an object to us (ob-ject means 'what is placed before us'), life has already taken hold of its own being and has embraced itself in the pathos of this interior and immediate experience of itself that makes it alive.

We want to speak about painting. If, placed before this enigmatic partitioning of being, we were to ask 'to which of the two realms—the visible or the invisible—does painting and its fate belong?', the answer would never be in doubt. Aren't painting and drawing a matter of the artist painting and drawing what he or she sees, what displays its being before the

regard in the light of the world? As the result of this obvious connection between painting, the eye, and the visible, our traditional conception of painting attests to its Greek origin. The weight of this origin is felt still today to the extent that it determines not only our conceptions about art and painting in general but also about their ends, the means that they must employ, and their problems, such as the problems of spatial representation, perspective, etc.

The Greek idea standing at the source of this network of relations and implications is the idea of the phenomenon. For the Greeks, the 'phenomenon' refers to what shines, what is shown in the light, in such a way that to show itself means to show itself in the light. What is shown and what is seen is thus light itself. To see is to belong to the light; it is to enter into it and to be illuminated by it. It is to be in the world.

The concept of the phenomenon undergoes a decisive transformation when it ceases to submit docilely to the injunctions of the visible and enters into relation with life, with the invisible. Once this transfer occurs, as it does with Kandinsky, a completely new set of questions emerge, along with a complete redefinition of the objectives and processes of painting. The hitherto insurmountable boundaries of art are also put into question or, better, destroyed.

Inasmuch as painting is the painting of the visible and thus of the world, it appears to be subordinated to a pre-established model of which it can no longer be anything but a replica, a reproduction, or an imitation. The Platonic idea of art as *mimesis* is the direct result of the Greek concept of the 'phenomenon'. Since what is shown in the light is always already given in this way, the artist only has to copy it. The value of art is the value of the copy, its greater or lesser fidelity to the model. This conception of art deprives it of any truly creative signification. Invention, in this sense, only has a bearing on the best possible means of rendering the artist's pre-established aim. One can also question the purpose of the entire process and the interest of art as imitation. Is not the artwork always inferior to the model, which does not necessarily attract our interest? 'Painting, oh what a vanity . . .'

Obviously, pictorial activity takes on a completely new set of objectives, meaning and scope when the Greek presuppositions and in particular the Greek concept of the phenomenon are dismissed. Pictorial activity no longer seeks to represent the world and its objects, when paradoxically, *it ceases to be the painting of the visible*. What, then, can it paint? It paints the invisible, or what Kandinsky calls the 'Internal'.

However, in any case, is not painting a matter of producing a work, something objective? Every painting must be considered from two points of view. First, in its materiality, as 'canvas' in the case of modern painting, 'wood' in the case of ancient painting, 'glass' in the case of a painting on glass such as those that Kandinsky admired in Bavarian churches, *'tesselles'* which are small cubes of rock and glass in the case of mosaics, 'sheets of copper' in the case of a copper engraving, etc. The matter on which the work is painted is a fragment of the world. It stands right there in front of us on the wall of a museum or church.

The painting, however, cannot be reduced to its material support. It *represents something:* a landscape, a genre painting, an allegory or a myth, a historical drama, a religious event, a portrait of a man or woman, etc. When we look at the painting, that is what we see. We do not see its material support, the cracks of the canvas, the splits in the wood or even the 'physical' way that patches of colour are spread across the painted surface; instead, we see what is depicted through these material elements, that is, the pictorial representation, the work as such, the genre painting, etc. According to the commonly accepted theories, the reality represented by the painting, the aesthetic reality as such, is not 'real' in the sense of the material reality of the wood or the canvas but rather is imaginary. This fact, however, does not prevent us from seeing it, whether it is with our eyes or our imagination. We are directed intentionally towards it, just as would be the case with a visible object perceived by the mind. Do not the painting and what it represents stand right there in front of us? Are they not 'external'?

If, instead, painting were to assign itself the task of painting the invisible, a unique problem would be presented to it then: how can it represent in a visible way, through a painting which has just been shown to be 'external' to every regard, this interior and invisible reality that is now the theme of artistic activity? In other words, even though the aims of painting would be altogether different, would not its means, that is the painting and what it represents with its colours and its linear forms, still be derived from what has always been their own domain? Would the painted work as such, the work of art, cease to belong to the domain of the visible?

This would introduce the general field of aesthetics to a hitherto unknown difficulty: *a dissociation between the content and the means of painting.* The content would undergo an ontological transfer from one region of existence to another, from the Exterior to the Interior, while the means would continue to display their being where, in their sensible appearing, colours and forms are shown and perceived—in the visible, in the light of the world.

Although it might seem to impose this dissociation between an internal content and external means, abstract painting will ultimately abolish this dissociation. For this reason, the extraordinary revolution conceived and accomplished by Kandinsky can be formulated as follows: not only is the content of painting, what is ultimately 'represented' or better, expressed by it, no longer one of the elements or parts of the world—either as a natural phenomenon or a human event—the same also holds for the means of expression of the invisible content that is the new theme of art. These means must now be understood as 'internal' in their meaning and ultimately as 'invisible' in their true reality.

We cannot hide our surprise any longer. Ever since human beings have painted, drawn lines, outlined spaces and covered them with colours, ever since they represented bison on the walls of the Lascaux caves, have they ever ceased to use form and colour in this activity which has captivated them for so long? Has abstract painting invented new, more appropriate means? Let us turn towards Kandinsky's paintings. Do we find anything there besides the lines and coloured forms mentioned above? Quite the contrary, they are all that we find. Likewise, in his theoretical writings Kandinsky considers points, lines, planes and colours to be the 'basic elements' of all painting. This is precisely why we said that the theory of abstract painting is the theory of all conceivable paintings. Abstract painting defines the essence of painting in general.

So, let us take the risk of stating two seemingly mad ideas:

1. The content of painting, of all paintings, is the Internal, the invisible life that does not cease to be invisible and remains forever in the Dark, and
2. The means by which it expresses this invisible content—forms and colours—are themselves invisible, in their original reality and true sense, at any rate.

To paint is to show, but this showing has the aim of letting us see what is not seen and cannot be seen. The means of painting are the resources used for this showing and are employed in order to give us access to the invisible. They sink into the Night of this abyssal subjectivity that no ray of light can enter and that no dawn will ever dissipate.

From this tangle of paradoxes results at least one initial truth that we can now notice. In traditional painting, or rather in the common conceptions about this type of painting, the content and means were homogenous; they both belonged to the visible world. It was a matter of painting this world,

and of doing so with the help of the colours and forms that were borrowed from it, had their place in it and came from it. With the emergence of abstraction, this solidarity seems to be broken. The content becomes the invisible while the means remain what they are: objective determinations, surfaces and planes, coloured patches and lines. But if the real being of these seemingly objective elements is referred to the invisibility of absolute subjectivity, then the ontological homogeneity of the content and the means of painting would be re-established. Perhaps one should even go so far as to abolish the idea of their distinction, content and means being one and the same reality, one and the same essence of painting.

One terminological remark confirms this view. Kandinsky calls the content that painting must express, that is, our invisibility, 'abstract'. So, the Kandinskian equation can now be written as follows:

Interior = interiority = invisible = life = pathos = abstract

Kandinsky also calls the means of painting 'abstract', so long as they are grasped in their purity. To the extent that they are abstract, colours and drawings are likewise inscribed in the equation formulated above, the equation which forms the original dimension of Being itself. In this respect, we have just discovered the true meaning of the concept of abstraction applied to painting.

The meaning of 'abstract' in the expression 'abstract painting'

In the most ordinary sense of the word, a thing is called 'abstract' when it is separated from the reality to which it belongs. Abstraction thus refers to the process whereby, in ceasing to envisage this reality in terms of all of its characteristics, one retains only some of them in order to consider them separately. With respect to a tree, one might only take account of the 'greenness' of its foliage or the 'hardness' of its wood. Whether it is real or only ideal, this process marks an impoverishment and extenuation, since it only takes up one part of the internally connected properties. Only their internal connection in a coherent whole can constitute a concrete reality, that is to say, a reality subsisting on its own.

If only the Whole is concrete, the process of isolating one of its properties in order to consider it on its own can only be performed in thought. It is thus abstract in a second sense, in the sense of a division or a separation that is situated in the mind and not in the thing. Because the process of abstraction is itself abstract, the concept of abstraction is affected by a second indication of its irreality. It does not only set aside the large majority of the properties comprising the reality of the real but also remains purely 'ideal'. Yet, if only the Whole is real and truly concrete, there is ultimately only one Whole, one sole concrete totality: it is the world, the visible world.

The concept of 'abstract painting', as it is used today in art criticism, is derived from the concept of abstraction briefly sketched above. The key point here is that this type of abstraction is understood and defined on the basis of this world of light that painting (ever since the Greeks) has taken as its sole reference point and as the basis for its means. In every case, the 'abstract reality' represented in the most recent developments of painting is

a reality *abstracted from the world*. That it is to say that it is conceived, delineated, dedicated and elaborated on the basis of the world, and ultimately it is the world's most adequate mode of expression. The pact sealed between the eye and the visible from the beginning is not undone or contested in a single instance; instead, it is matter of playing out its infinite number of virtualities and giving it its full effect.

The important role played by geometrical forms in pictorial compositions seems to provide proof that abstraction proceeds from the world and is always constituted as one of its possible derivations. Are not geometrical forms abstract? By 'abstract', here I mean that they are constructed through a purification of sensible forms. What is a line if not an outline suggested by the boundaries of a natural body where no account has yet been made of its thickness, its colour, etc? In this way, one goes from a 'round' thing to the circle, from all of the formal intimations of nature to their geometrical archetype. Although this activity at the origin of geometry deserves to be called an 'ideation' and not an 'abstraction'—to the extent that it creates a new, ideal being instead of isolating a part of reality—it nonetheless takes its point of departure and foundation from the world.

In classical painting, the presence of these pure forms as a principle of the construction of the painting—a construction that is linear, triangular, circular, etc.—is reconciled perfectly with the attempt to 'imitate nature', that is, its rediscovery and use of nature's deep laws. Indeed, they are drawn directly from nature. Even when this geometrical composition becomes predominant to the point of reducing pictoriality to itself, as occurs in cubism, the worldliness of this type of painting is never called into question. It is still an external reality, a certain interpretation *of this reality*, that serves as the premise of its revitalization efforts. *The abstraction of cubism belongs to the figurative project and must be understood as one of its modalities of realization.* Even when reality becomes unrecognizable in these architectures of planes, triangles and cubes (to the point that the spectator must squint her eyes in order to figure out whether she is looking at a mountain, a village, a seated woman or all of them at the same time), this external reality still inspires the various treatments that it undergoes. *The object dictates the rules of its deconstruction as well as its reconstruction to the artist.* The play with perspective, the (arbitrary) decision to increase or diminish it, the choice of several focal points instead of one, the simultaneous representation of the thing from the face, the side, above, below or behind—all of these deformations and 'audacities' only serve to explore the structure of

ordinary perception further. This is why they so quickly come to seem monotonous. They are mere techniques that have become impersonal and artificial (after all, how can one distinguish between a Picasso and a Braque in the cubist period?). They quickly give way to another 'style' that is just as artificial and boring.

With the most systematic and ambitious project of reducing pictorial representation to its purity—to horizontal and vertical intersections or to a purely archetypal display—the object seems to disappear completely, along with all the aftermath of representation. But nothing of this sort really happens. Mondrian or Malevich's pure abstraction is precisely a geometrical abstraction, an abstraction which comes from the world and gets its nature from the world while at the same time seeking to formulate its essence. What is the world, if not 'something that has length, size and depth'? The artistic avant-garde of the beginning of the twentieth century was three hundred years behind the founders of modern thought—behind Galileo who eliminated the sensible vestiges of things in order to reduce them to portions of extended matter, to the figures and forms that geometry provides adequate knowledge of and behind Descartes (from whom we just borrowed the key statement above) who added to the Galilean postulate concerning the cosmic meaning of geometry by giving it a mathematical expression.

The disappearance of the object in geometrical abstraction is thus only the bringing to light of its essence, that which allows every object to be an object: it is placed in front of us in the space of light that is the world. It is the opening of this world, the first emergence of the Outside in which all objects will be joined together. It is the opening of the horizon against whose background all external phenomena will emerge. All of these 'abstract' investigations allow us to see the visibility of the visible, to the extent that they can. At the end of their journey, the most demanding investigations will only encounter the emptiness of this pure space. Up to then, painting populated space with countless projections that came from elsewhere; now painting wants to conceive it in its bare presence, in its Nothingness.

The abstraction that releases the creative genius of Kandinsky has nothing to do with this type of abstraction that dominated the history of artistic creation starting from the second decade of the twentieth century and periodically returns under various guises. It would even be a contradiction, of the worst kind, to define it against these attempts—such as Cubism, Orphism, Futurism, Surrealism, Constructivism, Cinetism and

Conceptualism—that never cease to relate to the visible as their sole object. They seek only to grasp the object's true nature and ultimately to grasp the true nature of visibility, whether it is sensible light (Impressionism) or transcendental (Mondrian, Malevich).

In this sequence of ideas, one encounters considerations that are familiar to art historians and their readers. Forms of representation, whose sole aim is the exact depiction of external reality, end up very quickly at an impasse that is illustrated by naturalism and its variants. Museums devoted to nineteenth century art abound with these insignificant canvases, foretasted by eighteenth century English landscape painting. In the 1880s in Munich, Franz von Lenbach (1815–98) painted some of his famous portraits—those of Bismarck, for example—without the use of models, using only photographs. These disturbing effigies can still be admired today in the Lenbach House in Munich (where, in stark contrast, the Kandinsky paintings from the Gabrielle Münter collection can also be found). Such mediocre results by a fading art can only awaken, first for painters, a reflection on the project of objectivity, that is to say a *return to true perception*. One then sees that shadows are not grey but coloured; that there are blues on snow and green in the beard of this old ill-shaven man. Generally speaking, conventional representation and academic expectations never correspond to what is really given in the visual experience of the world.

What, then, is given in this visual experience to which one must return? Husserl says that the object is an ideal pole of identity over and above the multiplicity of its sensible appearances. That is why the painter does not really want to paint this ideal pole, this concept or entity which is always one and the same—*the* cathedral of Rouen or *the* haystack. Instead, the painter seeks these 'sensible appearances' in their singularity and changes: this form with ungraspable contours and with faint lights that twinkle in the dazzling night, a bedazzlement where reality breaks down into pure bursts of blinding light, slips into the unknown, loses all consistency, and ultimately disappears. It is precisely in seeing Monet's haystacks at the 1896 Moscow exhibition that Kandinsky felt one of his most intense aesthetic emotions. He joined the lesson from it with the one that he drew from reading Niels Bohr: physical reality has no substance and in some way no reality; quanta of energy move in leaps without crossing through it. In physics as well, matter is broken down into the dust of dubious, virtual particles; it dissolves into irreality and a sort of immaterialism. Now one can understand Kandinsky's famous question: if the object is destroyed, what should replace it?

Even if this historical genesis is true and does have the merit of making Kandinsky's evolution more or less analogous to those of other great artists of his time and thereby 'comprehensible', it nonetheless falsifies the true meaning of abstract painting to the point of completely concealing its rationality. The problem of pictorial representation did not come to be reconceived due to a crisis of objectivity that is more or less analogous on the aesthetic plane to what it was in the scientific domain, and in particular, the physics of the period. It does not come from a reworking of perceptual representation, either. Kandinsky's abstraction came from a sudden failure of the object, its inability to define the content of the work any longer. This abstraction, this content—the 'abstract content'—is invisible life in its ceaseless arrival into itself. This continual emergence of life, its eternally living essence, provides the content of painting and at the same time imposes a project on the artist, namely, that of expressing this content and this pathetic profusion of Being. 'Abstract' no longer refers to what is derived from the world at the end of a process of simplification or complication or at the end of the history of modern painting; instead, it refers to what was prior to the world and does not need the world in order to exist. It refers to the life that is embraced in the night of its radical subjectivity, where there is no light or world.

No other path leads to life but itself; life is both the end and the path. If no cultural, sociological or economic evolution can explain anything in the domain of art (no more than it would be able to explain the birth of love), this is because all creation takes place in life. It has already happened when one undertakes to interrogate its conditions, causes or means. As usual, history reverses the true order of things, the ontological order of their foundation. Kandinsky never truly asked himself what would replace the object and what painting would be able to paint from then on. Ever since a walk in the countryside around Munich where the violence of a colour perceived in the undergrowth gave rise to an intense emotion and he decided to paint what surrounded this colour—the view of this woods—*in order to represent his emotion*, he knew with a knowledge that no reflection can clarify and that no history precedes, with this knowledge that is constituted by this emotion itself, that he wanted to paint this emotion and this emotion was the only thing that he would paint thereafter. This was the content of all possible paintings: the profusion of life in himself, its intensification and exaltation.

The statement made a few years later in the 1914 Cologne Lecture (a lecture that was never delivered) leaves no room for doubt: 'One knows

much more often *what* one wants than how to attain it' (394). So, when the dissociation between the content of painting and its means (means that Kandinsky calls, in relation to content, its 'materialization' or its 'form') is established, the priority of the former over the latter is clearly affirmed. This priority ultimately has a historical meaning, because it bears on the ontological order. The same text adds: 'the work exists *in abstracto* prior to that embodiment which makes it accessible to the human senses' (ibid.). The anteriority of the invisible in a domain that previously belonged to the visible and the sense is confirmed in a striking way by the fact that the 'embodiment' of the originally 'abstract' content of the artwork is what makes the means of painting—these colours and forms—'accessible to the human senses'. This is what gives Kandinsky's abstraction its specific meaning.

'I regard the entire city of Moscow, both its internal and external aspect, as the origin of my ambitions', Kandinsky once said (382). A magnificent passage from 'Reminiscences' helps us to understand this important statement from the theorist of abstraction. There Kandinsky mentions a trip to the little Medieval German town Rothenburg-ob-der-Tauber. This trip greatly impressed him and, upon his return, he painted a wonderful, though still representational, painting 'The Old Town'. Kandinsky writes: 'Even in this picture, I was actually hunting for a particular hour, which always was and remains the most beautiful hour of the Moscow day. The sun is already getting low and has attained its full intensity which it has been seeking all day, for which it has striven all day. This image does not last long: a few minutes, and the sunlight grows red with effort, redder and redder, cold at first, and then increasing in warmth. The sun dissolves the whole of Moscow into a single spot, which, like a wild tuba, sets all one's soul vibrating. No, this red fusion is not the most beautiful hour! It is only the final chord of the symphony, which brings every colour vividly to life, which allows and forces the whole of Moscow to resound like the *fff* of a giant orchestra. Pink, lilac, yellow, white, blue, pistachio green, flame red houses, churches, each an independent song—the garish green of the grass, the deeper tremolo of the trees, the singing snow with its thousand voices, or the allegretto of the bare branches, the red, stiff, silent ring of the Kremlin walls, and above, towering over everything, like a shout of triumph, like a self-oblivious hallelujah, the long, white, graceful, serious line of the Bell Tower of Ivan the Great. And upon its tall, tense neck, stretched up towards heaven in eternal yearning, the golden head of the cupola, which among the golden and coloured stars of the other cupolas, is Moscow's sun. To

paint this hour, I thought, must be for an artist the most impossible, the greatest joy. These impressions were repeated on each sunny day. They were a delight that shook me to the depths of my soul, that raised me to ecstasy' (359–60).

The greatest painters, as we said, have lived and presented their art as a mode of metaphysical knowledge. In passing through sensible appearances and in some way going behind them, we discover the mystery of things, the secret of the universe. What sort of knowledge is at stake here? That, indeed, is the problem that abstract painting allows us to understand. In the context of Western consciousness which finds its completion in modern science, knowledge means 'objective' knowledge, a knowledge of the world, that is, of all external phenomena. These phenomena are what is to be grasped, even when they slip away as is the case in physics. Regardless of whatever progress it may make with its increasingly elaborate methods, this knowledge never truly arrives at its goal and never will. This failure is not due to the still provisional nature of its acquired results which are destined to be replaced by other more exhaustive ones. The domain in which science operates strikes its enterprise *a priori* with an insurmountable finitude. Because its object is 'external' and its being is spread out in the world, it only provides us with a section of exteriority, a surface on which the gaze slides without every being able to enter into the interior of the thing. This is because this thing has no interior, because it is not constituted as interiority. Analysis, dissection, microscopic and microphysical study with the aid of increasingly complex tools will only reveal new 'objects' and new 'aspects' that are equally impenetrable to the regard. The regard will only be led from one to another indefinitely, until the particle totally disappears, giving way to virtual particles, new 'objects' which are no longer those of intuition, however fleeting it may be, but a mere thought or estimate.

Art opens us to knowledge of an entirely different nature: it is a knowledge without object. Life is its ontological milieu, a life which embraces itself entirely without ever separating from itself and without being placed in front of itself like an object. We said that no path leads to life except for life itself. One must stand within life in order to gain access to it; one must begin from life. Kandinsky just showed us the point of departure for painting—it is an emotion, a more intense mode of life. The content of art is this emotion. The aim of art is to transmit it to others. The knowledge of art develops entirely within life; it is the proper movement of life, its movement of growth, of experiencing itself more strongly.

This is why art always expresses high forms of life, for example, those which Kandinsky evokes in Moscow when he says, 'I have only painted Moscow my entire life'. This is also why art is not an imitation, the knowledge of a pre-established reality or a pre-existing model by which one would be guided. Because the content that painting seeks to express is life, art is situated within a process of becoming. It belongs to and coincides with the drive of Being within us. Art has the task of supporting and carrying it to the extreme point, to this 'paroxysm of life', where life experiences itself on its own basis, in which it is lost in this 'impossible happiness' that Kandinsky calls 'ecstasy'.

Those who enter the path of art will thus never go in the direction of a truth external to oneself, towards which one might return as a stable being existing independently from oneself. Whether one knows it or not, one has made a choice of constituting oneself as the place of the arrival of this truth, of giving one's own substance and flesh in order to be its flesh—the flesh of Life, which cannot be anything but the life of the individual and its highest degree of fulfilment. Because the truth of art is a transformation of the individual's life, aesthetic experience contracts an indissoluble link with ethics. It is itself an ethics, a 'practice', a mode of actualizing life. This internal connection between the invisible aesthetic life and the ethical life is what Kandinsky calls the 'spiritual'.

The title of Kandinsky's first great theoretical work, *On the Spiritual in Art and in Painting in particular* (1912) which had a huge influence, thus has a rigorous meaning. It bears a twofold judgement, both on this epoch whose distress is perceived by Kandinsky and on the true reality of things. Our time is a distressed time because it is forgetful of reality and has abandoned itself to the increasing objectivism promoted by science. The ideological fulfilment of this type of thought which is given over to the External and thus deprived of what is essential is naturalism, to which the stiff and empty art from the nineteenth century provides overwhelming testimony. Its practical consequence is the materialism that spreads the negation of life's true essence across all the spheres of life, thereby offering itself as a sort of concrete nihilism whose true name is death.

Faced with this situation, *On the Spiritual in Art and in Painting in Particular* offers a programme of revitalization. First, against naturalism, one must establish that the true dimension of art is the 'spiritual', that is, the invisible life with which art is identified to the extent that it coincides with its process of self-expansion, constantly sustaining and stimulating it. In its very existence, art is thus the demonstration of the invisible life whose

inalienable right must be recognized and reestablished. Like all great thought, Kandinsky's thought is not a critique in the negative sense. It is hardly a question of naturalism and the works that follow from it (which fill the onerous museums that the reigning ideology today devotes to their glory such as The Neue Pinakothek in Munich, and the Orsay Museum in Paris), as if their insignificance were self-evident. Kandinsky's entirely positive work—his theoretical work in the writings that we will analyse and in his creative activity of painting—has the aim of showing the undeniable and universal nature of every authentic work of art, abstract painting being the one which provides the strongest force to this evidence.

Yet, if art in general (and painting in particular) brings about the revelation of the invisible life that constitutes the true reality of the human, it plays a double role. First of all, it must allow for a return to this lost reality. The past significance of the knowledge attributed to art becomes both more precise and more urgent in this fallen world. When exteriority extends its power over the whole of being and defines it, when nothing but objects truly exist any longer so that the sole true knowledge is the objective knowledge of science, then the liberation of the 'spiritual'—this invisible reality that we are at the core of our being and that is true Being—once again becomes the metaphysical knowledge that art provided in the past. Art accomplishes a discovery, an extraordinary rediscovery: it places before our wondering eyes an unexplored domain of new phenomena that have been forgotten, if not hidden or denied. These are the phenomena in fact that open our access to what alone matters in the end: ourselves.

Art is not only a theoretical proof of this invisible and essential reality of our being: it does not give it as something to be seen as an object; instead, it makes use of it: it is the exercise and development of it. We experience its certainty as something that must be, much like one experiences love. This certainty is absolutely identical to our life. All other certainties—those of the sciences included—pale and break down in comparison to it. Because art accomplishes the revelation of the invisible reality in us with an absolute certainty, it is a salvation. In a society like ours which is divorced from life—either by being content to flee it in the external world or by stating the explicit negation of it—it is the sole salvation possible.

But then art must be extended to the entire sphere of human activity, first of all, to the manufacture of material goods. The industrial production of objects must join their functionality with a properly aesthetic dimension in such a way that, when it enters with our being through consumption or use, it provides an opportunity for us to fulfil our own purpose. This was

the aim of the Bauhaus that Kandinsky rallied around in 1922, after he was called there by Gropius. He joined other remarkable artists there like Paul Klee. Kandinsky shared this ideal of a messianic meaning of art, which he had developed ever since his fundamental 1912 writings. The organization of studies at Bauhaus reflected this ideal. In the workshops devoted to the production of objects for sale (weavings, pottery, furniture, decoration, etc.), the fundamental teachings of masters like Kandinsky and Klee were added. This is a significant fact. While Bauhaus in principle was a school of architecture to which the other arts, including painting, were supposed to be subordinate, nearly all of the theoretical teachings were devoted to painters. This situation was challenged once the materialists, like Moholy Nagy and Meyer, sought to control the direction of the school and guide its fate.

All of Kandinsky's creative activities—in Munich during the years surrounding the discovery of abstraction in 1910, in Moscow (1915–21), at the Bauhaus (1922–33) and in Paris until his death in 1944—seek to promote and illustrate the essential truth contained in *On the Spiritual in Art*. This truth is that the true reality is invisible, that our radical subjectivity is this reality, that this reality constitutes the sole content of art and that art seeks to express this abstract content.

Of what does this expression consist? That is the second question we raised above and that we will now confront. Even though the abstract content that painting seeks to represent is *ultimately a content entirely foreign to the world* and really does escape from this world, do not the means of this representation belong to the world? Are they not themselves visible, in such a way that painting would have to be understood as an externalization of this invisible content, as its 'materialization'?

Form

The means of painting are what Kandinsky calls 'form'. The concept of form must therefore be understood in a broader sense. It includes not just forms in the strict sense of linear forms but also colours, or to recall the terminology of the 1913 article 'Painting as a Pure Art' which appeared in the magazine *Der Sturm*, the 'painterly form' and the 'pictorial form'. With respect to the form understood in the broad sense as the means of all painting and with respect to painting as a mode of expression and as a way of showing, this same text unequivocally states: 'Form is the material expression of abstract content' (350). If its content is indeed invisible, painting as the expression of this content would undeniably reintroduce us to the realm of the visible. The invisible would spread out through these lines and colours that we see. They are shown in the visible, and through the visible, the 'internal' content of the work is shown. Kandinsky writes: 'For the content, which exists first of all only "*in abstracto,*", to become a work of art, the second element—the external—must serve as its embodiment. Thus content seeks a means of expression, a "material" form' (349–50).

The definition of the 'work of art' that follows and that presents art as the externalization and manifestation of the abstract, invisible content, could not be any more clear: 'Thus the work of art is an inevitable, inseparable joining together of the internal and external elements, of the content and the form' (350). With the consideration of the artwork's 'form' without which it would not exist and of which it does consist, is not painting left in its traditionally assigned place, that is, in the realm of the visible from which 'abstraction' seemed to release us?

All of Kandinsky's theoretical and practical work will seek to undo this apparent fact. Let us note, first of all, that the affirmation that the artwork constitutes the 'fusion' of the 'internal' and 'external' can be understood in at least two ways. A classical, Hegelian reading, for example, would consider the artwork itself to be the external. This is not simply because painting involves the visible arrangement of form and colours but also because the internal is still only an indeterminate and empty subjectivity—the night in which all cows are black—as long as it has not yet become visible in the exteriority of form. The structure of the artwork is the objective structure of this form with its lines and colours. As such, the artwork truly comes into being only in and through its manifestation, in this external manifestation of form without which the internal remains a mere virtuality.

Kandinsky wants to say just the opposite. He wants to say that, considered in the radical interiority of this abyssal Night which does not give rise to an Outside, subjectivity is not something abstract in the sense that it would still lack reality and would only be capable of becoming real through the addition of an external element, namely, the exteriority of the world. To the contrary, subjectivity defines this reality, this plenitude of being outside of which nothing exists. This is because the external does not exist on its own. Considered in terms of exteriority, the artwork, such as this painting that we see, can only borrow its content from the subjectivity of life in which its reality is concentrated: '*The determining element is the content*' (350). Kandinsky calls this living subjectivity 'the soul' and its affective modalities, its concrete emotions, 'vibrations of the soul'. This is why Kandinsky writes: 'The inner element, created by the soul's vibration, is the content of the work of art. Without inner content, no work of art can exist' (349).

If the work of art is put forth as the 'fusion of two elements, internal and external', the way in which this fusion occurs must be unequivocal. The two elements whose fusion constitutes the artwork as an organic whole are not on the same level: the internal does not only *determine the form, the external element; it defines the sole content of the artwork and, as a result, defines the content of the form*. The first point is important, and the second can help us to understand the true essence of abstract painting. So, let us begin with the first point.

To say that the abstract content—the invisibility of subjectivity—must determine the form is to say that the form should no longer be modelled on the apparent content of the objects from the world of ordinary perception

or on the visible structures of the objective world. A revolutionary principle is already included in the postulate of an order of dependency between the two elements which comprise the work of art and in the affirmation of the primacy of the internal over the external. Kandinsky conceives this revolution in its full magnitude. He understands it on the principle that every true revolution is a liberation. Abstraction accomplishes the liberation of painting, first of all, by the fact that, instead of depending on the pre-existing and determined being of nature as a state of affairs which would act as an external constraint on painting, form breaks with this subordinate relation and is freed from every foreign imperative.

Foreign to what? To life. Life henceforth claims to be the sole principle of form, whether it is form *stricto sensu* or colour. These elements have always been understood to be parts and components of the world which are not only modelled on the world but in some sense find their place and true being there, but now they are suddenly torn away from the objective world. At any rate, the objective world ceases to be the principle of their organization, meaning, distribution and role in the painting. All naturalistic art is thereby taken in the opposite direction and has its explicit purpose overturned, since the form in and through which one represents can no longer be referred to or governed by its proper place as a form.

In realistic painting—which includes naturalism as well as impressionism and neo-impressionism, in spite of the two latter schools' use of the axiom that the essence of art is not what it represents but the manner in which it represents—external reality conditions the formal modalities of representation such that, as Kandinsky says, 'the choice of form is not free, but is dependent upon the object' (352). Form only acquires freedom as the result of this radical shift in reference whereby it is detached from the objective world. Form is drawn from the invisible life and finds the laws of its constitution and the principle of its sense in it alone. A new form is born in this way, a 'purely artistic form, which can confer upon the painting the strength necessary for independent life, and which is able to raise picture to the level of a spiritual subject' (353).

The freedom of purely artistic form is identical to the principle that Kandinsky assigns to all true painting, namely, the principle of 'Inner Necessity'. We can only enter slowly into the rationality behind this fundamental principle, if it is indeed true that 'internal necessity . . . is the only unalterable law of art' (350). Yet, a preliminary meaning can be offered at this point. Internal necessity is, first of all, the necessity of form insofar as it is determined by invisible life—by the Internal—by it alone and not in any

way by the world. The law for the construction of the external, 'material' element is thus located in a purely spiritual reality, situated within our being. It is identical with it and acts as the sole principle of aesthetic creation. 'On the Spiritual in Art . . .'

This determination by the Internal is radical; it is accomplished according to an absolute necessity; this Inner Necessity means that form surrenders its freedom to it; Inner Necessity defines the freedom of art in general as 'pure art'. These points explain at least one thing to us: the impression of necessity given by every authentic work, and the contingency, even the gratuity, characteristic of a mediocre painting. The weakness of mediocre painting consists in its possibility of being otherwise—the result of this uncertainty is the indifference of a regard that is constrained by nothing to reproduce a design from which it would no longer be able to turn away.

Identical to the freedom of art, Internal Necessity thus provides a rigorous and implacable criterion by which to judge artistic productions. Whereas the purely artistic construction subsists on its own with the invincible coherence that comes from Inner Necessity, from the necessity that presides over the choice of form—which no longer has or needs any external support—figurative paintings rely on external reality. Their pallid colours and loose forms collapse due to 'formal indigence', once this support is absent. This is the case for all naturalistic paintings, including impressionism. The breakdown of these paintings, for example, when one looks at them upside down or when in some way or another their reference to the objective world is broken—which in the eyes of many constitutes the sole 'sense' of painting—provides the proof that form derives its rigor and force from Inner Necessity and that, in spite of all appearances, it has no other possible content than life. Proof for Essay

We thus arrive at the second point of our proof. Form is determined by the abstract content that it seeks to express, and the determination of form by the content is the principle of Inner Necessity on which all authentic painting must be based and on which it has actually been based in reality from the outset. But does this form determined by Life cease to appear to us in the world? Can form exist without this external element in which the artwork is materialized?

Kandinsky's response will be affirmative, although we are not yet prepared to understand why. This unusual, hardly realistic or believable, position will allow us to enter into the secret laboratory of painting where the act of painting occurs and to truly grasp what this act involves. If in abstract painting, as in all paintings, form is determined by the invisible

content that it expresses, what does this 'determination' consist of? In other words, where does the principle of equivalence or suitability reside between what must be represented—this pathos, this 'vibration of the soul', such as the feeling of death—and the features and colours that will make it visible, 'materialize' it for our senses? Is painting anything but this principle of equivalence and suitability, this capacity to display and represent what we experience—to 'paint' it?

Kandinsky's genius is not only to have taken this capacity to paint the invisible—our drives, our affects, our force—to a hitherto unattained level but also to have provided an explanation of this extraordinary capacity. This explanation is not speculative and does not belong to a hypothetical order, whose nature would be to be accepted or rejected at the end of a more or less plausible argument. It is a phenomenological analysis, meaning that, outside of every theory, it lets us see, or better, feel, the 'essence' of painting in the undeniable truth and certainty of the immediate feeling that life has of itself.

Pure pictorial form

We have elucidated the meaning of the word 'abstract' in the expression 'abstract painting' first by applying it to the 'content' of painting, that is to say, to the invisible life that it paints. Then we applied the term 'abstract' to the 'form' of painting, that is to say, to the external element through which the work expresses the inner content. We are thus dealing with the concept of abstract form, which the preceding analyses have provided a dual meaning. On the one hand, form is abstract in the sense that it is determined exclusively by the abstract content, that is, by Internal Necessity. On the other hand, we have at least anticipated that form is abstract in a much more radical sense, in the sense that it is homogenous, and at the extreme identical, with the abstract content. It is no longer in the world; instead, it finds its ownmost being in the nocturnal dimension of absolute subjectivity. It thus comes to take its place in Kandinsky's formula of true reality:

Interior = interiority of absolute subjectivity = life = invisible = pathos = abstract content = abstract form

In reference to this latter sense of abstract form, 'Reminiscences' alludes to the numerous years of 'patient toil' and 'strenuous thought' that Kandinsky had to go through in order to arrive at a full understanding and mastery of his art: 'my constantly developing ability to conceive of pictorial forms in purely abstract terms, engrossing myself more and more in these measureless depths . . .' (370). Before pursuing the analysis of the abstraction of form to the point that this abstraction vanishes in the measureless depths of life, one remark about vocabulary must be made first. In the text cited above, abstract forms are called 'pictorial forms'. This term is

important because it assigns painting to a specific, autonomous domain. The recognition of the specificity of painting goes together with the discovery of abstraction, and here one better understands how the analysis of abstract painting can be the analysis of all painting.

What does this specific domain of painting consist of, that is, what is the specifically pictorial character of form? Form constitutes the external element of the work. Grasping its pictorial character requires us to return to this element and to draw a sharp dividing line in it. In ordinary perception, we deal with objects. These objects have a practical purpose. What I see is the door to be opened, the car that I will borrow, the green or red light allows or disallows me to cross the intersection, the store whose display is recognized to be arranged or lit in a certain way. To be sure, the door is shown to me, and it has a certain colour. The same goes for the car and the traffic light with respect to their colour. Yet, in each one of these cases the colour is not perceived in itself. It serves as a sign of the object to which it refers, and as a result, it is not grasped for itself but as a mere means, an instrument.

What we just said about the colour of the object also holds for its form in the strict sense. We never consider the form in itself; it is only an indication. It is the sign of something that only has a value for me through its relation to what I plan to do. Every perception is practical and utilitarian in principle. Each coloured appearance and each line that delineates it (which is commonly reduced to a schema) goes beyond itself towards the use that it indicates, and that is the reason of its existence in practical life. This discloses the structure of ordinary perception to us. When I go around a house, what is really given to me is a series of aspects. These sensible profiles are nonetheless grasped as aspects *of this house*. This is what attracts my interest, such that I do not pay any attention to this succession of profiles or to the ineffable features of each one of them. In this way, the sensible appearance is constantly dispossessed to the benefit of what it indicates—the house, the car, the traffic light, etc.

Painting is a counter-perception. What this means is that this chain of referential significations by which the ordinary reality of the world is constituted—this continual movement of going beyond the sensible appearances to a monotonous and stereotypical background of practical objects—is sharply interrupted by the artist's regard. By setting aside this practical background, colours and forms cease to depict the object and to be lost in it. They themselves have and are seen to have their own value; they become pure pictorial forms.

With respect to colours, Kandinsky offered a wonderful description of the elimination of the objective world of perception and the corresponding liberation of pictorial forms. This elimination is accomplished when colours, prior to being placed on the canvas in order to depict a well-ordered and comprehensible spectacle, are spread onto the painter's palette just as they escape from the tube. They are spread onto the blank surface without presenting anything but themselves and the dazzling tones they bring to our attention. Speaking about the purchase of his first paint box, Kandinsky writes: 'I can still feel today the sensation I experienced then—or, to put it better, the experience I underwent then—of the paints emerging from the tube. One squeeze of the fingers, and out came these strange beings, one after the other, which one calls colours—exultant, solemn, brooding, dreamy, self-absorbed, deeply serious, with roguish exuberance, with a sigh of release, with a deep sound of mourning, with defiant power and resistance, with submissive suppleness and devotion, with obstinate self-control, with sensitive, precarious balance. Living an independent life of their own, with all the necessary qualities for further, autonomous existence, prepared to make way readily, in an instant, for new combinations, to mingle with one another and create an infinite succession of new worlds' (371–2).

This 'independent life of colours' means that they are no longer taken as mere aspects of the object; they are given in their pure appearing, 'exultant', 'solemn', with their 'roguish exuberance', a serious 'deep sound of mourning' or the excess of sensibility that they show in their 'precarious balance'. The new world of pure pictoriality is born, without any relation to the prior sense of the world which has now been crushed, and denied. Kandinsky observes: 'In the middle of the palette exists a strange world' (ibid.). This strange world is 'living'. Is this a mere metaphor for the colours' independence? Or, beyond every image, should it be understood that 'these fresh, young forces' of colours have already led us back to our real life as the place in which every force is rooted?

At any rate, once he bought his paint box at 13 or 14 years old, Kandinsky had already sketched out his fate. His adventure is well-known: during a trip through the Vologda province with the intention of studying the local customary law, he discovered wooden peasant homes, carved on the exterior and painted all over in the interior. There Kandinsky experienced the impression of moving through the picture, and he later sought to transmit this experience by letting the viewer 'stroll' within the picture (369). This impression acquired its decisive significance only through this primal

experience of colour whose metaphysical significance will appear to us soon.

Fascinated by the almost magical power of these luminous masses, hearing their rustling sounds, gazing in wonder at their flow, their mixtures, their unforeseen movements on the palette 'more beautiful indeed than many a work', Kandinsky underwent their instruction to the point of becoming their accomplice (372). This is why he was able to remember colours better than objects. In his work, his attention focused on the pure colours spread across the palette, affirming that his regard of them should replace the regard given to nature up to then. An important pictorial principle follows from his bedazzlement with this strange and autonomous world: the non-realist use of colours. How can they be subordinated to a foreign world and continue to depict the banal world of practical perception, when they are resplendent in their incandescent flesh and filled with infinite virtualities?

The non-figurative use of colour, in turn, translates into one of Kandinsky's great discoveries: *the dissociation of colour and form*. This opens the possibility for colour to break free from the limits in which form seeks to contain it. Knowing no barriers, overflowing the drawing, and exploding outside of the predefined space it was assigned until then, colour spreads out wherever it wants to, submitting only to its own force and its own volition. Where, then, does this pictorial imperative of delineating a colour by a form, its inscription in a form and its subordination to a prior outline come from? It comes from the world and its 'objective reality'. It is in the world of perception with the really perceived object that colour ends where the surface that it colours ends. The contour of the object is wedded to the limit of this surface, plane, or volume. The liberation of colour from external reality implies its release from the form of objects and all graphics in general; it marks the arrival of a new life, the life of colour delivered to itself and *having become a pure pictorial form*.

The same goes for form in the strict sense, that is to say, for the outline, the lines, and the limits whose role in classic representation was to circumscribe the placement of colours and to regulate their distribution on the canvas. As long as these graphic forms determine the construction of the painting and aim to reproduce the reality of the world, they cannot be imposed by themselves. The mind can only grasp the depicted object through them. In the strict sense, *the perception of form does not exist*. It is a conventional outline—an outline of the house, the roof, the chimney or the smoke rising to the sky—that the painter draws and that the spectator

recognizes and thereby understands the painting. Everyday banality thus establishes the laws of art. Pictorially, this can be expressed as follows: only the forms of objects in ordinary perception have a place in realistic painting. The infinity of possible forms—all those forms that can be conceived freely by a mind concerned with nothing but the gradual discovery of this potential infinity—are excluded. In fact, abstract painting awakens and delivers this infinity. By separating itself from the world, it opens an entirely new formal universe and multiplies the means of graphic construction.

For all time, authentic artists have undoubtedly experienced within themselves—in their bodies and hands, in their capacity to move freely, to wander on the paper and to leave the trace of this wandering—this power to invent a free path in a space that no longer preceded them but gave way to their games. This is an unsuspected and new space, full of unexplored developments. But the invention of forms unrivalled in the world clashed with the world, its set structures and its objects which always remain the same. From this hidden tension between the creative imagination of art and the purpose that hitherto was assigned to it—namely, that of imitating nature—mannerism was born. The various 'manners' are nothing but the various ways of deforming objective reality in order to bend it as much as possible to the impulses and requirements of subjective life.

It did this as best it could, because external reality remained the model, the criterion and the sole aim handed down to art. Kandinsky lived through this conflict in pain, before resolving it superbly through the grand libratory gesture of abstraction. He no longer sought some accommodation with the world and its laws (the gentleman's agreement made by mannerism) but rather put the universe of the visible out of play and dismissed it once and for all. With ingenious insight, he saw that the source of invention and formal construction no longer did or could reside in the universe of the visible. In the 'Cologne Lecture', Kandinsky writes: 'I always found it unpleasant, however, and often distasteful, to allow the figures to remain within the bounds of physiological laws and at the same time indulge in compositional distortions. . . . I saw with displeasure in other people's pictures elongations that contradicted the structure of the body, or anatomical distortions, and knew well that this would not and could not be for me the solution to the question of representation. Thus, objects began gradually to dissolve more and more in my pictures. This can be seen in nearly all the pictures of 1910' (395–6).

At the very moment that Kandinsky carries out this liberation of form, he foresees its immense danger. Every artist, as well as every person's body, spontaneously experiences this capacity to draw unforeseen lines before imagining or conceiving them. It is inevitable that something like what Kandinsky calls pure pictorial forms—this emergence of absolutely free graphics—would be produced here or there, indeed, anywhere that human beings live. The historical existence of pure pictorial forms is manifest in a type of art that is as old as humanity—ornamental or figurative art—of which there are countless examples throughout the past three or four millennia. It is characterized by two categories of forms:

1. The stylized form that has an external imprint but whose weakness condemns it to decline and fading, and
2. The ornamental form that proceeds from the autonomous project of a drawing that is enchanted with itself and ultimately represents nothing.

Here we want to say that there would be no real, abstract content, if not for this pure effusion, this play that is guided and determined by nothing and that does not flow from an Inner Necessity.

Pure pictorial forms are elaborated without any reference to the world and 'chase away the objective origin of forms'; they have no consistency by themselves. They only acquire a consistency on the condition of first and foremost being abstract forms, by coming from an inner content, or better, by being identical to it, that is, to the invisible life. We now understand this mysterious fusion more fully. So, we can return to two problems that were set aside provisionally in order to elucidate the pure pictorial forms and that this elucidation of them now rejoins:

1. The radical determination of the form by the abstract content, a determination turning this form into an abstract form, and
2. The ultimate identification of the form with the content, an identification which alone will raise the enigma of painting for us, if it is a matter of understanding how the content can indeed determine the form, that is, how an invisible content can be expressed in a visible form.

The theory of elements sets us on this path.

Abstract form: the theory of elements

The elements considered here are the elements of all possible paintings. They are purely pictorial elements having nothing to do with the representation of the objects of perception whose use-values constitute the objective layer of the world, its ideal exteriority. These elements are of two kinds: 'basic elements' ('elements without which a work of any particular art cannot exist at all') and 'ancillary elements' (536). The basic elements of painting are colours, forms in the strict sense, and graphic forms, that is, point, line, plane and, most notably, the Picture Plane. To this, one must add the 'material' support on which colours are placed and forms are outlined, for example, canvas, wood, metal, stucco, glass, etc. We will come to recognize that the theory of basic elements is an analysis in a very precise sense. This is why, at the beginning of *Point and Line to Plane*, Kandinsky refutes the view according to which analysis would be a division aiming to 'dissect art' and would be synonymous with death. It signifies life, to the contrary. This derives from the fact that it is an essential analysis, in the phenomenological sense that Husserl gives this term, leading us to the essence of the thing, pertaining here to the pure pictorial element. The essence of the pictorial element is the abstract content, the invisible life that this element seeks to express.

A second remark must be made about terminology. Because the analysis of the pictorial element leads to its essence in a rigorous way, it claims to be scientific. For Kandinsky there is a 'science of art', which is still called an 'experimental science'. As one typically understands the science of nature and its use of experimentation as a manipulation of natural objects, it is important to clarify that Kandinsky's 'experimental aesthetics' will rely on

the experience of subjectivity. It thus develops in the interiority of life and as a modality of life. The knowledge that founds this science is thus the knowledge of life; this faceless embrace in which life holds itself. It is only with these two precautions that one can characterize Kandinsky's grandiose enterprise as scientific and experimental.

It is a strange fact that the essential analysis of the pictorial element begins with an element that is not pictorial: a letter of the alphabet. The letter is a sign that designates a specific sound—a phoneme. A whole organized with signs of this kind makes a word, which itself has an equivalent sound, its pronunciation. The letter is thus an 'abstract' form in the ordinary sense, something created by human beings to serve a specific end. It constructs the words of a language with the use of other similar forms. These forms, in turn, serve as the vehicle for ideal meanings like 'dog', 'tree', 'triangle', etc. Yet, it is possible not to take account of the letter's purposes and to no longer perceive it as a letter but only as a mere form, a specific design composed of various segments organized in a variety of ways. When the linguistic purpose of the letter has been set aside, it is no longer a letter. It has become a pictorial form.

A decisive event takes place then. Presented with this letter that no longer plays the role of a letter and ceases to belong to the system of language, the spectator experiences a new feeling, one that is different from what was felt in relation to the ordinary letter, a feeling so faint that it hardly seemed to be conscious. To the contrary, the emergence of an unknown form—the form of a letter that has never before been perceived in its purity and formal autonomy—provokes a particular impression, 'happy' or 'sad', 'languishing' or 'proud'. This holds for the form of the letter as well as the linear segments that compose it. We experience this undetectable change at the basis of sensibility—the change from the almost unconscious tonality experienced with the linguistic sign to the much more lively, sometimes overwhelming, experience that the form of this sign as such stirs in us—for example, when we are looking at an alphabet that we do not know. The visitor of an Egyptian temple who discovers its huge sections of rock covered with undecipherable writing feels the type of emotion that we are talking about. To be sure, this is altered and over-determined by the fact that the visitor *knows* that this is a text, that the characters have a religious meaning, and that the mind, influenced by the sacred character of the place, is directed respectfully towards them. But the deception felt on the plane of knowledge cannot explain the gravity and plenitude of the experience. This is not solely a religious experience,

since the sense of the specific content of the theological inscriptions is not known. It is primarily an aesthetic experience whose content—an abstract invisible content and also a sacred one—is the affective tonality provoked by the perception of unknown forms grasped in themselves and which are revealed to the visitor in and through this tonality.

The link between the affective, invisible, abstract content and the form reduced to its pure appearance as a form deprived of all linguistic or conceptual meaning is not an arbitrary or variable link that would be drawn from an external association and would thus be contingent. It is an inner, necessary and permanent link that is independent from the subjectivity of the individual who experiences it. Naturally, this is not a total independence. The one who contemplates a pure form feels the linked tonality more or less strongly, depending on whether or not one has the habit of paying attention to the world of forms and depending on whether one is a painter, a connoisseur or a novice. Yet, the link does exist in each one of these cases. When the perception of this link is deepened, for example, through education, the experienced tonality will be a tonality of a specific type: 'happy', 'sad', 'languishing' or 'proud'. Its intensity will be experienced differently due to the individual's culture or one's availability at the moment, or one's fatigue.

We are then in the presence of a pure theory of Elements—to recall, these are the pure components of all paintings: colours and graphic forms. Kandinsky's thesis is that every element is double: both external and internal. The theory of elements points back to the fundamental ontology that we already developed. It reaffirms the general division of being in terms of two modes of appearing: exteriority and interiority, visible and invisible. The element is not double; it is one and the same element, consisting of one single reality. But this element is divided in such a way as to be both the external appearance of colour, as this visible layout, and internally a specific affective tonality. This tonality is also particular in its own way just as much as colour is: a tonality corresponds to this red strawberry and this gilded bronze, or in speaking of graphics, this perfect curve whose thickness increases regularly and this broken line with unforeseen changes of direction. Because this particular, specific tonality constitutes the ontological reality of a colour or form and *because there is only one single reality showing itself to us in its two aspects—this tonality on the one side and this colour or design on the other*—tonality is not joined to colour or visible graphics as the result of an association of ideas that would vary with individuals or depend on their individual histories, such as an infantile trauma that

would give one a dislike of white and another a taste for black. *Point and Line to Plane*, which formulates the pure theory of elements of all paintings, should be understood with this radical meaning:

> The concept of an element can be understood in two different ways—as an external and as an internal concept. Externally, every individual linear or painterly form is an element. Internally, it is not this form itself, but the inner tension that lives within it that is the element (547).

This thesis is repeated again a few paragraphs later and then taken to its extreme consequences:

> In my view, one should differentiate between element and 'element', taking the latter to mean a form separated from its tension, and the former, the tension that lives within that form. Thus, elements are, properly speaking, abstract, indeed, form itself is 'abstract' (548).

Without yet being able to measure fully the scope of these overly dense lines, let us indicate a few of their implications, nonetheless. The first involves a clarification of the term 'external' which appears in the theoretical writings with a variety of meanings. 'External' designates, first of all, the objective reality of the world, including the totality of meanings towards which sensible appearances constantly reach and that define the world of objects and tools in the case of ordinary perception, and the letters and words that they fill with their semantic intentions in the case of linguistic perception. This exteriority of real objects and linguistic meanings has been and must be eliminated in order for the pictorial element to emerge in its purity, so that the form can be perceived in itself. What, then, does the exteriority of the pictorial element considered in its pure pictoriality and in abstraction from its cognitive and practical meaning, signify? It signifies that this element is shown as a sensible element, that it can be seen and touched, and that it is thus offered, in an initial sense, as 'external'. According to Kandinsky's thesis, the sensible appearing of the element—the visibility of the form or colour—is only its external side, while its internal revelation—in the affective tonality to which it is joined—constitutes its true reality and being. At least, this is what is stipulated above in the proposition stating not only that the content of the work is invisible or 'abstract', which is something we already know, but also that the same goes for form, colour and the drawing: 'Thus, elements are, properly speaking, abstract, indeed, form itself is "abstract"' (ibid.).

Another implication of the theory of elements should not escape us any longer. If the content of all painting is the radical interiority designated by the term 'abstraction', if the form in which this content is expressed is abstract in this sense, then no painting and no art in general would be possible, had not life given its essence in this dimension of the Invisible which is its Residence. All aesthetics that, in agreement with common sense, refer painting only to the realm of the visible are thus dismissed. Because the 'spiritual' refers to this dimension of the Invisible in which, against all evidences, painting finds its own substance, its content and form, Kandinsky can thus write:

> Its recognition or rejection divides not just artists today, but modern man in general into two opposing factions:
>
> 1. Those people who recognize, apart from the material, the nonmaterial or spiritual, and
> 2. Those who are not prepared to recognize anything other than the material.
>
> For the second category, art cannot exist . . . (548).

If this is the issue for painting, if it decides not only the nature of our beliefs but in some way our own fate and the fate of Being itself, then the crucial nature of the pure pictorial elements—the invisibility of content and form—cannot simply be affirmed; it must be demonstrated. We know that this proof is not a theoretical one; it is an experience that allows us to feel the true substance of colours and lines. This experience is what we just experienced in the analysis of the letter. By stripping away its linguistic meaning, the letter became a purely pictorial element; its form, whose reality is its inner resonance, was perceived for itself. Let us continue our proof which is itself a mode of life; the slow transformation of ourselves that painting in its own being—in its invisible being—brings about.

The disclosure of pictoriality

According to the preceding analysis, a letter can function in two ways, as a sign with a linguistic purpose and as a pure form. The latter effect is an inner tonality similar to what we experience with unknown characters, a strong tonality that continues to deepen and to become more precise in its own way. The former effect, the one which is produced by the linguistic sign, *is also an inner tonality*, but it is a weak one. It leaves us indifferent and slides into the gentle flowing of our life without producing any appreciable change in it. Kandinsky calls the letter's effect 'external'. This means that a form whose meaning transcends its pure sensible content (a linguistic, perceptual or practical meaning) only gives rise to a weakened tonality in us. 'External' designates a certain state of subjective life, an ordinary state, and this is the way one speaks about 'external painting', such as realism.

Kandinsky's abstract painting leads us in the opposite direction. By removing every function that is foreign to the pictorial element, most notably its representational role, it enables us to hear again its own, profound, intangible and untouchable tonality. Painting thereby carries out its proper function: disclosure. This disclosure is necessary, given that the tonality of things usually remains hidden. This tonality is hidden because we only perceive stereotypical meanings in ordinary life and the tonality of this type of perception is weak. This tonality hides the profound tonality, inasmuch as it is separated from it. A neutral affection in us thus replaces the powerful emotions of the universe. Painting restores the true being of the universe: its emotions. The analysis of the letter—its substitution by a pictorial form and its tonality—is nothing besides the substitution of one tonality for another. It allows the individual to hear the rustling of the

Absolute within, the strong forces of growth that press on oneself without one's complicity. Here disclosure means the disclosure of life. As life is this disclosure and this disclosure is a revelation of oneself in the interiority of the pathos of life, it is all the more inevitable that painting leads back to life. Painting is truly the exaltation of life.

The disclosure of the essence of life—as well as the disclosure of the essence of painting, as we understand it—through the analysis of the letter is only one example among others that Kandinsky's intellectual agility calls to our attention. The case of the dash is also instructive. Situated correctly in a sentence, it has a punctuation value that is immediately grasped; it is as fleeting as the inner sound that is bound to it and that we do not notice. If it is extended inappropriately or introduced at the wrong time, it will produce dissatisfaction in the reader, like a typographical error, because this sign does not fit in its new place. That is to say that the linguistic and, more broadly, practical meaning is difficult to separate from the term with which it is commonly associated. This separation, however, gives us access to pure pictoriality, that is, to the autonomous sphere of art. That is why art's efforts to introduce elements borrowed from the ordinary world, which are only separated from their quality in their original milieu with difficulty, usually seem unfortunate. Their attempt to pass for original creations fails pitifully, the impression that they give barely differs from that the impression tied to the perception of a misplaced dash. The same goes for *papier collés*, the display of photos on a canvas and the presentation of some useful object as an artwork, such as a statue, which becomes all the more mundane.

The Surrealist principle of composition—or better, the 'trick'—is a similar type of phenomenon. It involves putting together two types of objects that normally do not go together. Through this rupture of the order of practical perception, it provokes an impression of strangeness, unease and dissatisfaction in the spectator that is indeed aroused by this type of painting. Yet not every impression or emotion belongs to the aesthetic order—no more than does a collage, a montage or a photo. What is necessary for them to become aesthetic for the 'content' as well as the 'form' to enter into the realm of art? It is necessary for the path towards the aesthetic realm to be open already and for the world of transcendent objects of perception with their endless, intentional references to have made room for colours and forms to be perceived in their bare presence and their silent splendour. In so doing, it awakens in the subjectivity of the creator or spectator these new pathetic modalities and this temporality of growth with which aesthetic experience begins and ends.

This is not the case when one seeks to construct the artwork with elements that are not pictorial, that is, with sensible elements. For, it has been shown that sensible appearances can be grasped in their formal purity and their sound can be heard again, only when the world of objects is put out of play. Ultimately, a deficiency of sensibility defines the ontological site of art. It is the inability to show sensible invention and creativity that guides so many investigations that are foreign to the world of painting. The most certain sign of this deviation from aesthetic creation in the conception of artworks is the unwarranted priority accorded to the idea that pictorial elements can only be used as the means for a project that began far away from them—for example, the idea of deforming an object and making it into a limp watch, the idea of putting a naked woman or a torso without a head in classical architecture, the idea of drawing a coffee maker that resembles an elephant, the idea of constructing a spatial representation with multiple centres of perspective, the idea of reducing reality to cubes, etc. The most adequate expression of these fantastic thoughts are not the artworks that are unable to break away from the matrix of sensation and are judged inevitably by the criteria of sensation. Instead, they are the manifestos, the noisy declarations, of theories that are all the more 'revolutionary' in no longer being guided by the essence of sensibility that has always provided the sphere of possibilities for art; their powerless efforts are multiplied. Conceptual art—whose projects are detached from the will and laws of sensibility as well as from the laws of art claim to be their most advanced development—is the logical result of these bold claims.

Kandinsky's 'ideas' are altogether different, because they do not look outside of the domain of art for artificial stimulation of a faltering inspiration. They set out to explore the domain of art in a systematic way in order to discover within it and its own substance the sources of the only conceivable revitalization of art. There is indeed an intellectual element in Kandinsky's work: audacious moves and momentous decisions, such as the one to dismiss objective figure. Instead of being gratuitous, however, these choices lead us back to what is in question and to what is only in question in painting: sensibility and its primary elements. Here again, Kandinsky's analysis operates in the same way as does Husserl's eidetic analysis. It proscribes the foreign properties from the essence of art in order to perceive art in its purity. With the elimination of objective representation, the pure essence of painting is laid bare.

After the examples of the letter and the dash, the object itself provides an example of the method of variations. This method modifies and even

suppresses all the characters that can be dispensed from the thing whose essence is sought. This allows the characteristics that would not disappear unless the thing disappeared—the invariable characteristics which together comprise its essence—to be isolated. Kandinsky's abstraction is an analysis whose development proceeds as just described. It can be formulated as follows: the elimination of the object with its objective and practical meanings is the condition for the disclosure of the pictorial elements in their purity and thus for the disclosure of the essence of painting.

Should one insist on an important point that now appears more clearly to us? The non-essential characteristics of painting—the figurative characteristics joined to the object—and the essential characteristics, which refer to pure pictoriality, are not situated on the same plane. The non-essential characteristics are the objective meanings constituted intentionally by consciousness; they are external, 'transcendent' in the Husserlian sense. The essential characteristics, the pictorial and graphic forms, belong to sensibility, that is to say, as will be shown, to absolute subjectivity and its Night. The properties and meanings of Objects are joined to an inner sound; they have a certain tone of their own. But the tone based on ordinary acts of perception is weak. It must be eliminated because it conceals the deep tone of the pure pictorial elements. Kandinsky observes: 'In the former (representational art), the sound of the element "in itself" is muffled, suppressed. In abstract art the full, unsuppressed sound is attained' (570).

Surprising consequences follow from this essential law of the concealment of the pure pictorial element's tone by the representational aim and its disclosure by putting this aim out of play. The first is that the objective reading of a work and the ability to indicate what it represents—by naturally understanding by this that some fragment of objective reality or lacking that pictorial notations capable of leading back to it—does not enable us to understand the true sense of what is there before our eyes but rather precludes it. It is a terrible sight to read or hear, as often happens in museums, so many commentaries that, in dealing with works said to be difficult because they distance themselves from figure, force themselves to surmount the obstacle by inviting the spectator to regain a foothold by identifying some part of reality here or there. This is the epitome of the lack of culture in our time, this way of 'explaining' a painting by overturning everything about it that makes it a painting and by retaining only what it is not!

This method is often followed with respect to some of Kandinsky's works (for example, the Murnau landscapes) through which it is possible to

follow the gradual abandonment of representation and the corresponding birth of abstraction. In the famous 'Cossacks' sketch (1910–11) for 'Composition IV', representing an attack that Kandinsky witnessed in 1905 by horsemen in the streets of Moscow, this is how it becomes possible to interpret the black marks striating the canvas in the upper left as a horse battle. One can recognize the necks turned around, the strong force of the saber and the Cossack's shadow curved in an arc; one can also 'see' the row of menacing swords, at the bottom right two powerful lances are held in closed fists; at the upper centre a stylized flock of black birds swirling around the high profile of a castle, which are perhaps a memory of the Moscow towers shining in the light.

Generally speaking, the paintings of a number of artists from the first quarter of the twentieth century authorize an ambivalent grasp between representation and abstraction, switching from objective representation to pure form in a charming oscillation of the gaze. But figures like the ones found in psychology textbooks that can be perceived alternately in the background or foreground provide a type of pleasure that is not yet aesthetic. Aesthetic pleasure belongs to sensibility, and pictorial experience is only possible in the sphere of sensibility. The nature of this experience is to be weakened, 'suppressed' as Kandinsky says so well, by ideal meanings that are not only foreign to the pictorial intuition but are opposed, and in the extreme, even exclude it. So, Kandinsky was always very surprised when, in his 'transitional' works mentioned above or in the abstract paintings afterwards, people pointed out the presence of figurative elements that he never consciously painted as such and that are really only pure forms in these pictures.

The law of the concealment of the invisible content by the meanings constituting objective reality and the invisible content's disclosure by the exclusion of them is so important that we will give yet two more examples of it. The first example concerns linguistic meanings and may be considered as an extension of the analysis of the letter. It is an example of a voice heard without, for one reason or another, being able to understand the sense of the words that are spoken. There remains only a flow of sound freed from the usual layer of intelligibility that prevents us from hearing it. It becomes a purely magical presence prior to things and words. In each one of its modulations and inflections, what emerges in the sound is the invisible content of life, the slow arousal of Desire and the painful history of the voice.

The second example will be movement. We are no longer able to experience movement in itself, as the mere Stroke (*Trait*), the pure fact of

springing forth and joining itself through the space it overcomes. 'Lyric' (1911), a famous painting at the Rotterdam museum, restores the victorious affirmation of this lightning-quick leap, the implosion of life which only becomes separated from itself through our representation of it. The same force is conveyed by the admirable 'Romantic Landscape' in Munich, painted only a few days apart, where three horsemen tumble down the slope in an area devoid of any reference to an object—outside of the world—and who gallop off to this place where there is no longer an object or a world, and where movement embraces itself without any Distance separating it from itself and has already and forever undone this distance.

There are other, slower movements whose mystery is concealed by everyday life. This mystery can be disclosed by separating the practical meaning that is almost always tied to our activity, insofar as it seems to be carried out with a view to a certain end. The great truth of life is thus revealed to us: life only seemingly obeys a foreign purpose. It always carries the reason for its action within itself, because it is this reason. Even when it functions with the apparent designs of procuring some advantage or removing some obstacle, the ultimate motivation behind its effort is the happiness that it experiences through the experience of its force, which is ultimately to say, through the experience of itself.

Yet, the destruction of all these purposes that give structure to our world is also the destruction of this world. Movement can be felt in its own being, only when the world has lost its power. A 1912 text, remarkable for its clarity and lucidity, shows this:

'A very simple movement, whose purpose is unknown, produces of its own accord a significant, mysterious, and solemn effect. This, provided that one is unaware of the external, practical purpose of the movement. Then it has the effect of a pure sound. A simple, concerted action (e.g. preparing to lift a heavy weight) produces, if its purpose is unknown, an effect so significant, so mysterious and dramatic and striking, that one involuntarily stops still as if in the presence of a vision, of life upon another plane' (204–5).

The vision sought by art and what it gives us to contemplate or rather to feel within ourselves is precisely this magical vision of another world—which is no longer the world, because it always remains on this side of the spectacle and never shows itself in the world. The vision of the invisible is the invisible becoming conscious of itself in us, exalting itself, and communicating its joy to us.

Dance is the art that opens us to the mysterious reality of movement. Dance can only touch us because it puts us in the presence of 'abstract' movement, stripped of its extrinsic purpose and objective shell. Movement's essence consists of the pure deployment of force and it shows the history of force. Its inner history refers to how it seizes hold of itself in the happiness of effort brought to its completion; effort is not an external obstacle but the Basis of Life. It returns and agrees with this Basis when, capable of nothing more, it experiences another Power within itself, namely, the power of the life that gave it to itself. The activity of life has no other sense than to let us experience the magnificence of this gift.

The puerile and superficial nature of figurative ballet is not just due to the illusion that it gives dance a different object and purpose than it has in itself, namely, this manifestation of Force in its proper site. Here the limits of representation are due to a deeper reason that should be understood clearly because it concerns the other arts as well, and painting in particular. In objectivity, every movement can be reduced to a determinate line. The hand is in reality the source of movement and thus the real, concrete possibility of moving and being moved, yet it only occupies a place alongside other things in space. It is a figure whose 'rendering' will be appreciated in the same way as any other material thing. The objective conception of the body totally conceals the metaphysical condition of the hand: it is neither a thing nor a movement but the infinite capacity to produce movement; it is *power as such*. But, abstract painting—as well as dance, when its true essence is recognized—represents this power. We will return to this remark when the problem of the relation between dance and painting is raised concretely for us.

The theory of the pure elements of painting has been pursued up to now in a paradoxical manner. Non-pictorial elements initially served as the basis for the analysis: the letter, the dash, the object, the voice and the movement. Kandinsky's extraordinary intellect has brought us to understand how elements of any sort can become properly pictorial elements. Two changes were necessary: first, the element was freed from its meanings in practical existence and was reduced to its pure sensible appearing; second, this appearing was taken back to its inner condition as a tonality of invisible life. In this way, Kandinsky's theory of the elements verifies its double existence as both an external and an internal element. If indeed the sole aim of painting is to make the tones of colours and pure forms resonate within us, and if indeed the pictorial composition is constructed on the

basis of such tones, the inner element is the foundation of the external element's reality and is what is at stake in painting.

Now, we must set out the pure theory of elements not through any elements whatsoever but through the basic elements of painting, that is, the properly pictorial elements. Let us begin with graphic forms.

Point

In the Bauhaus period, Kandinsky offers a systematic overview of his reflection on graphic elements, elaborating the experiments and exercises whose result was in part the second great theoretical work—*Point and Line to Plane* (1926)—and in part a new style that can be characterized as geometrical. The work from the preceding period was characterized by bursts of colours; mobile masses erupted across the canvas diagonally and were deposited in zones of turbulence. The cosmic action of force was everywhere, such that even a seemingly negative theme like 'The Flood' seemed to be simply the result of an overabundance of life. This was the period of 'lyric abstraction'—a sumptuous proliferation of pure pictorial configurations with an intense Energy, a direct expression of the most powerful drives of Being—where Kandinsky, the genius of colour, donned striking finery. Many artists were so fascinated by the intensity of this lyrical painting that they sought in vain to reproduce it.

This frenzied dynamism, delivering entire areas of organic material whose boundaries explode as the result of too much pressure, halted abruptly when Kandinsky began his work at Bauhaus. The evanescent contents submerged below the triumphant outpourings of colour disappear. Colour itself gradually fades away and large cloudlike immaterial intervals create a sort of empty, homogenous space where the power and will of pure lines are given free reign. A new dynamism emerges with sharply cut out forms whose arrangements establish extraordinary equilibriums, give birth to a play of tensions, openings, and advances confronted with subtle counter-attacks, and are broken apart by some ideal line or an indifferent, self-absorbed and invincible sphere. Force is no less

great when it dwells in this atemporal confrontation of arrows, curves, opposed or joined angles and geometrical planes barely tinted with a vague light. Kandinsky said this in a famous remark: 'The contact between the acute angle of a triangle and a circle has no less effect than that of God's finger touching Adam's in Michelangelo' (759).

The first form on which the investigations of the Bauhaus period will focus is the point. It would be overhasty here to speak about these investigations as a 'geometry'. To be sure, the point is also a geometrical entity. As such, it is indivisible and abstract in the sense of an immaterial and ideal entity, which characterizes every geometrical figure taken and conceived in its purity (and not as a natural form). Even understood as an ideal geometrical element, the point nonetheless has an inner sound. Kandinsky attempts to express its tonality in the following terms: 'the utmost conciseness', 'the greatest reserve' and 'the ultimate and most singular combination of silence and speech' (538). At the beginning of the analysis of the Bauhaus work or rather the analysis of the graphic elements on which it is based, it should be emphasized that an affective tonality characterizes every conceivable geometrical figure and that every geometrical figure is thereby a pictorial element obeying the general theory of elements. Kandinsky states: 'Form itself, even if completely abstract, resembling geometrical from, has its own inner sound, is a spiritual being. . . . A triangle is one such being' (163).

Because the point has a specific impression, its own sound, it is not only joined to the geometrical point but to the real, sensible point resulting, for example, from the mark of a tool on a material surface. The point is the smallest possible sensible form, 'the smallest basic form'. Because the specific tonality of the point, and the sensible point in particular, is 'utmost conciseness', 'the ultimate and most singular combination of silence and speech', it has been used with this value in written language and has taken on the meaning of marking a pause in discourse, this basis of silence from which all language emerges. In order to be used this way in writing, the point transforms into a mere external sign, analogous to a letter. The result is that its profound inner sound will be concealed, and its place will be taken by a neutral, imperceptible and indifferent sound. The point has ceased to be a pictorial element, a pure graphic form with its own irreducible tonality. The emotion to which it was originally joined has been lost. It has become a use-object.

Kandinsky will have the point undergo the same treatment he already gave to non-pictorial elements: the letter, the dash and objects of ordinary

perception. The method of variation aims to reveal the essence of the point, its original resonance. Again, this involves tearing it free from its ordinary practical environment in order to detach it from the role it plays in the sentence. This release occurs in two stages: first, by displacing the point within the proposition so that it occupies an unstable position and allows its true being—its emotion—to be seen in a flash; second, by putting it outside of the lines on a blank surface where at last this extraordinary sensible form, 'the utmost conciseness', will be seen and its deep tone will be heard.

Yet, if the point is situated in its place in a written text and plays its normal role, it is accompanied with a resonance that one might call its resonance in writing. Its displacement within the sentence and then outside of the sentence in an empty space produces a double effect: the writing-resonance of the point diminishes, while the resonance of its pure form increases. At any rate, *these two tonalities have appeared now where there was only one, two modalities of invisible life within us when there was one single objective form in the world and there still only is one point before us*. The radical and now undeniable dissociation of the external and internal elements of painting occurs through the invincible force of essential analysis, if, as in the course of the experiment that we just carried out, it is the case that the external remains numerically one while the internal is duplicated and has become a 'double sound'. Once it is established that the composition of a painting depends and is constructed on the internal element, the evidence for the following crucial truth will be given to us: painting, which is this composition, is not a tributary of the visible. It does not receive its laws or principles from the visible, since it depends on what is duplicated and expresses this duplication while the external element has not changed.

Before drawing the consequences of this dismissal of the visible in pictorial creation, let us return to the emergence of pure pictoriality. The appearance of the 'double sound', that is to say the dissociation of the point's tone in writing from its own tone, creates what Kandinsky calls a 'senseless, anarchic situation'. This is due to the fact that the point as a pure form signifies the introduction of a heterogeneous element into language, which has nothing to do with language, the practical world or our world. The principle of abstract painting is the emergence of that which withdraws from the primacy of the visible and causes it to vacillate. It replaces simplicity and the evidence of the figure with the pathetic polyphony of life whose unity belongs to another order.

Kandinsky gave other examples of the division of tonality into a double tone. No longer an ideal point—the real sensible point—occupies a certain space on the canvas or sheet of paper. It thus has limits, contours, dimensionality and forms that, however small they may be, vary infinitely, such that the tone linked to it also varies. To be sure, the essence of the point, what gives it its specific tension, is to push back the space that surrounds it, to refuse to expand and to be dissolved into it. This tension is concentric, and its tonality is nothing other than this tension's experience of itself, its pathos. This pathetic concentration of the point defines it as a separate being, isolated from its surroundings with which, as a point, it can never be integrated. This is how the particular nature of its force is determined. It remains in itself, solidly maintains its ground, and shows, Kandinsky says, 'not the slightest inclination to move in any direction, neither horizontally nor vertically. Even any tendency to advance or retreat is completely absent' (547). This folding onto itself and the corresponding rejection of exteriority, this feeling of the Self can also be found in the circle. Kandinsky is able to use it with admirable mastery. This is what makes the impact of an angle on a circle, an act of aggression and a dramatic conflict comparable to the greatest effects obtained by Michelangelo on the ceiling of the Sistine Chapel.

The concentration of the point on itself does not prevent it from taking up a portion of space, no matter how small. A real point is more or less small, more or less wide. The more it widens and fills a surface, the more it becomes a surface, perceived and experienced with the tone of a surface. Here the classical problem of the limit is raised: when does a real point change into a surface? Kandinsky handles this problem with the help of a tacit phenomenology. While the point gradually changes into a surface or the surface is gradually taken again as a point, the two inner resonances and two affective tonalities of the point and the surface are superimposed even though one single external element—the real point—continues to capture the regard. Kandinsky discovers the plastic richness of this crucial situation: there are two sounds in one single form, that is to say, one form creates a double sound. When the absolute sound of the point prevails, it hides the sound of the surface and vice versa. It is thus possible to cover over the tone of one form with another one, to produce complex and layered sounds, to play with them and to lead the spectator's affective life down emotional paths chosen by the creator, even when the creator only uses one single formal appearance, such as the point.

Line

The tension of the point, which is to say the concentric force by which it refuses space and all movements towards it, can be combated and overcome. For this, another force must act on it from the outside and chase it from the site (or non-site) on which it stands through its own accord. 'This force', Kandinsky says with all the precision of poetic language, 'attacks the point as it burrows its way into the surface, forces it to emerge, and pushes it across the surface in one direction or another' (570). The point is pushed in the direction imposed by a new force acting on it—a direction that remains the same as long as this force does not change—the line.

From the outset, two features characterize the line. First, the line is the immediate effect of a force; the line literally deploys this force and gives it its direction. Second, against the specific tension of the point—a tension excluding movement—the line offers an opposing tension allied to and conveying itself through movement. Force and movement thus differ in Kandinsky's ontology. Force can go without movement, as in the case of the point and the circle. We also know that painting can express this difference rigorously between force without movement—through the point and the circle—and their action when joined to the line.

The movement of the line warrants a finer analysis of force. One can discern the plurality of forces that enter into a given drawing and that enable us to identify and evaluate them. Two cases must be distinguished here, depending on whether the line results from the action of one or two forces. The form produced by one single force acting on the point in a constant manner is a line that continues indefinitely in the same direction, that is, a straight line. Among the infinite possibilities of movement,

this one represents its 'most concise form'. It makes evident the super-imposition of a 'tension' in every line from the force that produces it and a 'movement' which results from the way that this force has overcome the point's concentric tension of the point and displaced it indefinitely in a constant direction.

In the second case, linear form results from the joint action of two forces. This situation can be distinguished depending on whether the introduction of the two forces is simultaneous or successive. Simultaneous action engenders a curved line, while successive action engenders an angular or zigzag line. It is clear that the degree of the curve will depend on the power of the action exerting itself laterally on the force which, if acting alone on the point, would have produced a straight line. Likewise, the length of each segment of a zigzag line depends on the time in which the two forces act, while the degree of the angle which brutally changes the trajectory of the line is the result of the intensity of the one that enters into play when the former is interrupted.

The possibility of expressing life through lines can be established, if we suppose that life is essentially—in virtue of what makes it alive—a force, and if we suppose that the forces acting simultaneously or successively on the point in such a way as to produce what we call straight, curved, or angular lines are in reality the forces of life, and that no other forces exist. Not only each force but each drive within the framework of subjectivity has its immediate equivalent in a specific linear form, since the force's inten-sity, its changes, the time of its action, its interruptions and its returns have their exact corollary in the genus (straight, curved or zigzag line) and acci-dents (slope of the curve, length of various segments and degree of the angles) of the linear forms described above. Yet, we should reflect on the nature of this correlation and the ability of linear forms to provide an equivalent to subjective forces.

Is it a matter of a simple 'representation' or 'illustration'? Does this equivalence mean that a parallel can be recognized between our most secret drives and aspirations, on the one hand, and the patent particular-ities of a drawing, on the other hand? The parallel would ultimately rest on the fact that in each of the two cases—the registers of the visible and the invisible—we are dealing with forces, movements and impulses. In short, these two ontological determinations would be capable of entering into a harmonious relation because they are more or less similar, analogous or, better, *homogenous*. Yet, how far does this homogeneity go? If every force is subjective because force is only possible in the pathetic embrace of the self

and can only take hold of its power and act through this embrace, if the force that weighs on the point and makes multiple lines emerge is the same as the one that unfurls in us, then linear forms do not only 'represent', in their infinite variety, the forces and drives of our life; they are identical to and united with them. It is in this radical sense that one should understand Kandinsky's statement that 'every phenomenon in both external and internal worlds can be given linear expression' (583).

This expressivity is not due to the fact that every internal motion has a mysterious analogue with a specific linear form. There is no mystery, because *there are not two realities whose 'correspondence' would be a problem, but one and the same living force that we experience as a pathos expressed in ourselves and this is also the force that produces the line*. This force is always makes it be a straight, a curve or some other line that no longer has a name, an archetype or an assignable cause apart from the will of a power thrilled with its own power and only obeying itself.

Kandinsky was fascinated by the expressive power of linear forms. Lyricism is the pathos of a force whose triumphant effort enters into action and encounters no obstacle. Because the straight line results from the initiative of a single, unopposed force, its domain is that of the lyric. When two forces are present and thus enter into conflict, as is the case with the curve or the zigzag line, we are in the domain of drama. This dramatic aspect increases and becomes more 'hot', when the action of two antagonistic forces is simultaneous. It is taken to its paroxysm when a large number of forces come from all sides and fuel the battle to the point of making it a sort of cosmic clash. Expressionism is a broad enough term to designate a dynamism that can either use colour (in the period of lyric abstraction) or go without it (in the Bauhaus period). This latter is the case because Kandinsky is capable of producing it solely though linear forms.

The rigorous dissection of linear forms is not a process of death, a reproach that we have already refuted. Instead, it is a release of the wild energies of life; these are not represented in the emergence of lines but rather are swallowed up in them and produce them at each instant. The master of this analysis of linear forms—*the world of linear forms being identical to the world of the forces of life*—will be in a position to express the forces of life truly. This means that they will be allowed to deploy, to grow, to fight or to join, to exalt and to express the entire gamut of their lyrical and dramatic tonalities. In other words, they will be revealed as they truly are. It is thus possible for a purely formal play of lines to realize all the powers of life—from their happy fulfilment to their dramatic conflict.

Kandinsky concludes: 'Thus, the realm of line embraces the whole range of expressive sounds, beginning with cold lyricism and ending with ardent drama' (583).

Given the infinite expressive possibilities of the line, Kandinsky's analysis is complex and its extreme richness cannot be fully captured here. For us, the problem was to go back to its principle, namely, abstract painting. What we now can perceive more clearly, among other things, is the scope of the rejection of representation and how abstraction, instead of signifying an arbitrary or chance undertaking, leads us back to the essence of painting, to that which determines both its content and form. In figurative painting, the line remains an external element in every sense of the word. It is one visible mark that imitates another visible mark, the contour of a real object. The enigma is how such a line can move us or have any 'force' whatsoever. Its patent meaning—objective representation—requires every drawing to be as insignificant as what it represents. When freed from the constraints of the world, however, the line does not simply offer itself up as a perfectly docile material for the infinite power of the imagination. It does not merely free its inner tone which had been concealed up to now by practical purposes; it also calls forth the plenitude of the forces of life to be exerted. It awakens the potential pathetic totality of absolute subjectivity from its slumber and brings it back to life. 'Abstract content'—that is what has replaced the object.

The analysis of the line also clarifies how the abstract form can be determined entirely by the abstract content. 'The question of form does not in principle exist', Kandinsky claims in an enigmatic statement in 'On the Question of Form' (248). One should understand that *there is no formal definition of form* and no formal prescription to which it must submit, because the being of form is not itself formal. It is not the design, the outline or the line as such; instead, their being is constituted by the force that produces them. It alone can decide what they are and ought to be.

This ontological conception of form means that there is no design flaw in an artwork, because there are no rules of design. Design never justifies itself; it does not establish a model or a criterion in light of which it can be judged. No line is satisfying in itself; it does not give rise to an impression of beauty on its own. The only thing that satisfies itself is the force that produces this line and enjoys itself in this production. This enjoyment, life's feeling of itself, is what justifies the choice of this particular line or mark, insofar as the inner experience of forces engendering this mark is precisely the feeling of life that one seeks to express. That is why Kandinsky can say

that 'a form that is the best in one case can be the worst in another' (248). Nothing is good or bad in itself; it all depends on whether or not the force it comes from corresponds to what the pathos of life seeks in it. It depends on whether or not the pathos of this force is the pathos of this life.

In agreement with Kandinsky, we have said that there are no rules of design, because every objective or ideal model has been disqualified. However, the principle of Inner Necessity does remain, and it implies a new set of rules. 'On the Question of Form' makes a brief but essential allusion to these fundamental rules of abstract painting: 'These supposed rules . . . are nothing more than the recognition of the internal effect produced by individual means and their combinations' (248). By the principle of Inner Necessity, the form of the artwork is radically determined by the abstract content. This implies that the artist knows the expressive power of a particular style of drawing, that is to say knows *what force produces it*, and likewise, the pathos of this force. This is the only way that, in being offered a great lyrical or dramatic theme, the artist will know which means to use in order to express it as well as which forces and forms correspond to this pathos.

The analysis of linear forms allows us to see how Kandinsky's programme of formal research was defined and the scope it had to have due to the tacit philosophical basis on which it rests. Every type of line must be examined, in order to test all of its conceivable variations and transformations and to evaluate the inflections and differentiations of its path, in order to discover the pressures behind these deviations, ruptures and undulations—pressures that are always revealed through their affects. This creates a graphic typology, a true dictionary of lines. Yet, this would be misinterpreted altogether if it were taken as a sort of external inventory or a mere catalogue. In such a case, Kandinsky's research would be prior to it, like all the other pre-existent 'means', the various graphic elements, that it would seek to master. It is easy to see that it proceeds in an entirely different way. Kandinsky draws all the lines that can be conceived and invents countless types and details of them. What he does not invent is the pathos that always corresponds to a certain style of drawing or configuration—the inner tone is the pathos of the force that produces a certain style of drawing. Based on this inner tone and the infinite modalities of life's pathetic diversity—*the abstract content of art*—Kandinsky constructs the formal vocabulary that expresses it. It can do this inasmuch as this pathos is the pathos of the forces from which lines emerge and inasmuch as the play of these lines (with the immense formal domain resulting from it) is the play of these forces, the history of our life.

We have given examples of the constitution of this dictionary of lines with its properly abstract meaning—both dynamic and pathetic at the same time. The analysis of the point, the straight line, the curve and the zigzag was always the analysis of a combination of forces with its proper affect. At Weimar and Dessau, Kandinsky systematically carried out the study of these 'examples', which are really variations in an analysis seeking to demonstrate the essence of the line. These exercises and the plentiful harvest of their results are well-known. They show the imaginative power and the creative intelligence of the Bauhaus master. One of the particularly interesting variations given to a linear form, such as a curve, concerns its thickness. It points back to the problem of the limit already mentioned above with respect to the point. We can formulate it now as follows: Where does the line end and the plane begin? The thickening of the line gives it the appearance of a minimal surface, while, with respect to its length, it remains a line with its own dynamism. In this way, two tones—those of the line and the plane—are superimposed. With the relations between multiple tones concealing or highlighting one another being introduced into subjectivity, another problem is raised here for the first time, namely, the problem of composition that Kandinsky considers to be the central problem of abstract painting.

The analysis of lines is not limited to the study of each type of line taken in isolation. When, by the mere fact of their spatial juxtaposition, several marks are perceived at the same time, the tonality of each one is changed by the tonality of the other elements entering into relation with it. Along with these new arrangements, there are new tonalities experienced in life. The unlimited variations that can be given to these arrangements of lines are likewise the possibilities of formal expression. The freely invented linear arrangements discover new feelings in subjectivity, emotions whose humanity perhaps had not yet been experienced, thereby infinitely increasing the sphere of conceivable experiences. They awaken what Nietzsche calls the 'great hunt' of culture, which is the total development and realization of the potentialities of life. Yet, at the same time as these unknown tonalities are felt, the ability to express them is also given. This ability resides in the formal complexes that the artist's genius has imagined; they are the tonalities of these complexes.

With these continually enriched and renewed configurations—these cross-hatchings, ladders and grids—the vocabulary of lines envisaged by Kandinsky reaches the height of its power. Linear groupings, with their own motor and affective meaning, can be arranged in ever new combinations

which are also combinations of the pathetic features of our life. The goal of abstract painting is to give feeling to everything that can be felt and to give experience to everything that can be experienced. All the forces of our being, as will be shown, are also the forces of the cosmos. The true vocation of art thus has no reason to limit itself to the reproduction of facts or ordinary events and their irrevocable profiles. Kandinsky's work at Bauhaus was twofold. He sought to bring multiple formal schemas out of nothingness by imagining all the types of lines that could be integrated there as well as the multiple ways for them to be and live together—to be separated, to be cut, to be developed in parallel, to be developed in various intervals, to be thickened, to increase or decrease their energy, etc. Once in possession of these elementary structures, cryptograms and ideograms to which no meaning corresponds, he then envisioned their reunion in broader structures with two characteristics: they are paintings and also have the powerful tonality that the painter sought to formulate. If one pays close attention to the works from the Bauhaus period, one will see clearly that their formal dynamism is constructed on the basis of a series of experiments putting the tones of each element into play. Never before have the first products of an analysis—the constitution of the vocabulary of lines—resulted in such a fabulous power of creation and expression.

The picture plane

Two properties of lines, as yet unmentioned, should be taken into consideration here due to their relation with the plane. The first is the ability to create the plane. For example, if a segment of the straight line pivots around one of its extremities, it makes the circle. The circle is presented as a surface with extreme solidity. Even though it is not completely closed onto itself, the same goes for a curved line. Each one of its curves can allow a plane to develop. Indeed, this is the case for every line that circumscribes a portion of space. This holds for the zigzag line, especially if it is composed of acute angles. Each one of them can change the portion of the area that it holds between its two sides into a surface plane. Free straight lines ('semi-diagonals'), if they lack a shared centre, will only be loosely related to the plane. They seem to float in an indeterminate place. As for the straight line, it is indifferent to the plane and will only be able to construct a plane as the result of a triple pressure making it first into a short angle and then into a triangle. The plane of the triangle then has solidity comparable to a circle, whose formation only required the introduction of two forces. Finally, the thickening of a linear form can engender a glimmer of a surface. It gives rise to the limit situation where, as we have seen, two tonalities—the line and the plane—are added together in order to offer new expressive possibilities through their respective concealment and disclosure.

The second property of lines involved in the constitution of planes belongs to straight lines. Kandinsky distinguishes between three fundamental types of straight lines: horizontal, vertical and diagonal. The horizontal corresponds to a primordial dimension of experience, the ground on which human beings stand, where they can either remain or

move away. Kandinsky defines the horizontal as 'a cold, basic support that can be extended in various directions' and as 'infinite, cold possibility of movement in its most concise form' (574). This stands in contrast to the vertical line, outwardly by its apparent mark and inwardly by its affective tonality, which no longer offers the human being any touchstone or resting point, where the flat and the 'cold' are replaced by the abruptness of the 'hot'. Kandinsky notes: 'Thus, the vertical is infinite, warm possibility of movement in its most concise form' (ibid.). The third type of straight line is extraordinary: the diagonal is the true mixture of the former two in its external as well as its internal tone. Consequently, it is a union of 'cold' and 'hot' and offers the possibility of gradually changing the respective roles of these two tonalities through an infinite number of imperceptible gradations. To achieve this effect, the slope of the diagonal varies, tending either towards the horizontal or the vertical. Due to its ability to produce a continuous series of tones that change into the opposed tonalities at the extremes of the spectrum, the diagonal will play a central role in Kandinsky's most elaborate compositions.

The Picture Plane is neither the circle nor the triangle but a rectangle. That is what most commonly constitutes the surface of a painting. The Picture Plane (which, with Kandinsky, we will henceforth refer to as the P.P.) does not present anything remarkable at first glance. This is the case as long as we consider it objectively, as an external element, as has always been done. From this point of view, things only begin with the first mark of the pencil or the first stroke of the brush. The genius of the Bauhaus master is to help us to understand that these actions are confined to changing an extremely complex and rich prior state of affairs. Only a rigorous understanding of the P.P.'s original givenness can permit us to understand the scope of the changes that it will undergo subsequently.

The P.P. exists as a blank, autonomous reality, like a living being. It has a 'breath'. Before beginning an artwork, the painter stands in the midst of this silent life inhabited by secret forces. This is why the painter's attitude must be one of respect and responsibility, comparable to the attitude taken towards every living thing, with a vague awareness that there is a requirement of life everywhere that life has carried out its primitive work—the work of coming to oneself and experiencing oneself in order to be able to feel, to be able to enjoy and suffer. Is it anything but a metaphor to say that the P.P. is alive in an original metaphysical and ontological sense and that its being is not limited to this type of blank page offered nakedly and indifferently to our regard? Why, according to Kandinsky, would the P.P. in its

extension bound by four straight lines, already be animated by a life of its own whose undeniable presence is sensed, if only unconsciously, by every artist?

The principles of abstract painting provide a sure response. The lines carving out the P.P. are two horizontals and two verticals, that is, two calm and cold tones and two calm and hot tones (in being produced by a single force, the straight line is a calm tension by nature). Before the P.P., we experience four different tonalities arranged in two opposed pairs as well as a global, nuanced feeling that results from their subtle composition. This is its life. It is mysterious because it is invisible. Yet, it is undeniable because there is now way to doubt or challenge the immediacy of the experience in its pathos. To speak of the silent life of the P.P. is therefore not to give way to a poetic paraphrase; instead, it is to return to aesthetic experience in its pure form. It is to investigate the work of art at its source.

The inner tone of the P.P. cannot be reduced to this complex, unnamable unity of the various tonalities that comprise it. There are a considerable number of variations resulting from changes affecting the relation between the size of the horizontals and verticals that enclose the P.P. Starting from a square P.P., it is possible to produce an increasingly elongated rectangle, arranged either horizontally or vertically. The size of a painting 'in breadth', as is usually the case, or 'in height' is enough to grant it a particular *a priori* resonance, prior to any action on behalf of the painter. Although this is usually unperceived, it is no less significant. It is clear that a broad size imposes a cold value on the painting, and the subsequent use of warm elements will inevitably give rise to a more or less violent contrast, depending on the number and force of these elements. The painter's free choice of a size is thus entirely motivated; it is a function of the tone belonging to each type of size as well as its relation to the general tone imposed by the painting's theme: crucifixion, village celebration, battle, etc.

For the first time here, we will take up the essential thesis of this book and provide an initial proof of it. The thesis is that abstract painting defines the essence of all painting. It seems that the abstract content of the P.P.—its invisible, subjective tonality—explains the preference for a given size with a given subject. When facing this initial problem for every conceivable work, the certainty that the great masters of the past have shown is due to the acuity of their perception of the tonality of each P.P. and its suitability for the theme that occupied them. *This theme was also a great pathos entering harmoniously into their life and merging with it* and with all life, such as the theme of pain (for which the passion of Christ is a privileged example),

themes of life, death, time, the vanity of things, the changes of the seasons, etc.

Several works provide a striking illustration of the importance of the question of size and the harmony of its own tonality with the pathos of the work. One can suppose that when Michelangelo set out to decorate the ceiling of the Sistine Chapel, he was disconcerted by this unreachable and poorly defined vault whose forces escaped in every direction. Before he even began his work, the ceiling's forces unravelled the object that he had secretly assigned to it: Power. This is how he had the idea of dividing the painted surface into as many parts as he had scenes or characters to place there, choosing a smaller size for each one of them. By enclosing them in these overly narrow spaces out of which they seem to explode, the monumental bodies of the prophets, saints, soothsayers, and God himself all received an excess of force. In the last and most beautiful masterpiece painted in his life, Dürer used the pathetic possibilities of the P.P. with even more mastery. The warmth of the verticals squeezes the profiles of the 'Apostles' together in a minimal expanse. Having become colossal, they are conferred a great power—the power of Faith and of the faith of Life in itself—whose unshakable certainty they sought to affirm in a time of heresies and unrest.

The horizontals and verticals framing the P.P. are not just of any sort; they are laden with the existential categories that structure the first relation of life to the cosmos. These categories are 'above' and 'below' for the horizontals and 'left' and 'right' for the verticals. The P.P. is thus constituted by four basic regions between which there are many passages and transitions. The P.P. is itself only the site and, in a certain sense, the substance of these transitions. Originally, this site is not spatial or objective; it is all the tonalities corresponding to these fundamental categories of existence and their specific properties.

Kandinsky's observation about weight should be extended to all of these properties, namely, that this apparently mundane and 'physical' determination is drawn from subjectivity and only derives its sense in relation to life. He writes: 'The term "weight" does not correspond to a material weight, but rather expresses an inner force, or in our case an inner tension' (641–2). How, indeed, could I know what a weight is independently from the experience that I have of it and from the effort that I make to get up and its inherent pain? Ultimately, *weight is the weight of life*; it is life's experience of itself. It is the way in which life is completely passive with respect to itself, unable to separate itself from itself, and unable to escape from what is

oppressive about its being. Life undergoes this experience in a suffering that is stronger than any freedom and in a suffering of this suffering. Notions as simple and common as those of weight, density, constraint, gravity or their contraries of lightness, ascent, flexibility, happiness and freedom refer to this 'weight of existence' which is the essence of subjectivity.

Kandinsky uses these notions, or as we said in order to underscore their subjective and affective origin, these categories of existence in order to describe the regional properties of the P.P. Kandinsky writes: '"Above" conjures up an image of greater rarefaction, a feeling of lightness, emancipation, and ultimately, of freedom' (639). Henceforth, it is clear that every pictorial element entering into this zone of the P.P., which is to say approaching its upper limit, will find itself to be deeply changed. As for small, scattered elements, they will distance themselves from one another and will lose their weight to the point of seeming to float 'freely' without gravity. At the same time, their ability to support other elements will be diminished to the point of disappearing altogether. Conversely, heavy forms placed at the top of the P.P. will become still heavier. This is because the tones belonging to the upper part of the P.P. will be added to the 'tone of weight' along with all of its other individual properties: size, contour, colour, etc.

With a contrasting effect that is subtle but obeys the pathetic logic that Kandinsky discovers, these same heavier forms, as they move up the painting, give rise everywhere, both in and around themselves, to rays of new forces whose task is to keep them at this altitude in spite of their weight. This fantastic advance results, it seems, from the artist's creative genius, which actually awakens the hidden potential of the Plane and its silent life. This way of overloading the top of the composition (repeated by some American artists in later generations, for example, Pollock) will recur frequently in Kandinsky, giving his greatest works a truly magical power— the power of a strong dynamism. This power is concealed and petrified by the solemn, formal, hieroglyphic vocabulary of the last Parisian period.

The horizontal at the bottom of the P.P. is equally rich in emotional and motor determinations. These are called 'density, weight, bondage' (640). Due to the weight of the 'below', here movements are made with difficulty; every upward movement requires a violent, 'sharp' effort. The forms that do try to move must break away from a place where they seem to be stuck and, Kandinsky adds, 'the grating noise produced by friction is almost audible' (640). If one takes up again the example of the small scattered

elements moving freely and spreading out in the light air of the heights, one sees the inversion or the paralysis of the flow that carried them along: they cluster together in the denser atmosphere of the lower zones of the P.P. Inertia permeates them, thickens them, and leaves them capable of supporting more important and heavier elements.

The mere relation between these upper and lower limits—which is inevitable because it is constitutive of the P.P.—thus brings about a pathetic confrontation. If every conflict is synonymous with drama, the mere consideration of two of its elementary properties makes clear that the P.P. already provides a potential dramatic element for every conceivable pictorial composition. The actualization of this dramatic element—due to the accentuation of the contrasting tones of the above and below—will be increased by the appearance and addition of heavy forms in the lower part and lighter ones in the higher part. This contrast can be diminished by the reverse process about which we have already spoken: it fills up the composition with heavy elements on the upper half, while allowing light figures to dominate the lower half. Kandinsky's art is characterized by this weakening of contrasts and the production of subtle equilibriums as a result of revealing or concealing these tensions. The titles of many of his works prove that his art is fully self-aware and that it results from a complete mastery of the pictorial elements: 'Reciprocal Agreement' (1942), 'Tension in Height' (1924), 'Contact' (1924), 'Floating' (1924), 'On Point' (1928), 'Gentle Ascent' (1934), 'Soft Hard' (1927), etc.

The mastery of the pictorial elements is the knowledge of their specific tonalities. The extraordinary analysis of the P.P. is an important part of this knowledge. It shows that the elements never act alone and cannot be considered in isolation, given that their tone is always overdetermined by the tone of the Plane. Abstract art is a rigorous science with multiple applications, because the tone of the Plane does not change contingently but in accordance with a fixed rule that expresses the dynamic and pathetic structure of the regions. It is not only possible to give each element a new tone by transforming it inwardly. This tone can also vary infinitely due to the element's movement on the Plane. That is why the prior knowledge of the Plane's properties is indispensable.

The Plane is not only bound by the two horizontals whose 'cold calm' is distinguished by the antagonistic tonalities of the upper and lower regions; two warm verticals also determine it laterally. The left side of the P.P., according to Kandinsky, is placed in front of the left side of the spectator (and not, as in the case of a mirror image, facing the right side). Its reson-

ance echoes the properties of the 'above' to a lesser extent, so it is also 'light', 'free' and 'rarefied'. It will show a more pronounced 'density' than the 'above' but still much less than that of the 'below'. A pictorial element moving in the upper half towards the left of the P.P. will thus remain within a system of homogenous, existential categories. Its changes in tonality will be gradual, as it travels a continuous emotional sequence. The right side (which is situated facing the right side of the spectator) echoes the tonalities of the below but in a weaker way. The density, weight and constraint that govern this zone of the P.P.—and which are still to be understood as modalities of subjective life that are experienced but not seen—also change depending on whether the elements move towards the bottom (where density and constraint increase) or towards the top (in which case they gradually decrease).

'Above' and 'below', 'left' and 'right' are not homogenous zones since their tones vary by a continuous gradation, increasing as one moves towards their limits and decreasing as one nears the centre. That is the reason why a form is increasingly heavy as it descends and increasingly light as it ascends. A potential dynamism cuts through these existential zones of the P.P. and pervades all the elements. Each one of the elements is an unstable form, since its tone increases or decreases with the least movement. Its movement inscribes a tendency in it to go up or down, to become lighter or heavier, just like the negative modalities of affective life in which every need seeks to change into its satisfaction. This is how the rigorous parallel between these two categories of 'living beings'—which for Kandinsky are the human and the P.P.—can be explained. As we have indicated, this parallelism must be overcome, if it is the case that *there is only one single life*. The affective tenor of the P.P. does not represent the life of the human being; instead, each transformation of an element on the P.P. is really, in its own tonality, a modification and modality of this single life belonging both to the P.P. and ourselves.

The dynamism running through the P.P.'s different existential zones calls on us not to restrict our investigation to their affective qualities (heaviness, lightness, etc.). One must also consider the movements resulting from the serial arrangement of these qualities in terms of their growth or decay. Kandinsky did not dwell on these movements, when they were directed towards the top or the bottom, because their meaning for life is self-evident. To the contrary, he sought to put forward an interpretation of movements to the left and right, justifying his explanation by the fact that the human possibilities of movement are limited. The human being really

only has the choice between two directions. Movement to the left is understood as a wayward movement. Kandinsky writes: 'Man distances himself from his habitual environment, liberates himself from those conventions that weigh down upon him, restricting his movements with their almost petrifying atmosphere, and breathes more and more fresh air. He goes in search of "adventure". Those forms whose tensions are directed towards the left have, as a result, something "adventurous" about them, and the "movement" of these forms increases continually in speed and intensity' (644). Movement to the right, by contrast, is taken as a 'return' and a 'homeward' movement, associated with the feeling of weariness and the desire for rest implied by such a decision.

How can one avoid being surprised by this type of description? Doesn't it seem 'literary', or even more so, surprising in an abstract perspective that supposedly goes without all objective references? Does it not call upon a representation of human life in the effort to justify the emotional values donned by the pictorial elements in the course of their journey across on the P.P.? This appearance must be overturned so as not to lose sight of the principle and the rigorous nature of Kandinsky's analysis.

What constitutes the 'homeward movement' that the slow procession of forms towards the right evokes? Their movement, as they enter into a zone of greater density, becomes increasingly difficult. Their dynamic possibilities—changes of direction, various initiatives—are exhausted. It tends to be immobilized, a prisoner of a site whose constraints gain the upper hand over its exhausted energy. The position of the forms on the P.P. governs their movement up to the point of making it impossible. The tonalities of the places that they pass through have become the tonalities of these forms, filling them with an inertia that quickly paralyses them. *The history recounted to us here is the history of life.* It is the history of a force coming up against an increased resistance—its decreased effectiveness and powerless effort change into fatigue and an increasing suffering in search of relief, a rest and a stopping point.

The journey of a human being returning home at the end of an exhausting day or trip is thus only one particular representation, among an infinite number of possibilities, of a much broader development. This is the development of the absolute subjectivity of life and the fundamental affective tonalities into which it changes, in passing necessarily from one to the next along the continuum of an uninterrupted series going from the extreme of suffering to the extreme of joy, like the tonalities of the plane. With its successive determinations—the slow increase of effort, its perseverance, its

paroxysm, its decline, its return to the source of its power from which it emerged and spent its force—movement is only a manifestation of this primordial and pathetic history of the Absoluteness of Life and its eternal arrival in us. Abstraction's complete revitalization of the expressive powers of painting is confirmed by this story about the fundamental affective tonalities of life finding their precise expression in particular pictorial compositions, for example, in a concentration of forms in the lower right portion of the P.P. to express the tonality of exhaustion.

The P.P. exerts its invisible influence on the elements, concealing or exciting their specific tones depending on whether they are harmonious or dissonant with its four regions. But the elements, in turn, act on the plane. We cannot hear the tone of a particular place; it is covered over by the tone of the element that has come to occupy this place. This offers an extremely fecund plastic situation. Let us suppose that elements are filled with particular powers, for example, the power of moving towards or away from the spectator. To the extent that such elements will be profoundly anchored in the Plane, they will impress their movement on it, dilating it towards the front or pushing it towards the back depending on their own dynamism. For, as we will see, such elements do exist. Inasmuch as they are united with the plane, the plane will warp under their effect, will take on an 'accordion-like' form, or will cease precisely to be a plane—thus giving rise to new spatial constructions.

With respect to the situation described above, another possibility can be analysed. Instead of being integrated into the Plane and being physically united with it, the properties of some elements will leave this relation uncertain and, at the extreme, even destroy it. This was the case for the free straight lines that lacked a common centre and seemed to detach themselves from the P.P. They seemed to wander in front of it in a sort of ideal space situated in front of the painting. The conception and systematic study of this type of space opens up the investigation of still unexplored possibilities. At least two of these possibilities should be considered. The creation of a second or first space in front of the P.P. can put the P.P. in the background. But it is also possible to imagine the destruction of the P.P. by elements whose tonalities would cover over its tonalities. Let us then return to the study of the elements. What we now know about them presents us with an essential problem for abstract painting as well as for all painting, namely, the problem of their unity.

The unity of the elements

The unity of the elements is nothing besides the unity of the painting. It is the unity of the composition, or more precisely, it is this composition. To consider things only from the outside, as one usually does, the unity of the elements shows itself to be identical to the unity of the P.P., since they take their place side by side on the surface of the P.P. The artwork itself consists of this juxtaposition; its harmony and beauty result from the way in which it functions and from the order in which the forms and colours are assembled on the canvas.

From this self-evident perspective, a preliminary difficulty emerges. Space provides the possibility of juxtaposing the elements. In its intuitive content, space is the category of the 'one next to the other' on which every conceivable juxtaposition depends. One thereby grants space the role of founding the unity, the harmony and the beauty of the work. But is this a real or an imaginary space?

Classical painting distances itself from real space, the space of the canvas and the P.P. This space is a planar space. Like the wall on which the painting is hung, it has only two dimensions. Classical works develop three dimensions. Starting from the planar surface of the canvas (or the wood or the wall of a building in the case of frescoes and mosaics), they give rise to the illusion of depth that the canvas itself lacks. The painting thus appears like a hole in the wall, a window opening onto the world, onto the real world of ordinary perception with its three-dimensional space that is familiar to us. Would we only know our fatigue when, going from the nearby house to the faraway field, we would have to work for a long time? We also know the time of this effort, having learned to measure time

in relation to the size of the appearances of things, such as the house or the field.

Classical painting is a set of rules whose application allows for the creation of the illusion of the third dimension. These are the laws of perspective. Yet, to say that perspective, with respect to painting at least, is illusory is to say that it constructs an imaginary space. This is easily shown by observing that a small portion of the real surface of the P.P. can depict an immense space, as with the Flemish primitives where, on both sides of the main scene, one can see a countryside that extends to infinity through an open window.

The question is thus to know whether an imaginary space allows the elements of the painting to be used in accordance with its own order and its own spatiality—or whether, to the contrary, the properties and specific arrangements of these elements authorize this creation of a three-dimensional space, the illusion of depth and perspective, in spite of the flat surface of the canvas or the fresco. This is indeed the case: a large figure placed in the foreground and defining it by its importance pushes the various small forms behind itself, thereby suggesting a distance between them that the play of light and colour can increase even more. The Antwerp landscape systematically uses three orders of colour—green, brown and blue—in order to carve out inaccessible distances. The alternating reflections of shadow and light on the clouds covering the ground are able to give the ground the extension of the sky. Some painters master these types of techniques so well that one refers to them by their ability to produce certain effects. For example, the Italians have named the Flemish painter, Jan Van Bloemen, the 'Orizonte'.

Classical painting claims to assign perspective, that is to say space, the task of distributing the elements, but in reality it requires us to go back to the elements and their properties as the true principle even though they are hidden in every pictorial organization. The advent of modern painting offers proof of the decisive role of the elements. When the space of the painting is returned first in an equivocal way (Vuillard, Bonnard, Matisse), and then explicitly (Kandinsky, Klee) to a two dimensional space, we are led back to the P.P., which is by definition a flat surface. Is not the spatiality of this elementary space defined by the category of juxtaposition that allows us to place forms and colours side by side and to construct the work in this way? By abandoning the representation of the third dimension, the elements required for the illusory production of depth and consequently the classical definition of space as imaginary space would no longer play

this role. The possibility of composition, which is to say painting, would reside henceforth in space itself and in exteriority as such.

But the analysis of the P.P. has shown that it is not exterior at all. When facing its most powerful objection, Kandinsky's analysis achieves its most striking success. An exterior space is composed of homogenous parts, each one of which is external to all the others. Without further delay, one sees clearly that an element placed in a particular location of space does not receive any different properties than it had at another place. Utter indifference, if one may say so, characterizes this spatial determination reduced to its pure spatiality. In other words, it does not matter whether an element is situated at the centre, the top, the bottom, the right or the left of the P.P.

This claim belies the immediate experience that Kandinsky's analysis describes so faithfully. This analysis shows that the parts of the P.P. are not what they are due to their mutual exteriority. Such a characterization can be repeated monotonously; it is as empty as the spatiality that it speaks about. How can this spatiality explain the heavy affective weights and the motor potentialities of the Plane and determine the specific regions whose existential values are awakened once a form ventures into their territory, changing its own tone as a result of their contact? Here one must reiterate that the spatiality of the Plane is only its external aspect, its emergent part. To put it better, *the Plane is itself an element.* As such, it is revealed in two ways: outwardly as this exteriority itself and inwardly by the pathetic modalities of life. The unity of the Plane is its internal unity. Because it resides in and joins with life, this unity is a pathos and the P.P. is filled with the underlying, dynamic structure of its secret pulse.

To say that this dynamic and pathetic unity is the unity of the Plane means that it is the unity of exteriority itself. That is to say that the unity of exteriority is not its truth. How, in fact, can one portion of the area be united with another one, if it stands entirely outside of it in a radical exteriority, which is hardly conceivable and which would collapse into nothingness? It is only possible for exteriority to exist and to develop with a continuous increase resulting from the addition of one part to another, if this development does not cease to be experienced internally while it is being produced, that is, if it is alive. The P.P. is nothing but this pathetic exteriority which is possible because it is always given and retained by the self.

In the P.P., however, exteriority does not unfold freely through the continuous increase described above. It is interrupted abruptly by the encounter with lines that cut right through it. That is why the Plane's tone

is not homogenous, and it is not the pathos of a continuous place. It is overdetermined by the hot and cold tonalities of the horizontals and the verticals that imitate the human being's existence and fate.

But, the unity of the elements is what we are trying to think about. Two problems arise here: How can each element be united with the Plane, on the one hand, and with the surrounding elements, on the other hand? These problems are parallel and can clearly receive the same solution, if the Plane is itself an element, that is, if it has a phenomenological duality. We have already addressed the elements and have seen how the element duplicates itself depending on whether it is truly anchored in the Plane and physically belongs to it or whether it is detached from it. But it is no longer a matter of describing the modalities of the elements' relation to the Plane, it is a matter of grasping how it is possible. This possibility resides in their respective tonalities, in the fact that they are both, in their original being, a pathos. Inclusion and exclusion result from their tonalities. Tonalities, in virtue of their being, call forth or repel one another in and through their affectivity. That goes for the force of the Plane, the force of the element, and the force that presides over their unity or disunity.

The failure of ordinary theories of painting that seek to explain this unity on the basis of the categories of the world is clear. With respect to our problem, the temptation is to base the unity of the composition on the unity of the space in which the composition is developed. As we have seen, space naturally lends itself to the introduction of the colours and forms that will make the painting. But, from the point of view of space, there is no reason to place a particular element in a particular place instead of any other one, since, considered in their pure spatiality, all places are the same. If one begins with the form—including both the colour and the graphic—the difficulty is the same: no affinity emerges between a particular formal element and an undifferentiated location in space. Thus, the relation between the elements and the P.P. is necessarily produced outside of spatiality and exteriority in the invisible domain to which abstract painting leads us.

Invisible colours

The second problem concerning the unity of the elements can be resolved as well. Here again it is the problem of their respective tones and the harmony or discord between them. Such a problem, however, is absolutely concrete: it concerns the relation between graphic forms and colours. This problem takes on a crucial importance, if composition is what makes this relation possible. This possibility is not yet entirely clear for us. With the aid of the masterful analysis in *Point and Line to Plane*, we have established that the real being of lines is the force that produces them, that this force is a pathos and thus an invisible being. Can this proof be carried out in the same way and with the same degree of evidence with respect to colour? Colour does not seem to be joined to any force; it does not use any medium of a subjective nature allowing it, in turn, to be included in the sphere of subjectivity. We certainly do know about Kandinsky's passion for colour, a passion that gave rise to his vocation as a painter and marked his work from the beginning, especially the 'Fauve' period prior to the discovery of abstraction. We also know that this passion for colours is what pushed Kandinsky to provide a systematic theory of colours. This theory stands out to us for its unmatched scope and precision. Its major thesis is that each colour has its own affective tonality. *To this extent, it conceals its being from the light of the visible*. Yet, this paradoxical claim requires justification.

Here we rejoin the second general question that abstract painting poses to us. The content of the work, its abstract content, is life. Its means—the form of this content—are also abstract. The force that draws linear forms is the force of life and thus an invisible reality. But what about colours? The

fact that they are generally or even universally associated with tonalities and thus with life does not yet establish that colours have an affective and invisible nature *in themselves*. Are not these striking tones, these incarnate beings that Kandinsky watched with wonder as they burst out of the tube and spread out their thick and glistening flows, their material and magical mixtures, onto the palette—these colours that the play of light heightens—shown to us in this light? Do they not belong by all accounts to the realm of the visible? In such a case, their link to subjectivity would only be an external link, not their substantial reality. Is it not pure folly—deriving from some outdated theosophy and honestly a little too 'mystical'—to claim, instead, that colours would be revealed in the Night of their pure affectivity?

Here let us call upon the founder of modern rationalism—Descartes. In the eyes of one of the greatest philosophers, it was sheer absurdity to claim that colour is external and that it would be spread out in the external world and belong it. If I put my hand on a wall exposed to the sun, I think, 'The wall is hot'. But that is false. To be hot means to experience heat and to experience oneself as being hot. Only what experiences itself, only life, can experience heat and know what it is to be 'hot'. The same goes with pain. I think, 'My arm is in pain'. But, as an extended outer reality, my arm would not be able to experience anything whatsoever, not even pain. In an exteriority that is outside the self and does not touch or feel itself, nothing can be experienced: no pain, no suffering and no joy.

What is true about heat and pain is also true about colour. The rock is no more red than it is hot or painful. It can only have a colour—red, blue, yellow—in the invisible life where the colour is felt, on the basis of 'feeling oneself' (*se sentir soi-meme*). Life's feeling of itself and its feeling of colour is a pathos. Colour is not linked to a tonality through an external and contingent association that would vary with individuals. In the phenomenological substance of its flesh and being, colour is a sensation and subjectivity; it is this affective tonality and inner tone.

It is true that colour seems to spread across the thing, blending with its surface and its extension. But the colour perceived on the object, or likewise on the artwork—what Husserl calls the 'noematic' or objective colour—is only the projection of a sensation of colour onto the thing. It only exists inasmuch as it is felt and it is only felt inasmuch as one feels oneself—in the invisibility of its affectivity. This clarifies the thesis towards which our analysis is pointing, a thesis which identifies form ontologically with the abstract content of the work: 'form is also abstract'.

Because Kandinsky's impressive theory of colours is founded philosophically, its most original and profound meaning is missed by inserting it into history and by recognizing its obvious antecedents. To indicate the tone that each colour evokes, the type of resonance in which it is mysteriously shrouded, the 'impression' it usually awakens or to attempt to show that their linkage is not accidental but constant in such a way that this colour can be used to suggest this impression: all of that remains uncertain, vague and 'literary'. For, it has not yet been understood that *this impression is nothing but the sensation of colour and thus colour itself*. Being-felt-by-oneself is its sole conceivable reality and truth.

What is vague, relative, uncertain and literary is the figurative language with which one seeks to express the affectivity of colour, that is, its sensation. Figurative language is not the link that joins colour with its affect, a link which is not either one of them and which is not some external connection between two foreign terms; instead, the link is the internal relation of life to itself, the immediacy of its pathos. Human beings have always sought to translate what they felt, first by gestures and later by words. When this translation claims to be faithful and the analysis of feelings seeks to be precise and seeks a conceptual formulation, a number of difficulties emerge. With the pathos of life whose modalities are irreducible to any objective representation, it is a matter precisely of what is beyond words and of what we do not have any words for. When it comes to our own subjectivity, the referent of language is so fleeting that the project of objective, scientific knowledge has no other resources, unless it wants to renounce itself, than to put this cumbersome reality of life out of play. Language replaces it and then becomes the sole object worthy of knowledge, because it is an objective matter given to all sorts of analysis—linguistic, logical, symbolic, mathematical, historical, social, economic, psychoanalytic, etc.—and thus lends itself to all the ways of thinking that have fostered the overall success of 'science'. Logical positivism is one example, among many others, of this theoretical negation of life, whose ultimate wrong is to hide from the domain of objective rationality and all conceivable positivity.

Painting does not use language. Abstract painting teaches us this, and this is what gives it its power of expression. If colour does not relate to the feelings of our soul through an external relation but finds its true being in them—as a pure sensation and a pure experience—then it does not even need to translate, through a means, the abstract content of our invisible life. It coincides with our invisible life and is its pathos: its suffering, its boredom, its neglect or its joy.

The great art critic, Guilio Carlo Argan, pronounced a strange verdict on Kandinsky's painting: it is, he wrote, 'the first and already the perfect model of modern popular art'.[11] This type of painting is not popular due to Kandinsky's taste for popular art—Russian, Bavarian, African or any other—but for the deeper reason that it eliminates the mediation of object-ive reference and everything based on it: language, representation, and thought. Inasmuch as culture is traditionally comprised exclusively of the group of significations delivered by language as a discourse, it is in fact this linguistic, mythical and conceptual culture based on the universe of repre-sentation and the symbolic or cognitive relation between the subject and the object that abstract painting puts out play. Abstract painting does this by replacing every mediate form of expression with the immediate affective arousal of colour in us, that is, with the original reality of colour as such.

If communication takes place between the artwork and the public, it is on the level of sensibility, through the emotions and their immanent modifications. It does not have anything to do with words, with collective, ideological or scientific representations, or with their critical, intellectual or literary formulations, in short, anything that is called culture. It is totally independent from that type of culture. This is why it is addressed to the group of people who 'lack culture'. It is popular in the sense that it leads to what is most essential in each human being: one's capacity to feel, to suffer and to love.

It is not at all paradoxical that this popular painting would stand in total isolation today, that there would be practically no audience to view or understand these masterpieces of the one who Argan says 'determined the fate of contemporary art', that the admirable rooms of the Lenbach villa would remain empty all the time or even that at the Beaubourg half of the collection donated by Nina Kandinsky would stagnate in the reserves where no one can see them. It just so happens that people today are no longer popular, spontaneous, instructive, real or alive. A mediation has separated people from themselves. The media has replaced the free play of life and its sensibility with the substitute of an unreal, artificial, stereotypical, consumer world where life can only flee instead of realize itself.

If abstract painting does not require any mediation, especially not the mediation of discourse, this is because it is absurd to define art by its cul-tural, historical and social context. According to such conceptions, there would only be a work of art in light of a specific regard and thus specific objective conditions: sociological, historical or cultural ones. It would thus

be possible for an artwork—or at least for what is called 'art' today—to enter or leave the art world depending on the changes of these conditions. Today a ritual object or a sanctuary can be the development of a perspective; they can be revealed to us with aesthetic predicates that they did not have in the eyes of those who built them. They were tools that played a specific role in a religious ceremony. Outside of this, no meaning—no artistic value— could be given to them. At bottom, one must cease to believe in God in order to perceive the beauty of cathedrals.

The above types of theses—including the claim that art begins with the discourse about it—are as widespread as they are superficial. They all stem from the bastardized intellectualism accompanying the most bland positivism. The illusion is based on 'seeing as'. To perceive a specific object *as* a work of art certainly presupposes a regard, an intentional regard whose role is to bestow a sense, such as an aesthetic value, on what it constitutes through the act of regarding the object. Through the following observation, we can understand abstract painting and painting in general: *in life's relation to the work of art, no regard can bestow a sense or a value to the object, because there is no regard, sense, or object; life's relation to colour, for example, is the subjectivity of this relation, that is, life itself*—the inner tone, the inner resonance and the pathos of this colour. Hence, those who build temples and sacred edifices and who decorate them with splendid ornamentation feel the colours of these decorations just as we feel them today. Colours exist *in the sole way in which a colour can be felt*: by blending with and being nothing but the sensation of the colour.

It is absolutely true that these builders did not perceive their work *as* art and that they did not have the stupid idea that art could only come into being through an ideological context from which its existence would be derived. This demonstrates that aesthetic experience is not an experience that bestows a sense on objects. The experience of red does not consist of perceiving a red object or the colour red as such and of taking it as being red; instead, it consists of experiencing the power of the *impression* in ourselves. That is what eliminates all objective mediation from painting: the mediation of objects, the sense that they can be given, thought, 'culture' with its variations by time and place and ultimately the various theories that represent this non-existent mediation. That is also why abstract painting, which bypasses the mediation of language and culture understood as a group of representations, can be called a popular art. It is devoted to the expressive power and the direct communication of colour, its immediate experience in life.

This equation of the original being of colour with its tonality does not only free art from the domain of objectivist and symbolic culture; it also dismisses every attempted psychological interpretation of art. This type of interpretation was already presented with respect to the current problem. It claims that a tonality belongs to a colour on an associative level. Although psychology deals with the soul, the type of association that it uses and abuses takes us back to the world of representation. It provides a link that is based on spatial and temporal contiguity or objective resemblance. In such cases, exteriority is the basis of the associative connection. If it is reduced to this connection, the primal unity of colour and tonality is broken. It becomes an external relation depending on circumstances. No universal science of painting can have such a contingent basis. The brilliant insight of abstract painting is to reverse the psychological explanation and to show that all the associations organized around a colour, instead of explaining its particular tonality, depend on its tonality. The pathos of each colour produces the variable network of images that it typically awakens; the permanence of this tonality and its link to a colour explains all of its associations.

Kandinsky's theory of colours rests entirely on the interiority of the tonality-colour link. This link is nothing but the colour's own interiority to itself as a pure impression, or, what we have called its pathos. The analysis of colours should not be understood as a creative yet vague poetic discourse but rather as the regard entering the heart of the pictorial thing and, once possessing its essence, being able to 'use' it. The difficulty that the theory of colours runs into as long as it speaks from the perspective of 'physics'—a difficulty that *On the Spiritual in Art* does not altogether avoid—disappears once its approach, either consciously or unconsciously, becomes phenomenological. It is no longer a matter of speculating about the physical or physiological bases of colour (it is noteworthy to see the degree to which science and speculation go together) but of describing what is experienced as experienced, 'the examination of colour which by and large must affect every man' (177). In this return to pure subjectivity, Kandinsky's theory finds its radical foundation, the same one that Descartes gave to philosophy and that protects it from the reproach of being a mere interpretation.

The phenomenological principle of Kandinsky's analysis is stated from the outset. He writes: 'One concentrates first upon colour in isolation, *letting oneself be affected by single colours*' (177; Henry's italics). We will recapitulate only the main findings of this 'description'. Two major phenomenological distinctions—Kandinsky says they 'appear at the same time'—guide the

analysis: hot and cold, on the one hand, and light and dark, on the other hand. Every colour thus potentially has four basic tones, since it can be hot—and at the same time light or dark—or cold—and again, light or dark. The main conclusion is that each colour has a fundamental tonality and, in a certain sense, its own affective flesh. The permanence of this affective flesh ensures its continual action on the soul, or rather, it *is* this action. Its heat or cold must be understood—must be felt—though this fundamental tonality. Each tonality is hot or cold on its own.

Yet, according to Kandinsky, hot and cold also indicate a movement or a tendency. In the case of heat, the movement goes towards the spectator, while in the case of cold it retreats. In the case of heat, the tendency is towards the colour yellow, while the general tendency of cold is towards blue. These fundamental tones of colours can only be discovered experientially, that is, through experience. Experience, not as an experience of the world but as an invisible experience, resides in absolute subjectivity as a pathetic immediacy. This is what founds every possible theory of colours.

Through experience, yellow is hot and has a horizontal, approaching movement, while blue is cold and has a horizontal, retreating movement. Thus, the 'First Great Contrast' is born between the contrast of hot and cold; it is polarized between the colours of yellow and blue and their antagonistic outward and inward movements. The 'Second Great Contrast' is between white and black, which along with yellow and blue form the 'four basic tones'. This contrast can be described phenomenologically on the basis of a double tendency and movement: the tendency of every colour towards the light or dark and the movement either towards or away from the spectator, a movement which is understood here not in dynamic but static, fixed terms.

Experimental proof of the properties of various colours, in the sense described above, is one of the tasks that Kandinsky pursues systematically. It was an opportunity for him to give free reign to his methodological and creative genius. Nowhere better can one see creation emerge so directly from experiments. Let us discuss one procedure among countless others— covering a single form with two different colours. A yellow circle radiates, is animated by an outward movement, approaches the spectator threateningly, seems 'unbearable to the eye' (181). A blue circle, animated by an inward movement, distances itself. The First Great Contrast can be outweighed by the second one. In virtue of its tendency to the light, yellow increases its effect as it is lightened. This tendency is so strong that it is nearly impossible to conceive a truly dark yellow. The effect of blue, by

contrast, will increase as it darkens. The play of these properties of colours and in particular the fundamental colours can go on to infinity. Kandinsky, for example, attempts to thwart the inherent tendency of a colour by giving rise to perverse effects that seem to disrupt its true nature. This occurs when seeks to turn yellow cold and it takes on a 'sickly hue' (181). Affinities, however, are discovered between yellow and white, blue and black.

Obviously, the greatest possibility for experimentation with colours is by mixing them. Applied to fundamental colours, this process is painting and has been used for all time; it yields results that are predictable to some degree. The opposite movements of two antagonistic colours will tend to cancel each other out. Blue gradually added to yellow halts and then paralyses its tendency to confront the spectator, which is gradually weakened to the point of changing into rest. The new colour resulting from this mixture, green, is characterized by immobility. The opposing movements of white and black cancel one another out in grey. Colours resulting from a mixture keep the dynamic properties of those from which they originate. Because black and white lack a truly active force, they lead to 'completely lifeless' grey. To the contrary, green is composed of two powerfully dynamic colours and will thus retain their dynamic potential. Each addition of one of its components will change its equilibrium, with its tonality leaning in the direction of youth, happiness and animation under the effect of yellow and towards the seriousness of thought under the effect of blue.

The theoretical problem in play throughout these various descriptions is the problem of the unity of colours. If the original being of colours resides in their tonality, then this unity is and must be of the pathetic order. It is an illusion to believe that the diversity of colours can be explained on the basis of their 'physical' mixture. The range of tones obtained through the combination of the primary colours does not result merely from their material properties. These properties never exist as such, because colour is a sensation whose subjective nature can only be explained by subjectivity and its specific properties. That is why colour has a tonality and why the mixture of colours is a mixture of their tonalities. If this is the case, the condition of the possibility of this mixture is subjectivity. It alone provides the ontological milieu where *sensations* of colour are able to meet and merge into one life. Because Kandinsky experienced primitive colours and their dynamic properties (as well as their tonalities) in his life, he was able to conceive and thus *to think a priori* about what would result from their encounter. Kandinsky observes: 'One can in fact establish their spiritual effect purely theoretically, on the basis of the character of the movement.

Likewise, if one proceeds in a purely experimental fashion, letting the colours affect oneself, one comes to the same conclusion' (180).

What we also understand better, as a sign of rigor and not uncertainty, is the literary character, which is to say the emotive and affective character, of Kandinsky's remarkable descriptions of colours and their combinations. Consider, for example, the description of yellow: 'yellow . . . is disquieting to the spectator, pricking him, stimulating him, stimulating him, revealing the nature of the power expressed in this colour, which has an effect upon our sensibilities at once impudent and importunate. This property of yellow . . . can be raised to a pitch of intensity unbearable to the eye and to the spirit. Upon such intensification, it affects us like the shrill sound of a trumpet being played louder and louder, or the sound of a high-pitched fanfare. . . . If one compares it to human states of mind, it could have the effect of representing madness . . . like the lunatic who attacks people, destroying everything, dissipating his physical strength in every direction, expending it without plan and without limit until utterly exhausted. It is also like the reckless pouring out of the last forces of summer in the brilliant foliage of autumn, which is deprived of peaceful blue, rising to heaven' (181).

Once again, in spite of all appearances, the recourse to representation—to sickness, summer or autumn—does not point back to an external referent. The external referent is solely mentioned for its subjective value. The tonality of each one of these natural or human events is evoked in order to allow the reader to understand the tonality of the colour (e.g. yellow) through a comparison that operates on the level of these tonalities.

The analyses of other colours should also be mentioned. Blue is the colour of depth, the 'heavenly colour' (181). It appeases and calms; it 'calls man towards the infinite' and awakens 'a desire for the pure and, finally, for the supernatural' (181). As it moves towards black it becomes sad, while it becomes more remote and impersonal as it lightens. Green is the most tranquil colour. It does not move in any direction and has no passion. It does have a beneficial effect on people, but it can become tedious after some time. White is elevated far above the world and its colours (to such an extent that the Impressionists scratched it from the list of colours). It is an absolute silence, not a silence that is dead but one that is filled with possible things. This 'nothingness' precedes every birth and beginning. In relation to it, the sounds of all other colours 'become dulled, while many dissolve completely' (185–6). By contrast, black is a nothingness bereft of possibilities. It is a future 'without hope' and a death 'as if the sun had become

extinct'. It comes 'full circle', a 'spent funeral-pyre, something motionless, like a corpse, which is dead to all sensations' (185). Finally, red is 'a limitless, characteristically warm colour ... with the inner effect of a highly lively, living turbulent colour' and that 'for all its energy and intensity, a powerful not of immense, almost purposeful strength' (186). Yet, this analysis of colours is not our topic. Understanding the internal, invisible and pathetic being of colours simply helps us to understand the possibility of their union, mixture and the generation of the colour spectrum with its countless nuances. What the theory of elements now requires is an understanding of the possibility for the unity of the elements in general—the unity of colours and graphic forms.

Forms and colours

In exteriority, forms and colours seem foreign to one another. What relation can be observed between pure linear forms, on the one hand, and the series of fundamental and secondary tones, on the other hand? Their diversity also differs. The various colours, with their subtle complementary or contrasting shades, may have a physical thickness to their visual presentation. Yet, this has nothing to do with the ideal limits of the design of a graphic, the intertwining of lines, the dissemination or concentration of points or the clear-cut intersection of volumes or planes.

Here one might recall the distinction between geometric and real forms. A real form—what Kandinsky calls a material point—is a sensible reality. As such, it has a certain colour, even if it is a neutral one. Likewise, every colour occupies a certain space, covering it either totally or partially. Even in the latter case, no portion of the area remains colourless, allowing at least the colour of the background to be seen. It is only with the appearance of unreal, geometrical forms grasped through ideation from the sensible world that a separation is conceivable between the drawing and the colour. The figures treated by the geometer and the properties discussed in its proofs are without colour just as its lines lack thickness. So, they are both heterogeneous to the domain of painting, and for this reason, it is incorrect to speak, as is often done, about the 'geometrical' construction of a painting. This term signifies something completely different in a plastic perspective. It means that forms, which ordinarily escape our attention and whose character and formal power are stuck within the practical aims of ordinary perception, are at last grasped and experienced for themselves. This 'geometry' really marks the disclosure of the pictoriality of the pictorial elements

and their entrance into the dimension of art. Abstract painting has revealed the meaning of this event.

In order to resolve the problem of the unity of colours and forms, classical art was based on the fact that real forms (in painting there are no other forms) and colours are bound together by the sensible reality of the world and by the essential connection of this world where every extension is coloured and every colour extended. It was not really a problem since the solution was always there: it was in nature as we see it. Neither Galileo nor Descartes had yet come along to disqualify sensible qualities from the world reduced to a pure intelligible extension and its ideal figures. In this inaugural act of modern science, they were fully conscious of keeping a domain out of its area of expertise, namely, the domain of sensibility and consequently of art.

Let us recall that one of Kandinsky's central theses is that art belongs to the sphere of sensibility: 'What is right artistically can only be attained through feeling' and 'Since art affects the emotions, it can only exert its effect by means of the emotions' (176). Because, though it is said parenthetically, the famous laws of beauty belong to sensibility, they will never have the appearance of ideal, objective, mathematical laws. Even though one might be able to provide a rigorous mathematical formula of the relations between the various elements of a painting, this would only be an ideal approximation of proportions and equilibriums at play in sensibility. They are made possible by the laws of sensibility; they respond to its requirements, which are their ultimate explanation. This is why Kandinsky states, 'proportion and scales are not to be found outside, but within the artist' (176).

One must therefore pose the following question to classical art once again: Does the unity of real forms and colours truly reside in the world, since the true nature of the world is understood in its original, Pre-Galilean meaning as a sensible world? Does the fact that colour extends over a surface and belongs to this surface phenomenologically—and conversely, the fact that the surface is coloured—provide the *aesthetic motivation* for the act of painting? Can they explain why the artist chose to place this colour in this form—why he first chose this one? Or, moreover, why he decided no longer to contain the colour within the boundaries of the form or to invent forms that do not exist anywhere? Abstract painting's decisive choices sketch out in rough outline the shortcomings of representation. Artists have always detected the reciprocal connection between colours and graphic forms in the world. But this actual union, this dull

collection of limp forms and faded tones of the world, never guided its project. They could only render it useless, or even impossible if, as we have shown, colour reduced to its extension shows no preference for how it is placed, if pure spatiality is pure indifference, if the fact that each place is external to the others does not allow them to be distinguished from one another, and if, conversely, these equivalent and interchangeable places no longer have any reason to take on one colour rather than another one. We should reiterate the theses of abstraction and the theory of elements.

Every element has an internal and external aspect—the internal is not an 'aspect' to be seen but an invisible revelation. In the case of colour, the external aspect is the coloured patch that spreads across the surface of things: the objective, 'noematic' colour. The internal revelation is the tone of this colour and the possibility of feeling the world being born for white, dead for black, calm for green or the profusion of life itself for red. In the case of form, the external element is the visible drawing, which can be defined in a number of ways, for example, 'delineating this material object upon the surface plane' (165). The internal element here is a pathos. Here one should re-read the following essential claim: 'everything external necessarily conceals within itself the internal . . . every form has inner content. *Form is, therefore, the expression of inner content*' (165).

If graphic forms and colours are elements, then while they may manifest some difference by their external aspect, they do share a common essence—their tonality. These tonalities are homogenous. They are the modes of subjective life or the soul in the Cartesian sense. Their unity is not merely possible but necessary. It exists by right, *a priori*, prior to experience as the condition of all experience. For abstraction, or better, its ontology, the principle of the unity of forms and colours is the principle of their reality.

The homogeneity of subjective life's modalities does not exclude their differences. Quite the contrary, our life is really the constant passage from one feeling to another, and this explains their differentiation and diversity. These feelings are not just of any sort whatsoever. They obey rigorous laws that are not the laws of the world (laws of space, time and causality—of physics, mechanics, chemistry, biology, etc.) but the laws of life. The most important of these laws is in fact the passage that belongs to the affective order and explains the most profound nature of subjectivity. Because this is the experience of oneself, a way of suffering oneself, because this suffering

is also the way for life to take hold of its being and to enjoy itself, the 'passage' is the perpetual oscillation from suffering to joy—an oscillation that is at the core of our being. Painting represents this history of our feelings. The change of colour is the change of its tonality. The colour spectrum, with its subtle transitions and magical transformations, is nothing other than the passage from one tonality to another. It is the becoming of our life.

The homogeneity of colour tonalities is also the homogeneity of the tonalities of graphic forms. Just as the homogeneity of colour tonalities signifies their diversity in the becoming of life, the same applies to the case of forms. We thus encounter the fundamental laws of painting, the fabulous laws of abstraction that Kandinsky did not formulate but are implicit in his analyses and the study of his artwork. Based on the unity between colours and graphic forms, they are as follows:

1. Homogenous elements like colours can have different, even opposed, tonalities (such as the tonalities of yellow and blue with their contrary 'movements'). Moreover, this is necessarily the case if colours are differentiated from one another not only by their objective or noematic appearance but by their tonality (which is only the internal experience of this appearance, its auto-impression)—if to each appearance of colour, for example red, there rigorously corresponds a determinate tonality (for each individual).
2. This law holds likewise for graphic forms.
3. Heterogeneous elements, such as colours and graphic forms, can have, in spite of differences between their external aspects, closely related, if not identical, tonalities. One single tone can thus be obtained more easily by the reconciliation of two heterogeneous elements—one colour and one form—than by the reconciliation of two homogenous elements—two colours or two forms.

This third law of abstraction requires us to make a very general observation. Exteriority is synonymous with diversity to the extent that, by its own nature, it puts each thing outside of all the other ones. This is done by space and time as well as the laws based on them. The surprise is the unity of the world, the unity that, in spite of everything, exists in its diversity. Such a unity is due to the fact that this world would not exist if it were not experienced inwardly—in a subjectivity that is the internal experience that the world has of itself at each instant: its affectivity. That is why every external aspect of reality—every 'external element'—implies a tonality in

its interiority as a sensation, the auto-impression of colour without which colour would not exist.

This law of the affective unity of the world implies, in turn, the reduction of diversity to unity. This reduction is not a suppression of diversity to the benefit of unity but rather a support of their coexistence. Yet, this support is such that it occurs as a reduction: diversity is only possible in and through an underlying unity that reunites it. This source of unity is the affect. Concretely, one can say that the multiplicity and infinite diversity of external things only gives rise within us to a limited number of sensations and impressions—better, of feelings. For this reason, realities, as different as a drawing and a particular colour, can be revealed as a single tonality in life. The miracle and the mystery are perfectly explained here: two objects, one single impression. This impression is, in an absolute sense, their unity.

The third law of abstraction, whose general formulation was justified above and was applied concretely by Kandinsky, demonstrates this point. For example, the colour yellow and the triangle will have an identical tone. We express this through the use of closely-related words: ''high-pitched', 'loud', 'shrill', but these terms refer to one and the same subjective reality that constitutes the identity of the triangular form and the colour yellow. The nature of their unity is not based on a shared but difficult to isolate part of two numerically different and separate terms. The unity between the colour yellow and the triangular form is in fact a single reality: one and the same affect, one single emotion. This single reality on which colour and form are based is not external to them; it is precisely their inner reality, their flesh.

The ontological identity between a form and a colour is demonstrated or 'experienced' in numerous cases that aesthetic experimentation will discover progressively. Here let us mention not the affinity but the identity between the colour blue and the circle. Each one of these external elements (like a specific blue and a specific circular form) has the same inner content. To paraphrase Kandinsky, it is one and the same 'subjective substance' contained in two different 'objective covers'. Blue, as we have seen, contains a movement that draws away from the spectator in addition to a tension towards its own centre. The pathos of this complex dynamism is a feeling of deep calm. The circle produces the same effect: its concentric force combines with the perfection of a continuous movement to give a feeling of the power and peace of eternity. Given that there is an infinite spectrum of colours and likewise an infinite number of forms—once they are no longer reduced to forms in the objective world—the possibility of

joining external elements in order to give rise to corresponding feelings becomes inexhaustible.

And yet it never happens, at least in the pure theoretical form that we have just studied. This is what some difficulties pertaining to the problem of the unity between colours and forms will show.

Difficulties pertaining to the unity between colours and forms

A specific colour and a specific form can be placed before a spectator successively and produce the same impression in him or her. But, this is not how Kandinsky's experimentation or painting in general ever proceeds. To paint is to cover a form with a colour. Even when they are joined theoretically to the same tonality, their overlapping changes this tonality considerably. It highlights and strengthens this change, and produces a new tone. It is in this respect that art is creative. If it is the case that their unity is conveyed by a different tonality from the ones that produced it, the use of a vocabulary of forms and colours, at best, only offers a point of departure for the development of combinations. Composition is the joining of elements, their fusion into a new and unforeseeable tonality. The unity between colours and graphic forms whose possibility we just established is the presupposition of every composition and every masterpiece. Composition presents us, however, with a difficulty.

The theory of elements sought to circumscribe the tone of each one of them. That is what it analyses. If we think back to the various processes used in order to accomplish this disclosure, we realize that this analysis has never given us a simple tone. For example, we began with the consideration of a point placed at the centre of the P.P. The experienced tone was really twofold: it was the tone of a point superimposed on the tone of the Plane. In one sense, a tone is always simple, because it belongs to life and life remains one, one and the same life, completely present to itself throughout its many changes. But the tone felt with the point at the centre of the Plane is nonetheless the result of the two ideally different tonalities corresponding to these elements. These two tonalities are *concealed* by the

single tone. To reveal them, Kandinsky had to move the point along the Plane in order to let us feel what we never feel or perceive in itself—the point and the P.P. as such.

The same phenomenological situation, however, occurs in the case of the moved point. The change that we experience indicates that the Plane's tone changes depending on its regions, since one single point placed successively in various places resonates in a different way. But this different resonance is also always the result of two tonalities, where the one remaining the same is never perceived in itself but only through its combination with the change of the Plane's tone.

The unity between colours and graphic forms, which is the basis of composition, illustrates the same difficulty. The analysis seeks the simple but it is always really a result, a composite. To be sure, we do have an idea of the specific tonality of red, yellow, blue or the circle, triangle, the angular, curved and straight line. Composition would not be possible without the painter being conscious of this implicit and differentiated knowledge that the painting aims to make explicit. This relies, for example, on the harmony between colours and forms. If he seeks to produce a bold effect, the painter will colour a triangle yellow. If he wants to produce an effect of depth, the painting will have recourse to a blue circle. But, a harmony between colours, that is the overlaying of neighbouring or identical tonalities, presupposes prior knowledge of each one of these tonalities in its own irreducibility.

Not all compositions, to be sure, rest on the agreement of colours and the harmony of forms. Composition can also play on their difference by seeking to produce an impression of contrast, conflict or even by diminishing the effect of a particular colour. Instead of painting a yellow triangle, a blue circle or a green square, one can paint a green triangle, a yellow circle or a blue square. There are as many combinations as one might like, and from each one there always results a determinate impression. But, whether a composition is based on agreement or contrast, on strengthening and increasing their effects or on moderating and weakening them (which must give rise to complex investigations because the hiding of a form or colour can also make their action more powerful), a prior knowledge of the elements' specific tonalities is always necessary.

This point is so important that Kandinsky sought to establish it. He did this in at least three ways that respond to the difficulty facing us. There is only red in painting—which is to say on the plane of sensibility, as a real, sensible red—through a particular colour taking its place in the spectrum of

reds. Every real colour, in other words, takes on a unique colouration for which, at the limit, there may be no name, and that is irreducible to all the other 'tones', even the closest ones. This unique colouring is made even more particular by the fact that it cannot do without a support on which it is spread, however small this support may be. In this way, it contracts a double relation: with a form and with the other tones covering or surrounding itself. This relation with a form and other colours is the fusion of all the tonalities of the elements considered. The single tonality is the complex result of this fusion.

In order to isolate red from this cumbersome environment, Kandinsky had an ingenious idea that reveals his profound philosophical instinct: to tear it away from reality, the limits of the surface, and other contiguous tones. In order for a tonality to resonate within us, one only needs to say the word 'red' or even to think of this colour without the image or perception of a real red. The tonality of red itself is thus detached from every form and colour that might alter it and thereby conceal its own tone. It can thus be considered as the pure tonality of red—purified of every mixture.

In speaking of 'this inner vision', it is quite remarkable that Kandinsky calls it 'imprecise' inasmuch as it is presented only with 'fine gradations of the shade of red'—which is to say that it is represented in the objective series of tones. However, it is 'precise' when it is considered in its inner tone. Its subjectivity—the fact that, inescapably and beyond any doubt, it is the sensation and impression that it is—does not suffice as the basis for this 'precision'. This precision is based on the fact that the red tone no longer enters into combination with any other tone—light or dark, a surface, a simple horizontal or vertical line, 'hot' or 'cold'. The red tone is felt here as the red tone reduced to itself; it is red as such. Kandinsky is able to describe this 'pure' tone, withdrawn from the influences of a plastic surroundings: 'This inner sound resembles the sound of a trumpet, or of the instrument one pictures in one's mind when one hears the word trumpet, etc. where all particularities are excluded. In fact, one imagines the sound without even taking account of the changes it undergoes, depending on whether it is heard in the open air or in an enclosed space, alone or with other instruments, whether played by a postman, a huntsman, a soldier, or a virtuoso' (162–3).

Philosophically speaking, it can be said that what Kandinsky seeks to define is the essence of red, the ideal type of red as well as the impression of this red that is conceived by the mind but not sensed. The following observation establishes that this tonality of red does exist, and likewise, that

there is a tonality belonging to the triangle, the circle, and the point. Even though a real colour can vary by passing through the series of its various possible colours, as when a shade of red, for example, becomes 'red lead, vermilion, English red' (186), this colour, Kandinsky asserts, 'displays the possibility of maintaining more or less the same basic tone' (186–7). The specific tone of red is so assertive and powerful that its effervescence and ardor remain throughout the shadings of its tones from the lightest to the darkest. It thereby resists the basic changes of 'cold' and 'hot'. Points, triangles and circles all do the same: they too keep their own characteristic tone in spite of all the formal alterations imposed on them. Three arguments thus protect the internal-being of the element from its absorption by the environment:

1. The existence of its specific tonality given proof with the help of a simple sign that designates it.
2. The reference of this tonality to an ideal type, which also exists and can be conceived as such.
3. The permanence of this fundamental tonality throughout all the subsequent transformations of the element.

One insurmountable objection, however, can be raised. By agreeing that there is evidence of an ideal type—the genus 'red' or the essence of the 'circle'—the impression by which it resonates in subjective life cannot be separated from the flow of subjective life or from the collection of tonalities that comprise it and make it into a single feeling. In other words, if it is possible to display the discrete, autonomous nature of the element and to recognize it as the true element of an analysis, this possibility only holds for its external aspect (for example, what is perceived by the mind as pure red when I say the word 'red' or as an isosceles triangle when I produce this concept) but does not hold for its internal relation. The internal relation is lost in the flow of invisible life where there is no limit, part or independent sequence and consequently no discontinuous element or 'simple' tonality.

Moreover, the discreteness of the external element is only identifiable within the domain of ideality, which is the domain of the genus red and geometrical forms. This domain is precisely not the domain of painting. When we considered real colours and graphic forms, we should have been able to provide evidence of their objective connection—if it is the case that every sensible point already has contours, surface and colours; if this colour rests on a basis, however small, without which it can be known by the mind but not intuited, since intuition can only occur in space, and

consequently, on a surface. If the external aspect of the element, as a real and sensible aspect, already synthesizes the required components of painting within itself, this is all the more true for its inner reality, the pathetic unity in which the various tones of graphic forms and colours are one single life.

Kandinsky's stroke of genius is to have perceived that what seems to be composition's major obstacle as its very own condition and nature. Instead of working away to find elements conforming to our ordinary conception of analysis as the analysis of external things, the elements must be led back to their true nature and its laws. In life, the tones of the point and the plane are confused. Phenomenologically, we have explained the meaning of this confusion: two tones are united in one subjectivity excluding all real separations, but they conceal one another. The unity of this undifferentiated tone is the state of one who gazes at the point at the centre of the plane with a dull eye. This is a dull, unexpressed and blind tone, because it does not allow what is really there to be experienced, namely, the Plane with its hidden tone.

The second obstacle for composition is the concealment of tonalities, such as the unconscious tone of the Plane. For, how can one use graphic forms and colours on the surface of the artwork, if one does not know about the action of this surface through its dynamic and pathetic structure? How can this action be appreciated? Does it not derive from and combine with the tone of the Plane? In this way, the two difficulties encountered by composition—1. the impossibility of delineating discrete elements and the concealment of their respective tones; and 2. the lack of a simple tone— are really only one. In sum, they express the fact that Being is an indissociable whole. Just as there is only one life, there is only one world.

That is the true presupposition of Kandinskian composition. If the tone of the point and the plane together only form one single tone in which the plane is concealed by the point, then moving the point along the plane and causing its entire tone to change is allowing what was not experienced up to then to be felt. Whereas the entire tone continues to change and to diversify as the point approaches its limits (top, bottom, left or right), the *modification* of this tone reveals the tone of the various regions of the Plane. This modification is the tone of the Plane.

The same analysis holds if one replaces the point with a line or a colour. In each case, the affective modification reveals the difference of the Plane's tone from the element under consideration, and at the same time, it reveals the tone of the element. For, the difference between the entire tone of a

point moving along the plane and the tone of a line undergoing the same treatment brings out the difference between the tone of the line and the tone of the point. The same goes for all sorts of lines, formal complexes and colours. The infinite research programme sketched out here was largely accomplished by Kandinsky, and we have presented a few significant examples of it.

The realization of this programme is the analysis of the elements. Reflecting on this, we see that its point of departure is never an isolated element. The point provides the initial theme for the work of the Bauhaus period, but it is not an element of this kind: it is a point on a plane. The initial given is indeed a minimal given, but even in the simplest case, this given is already double, or to put it better, a complex unity. The method of Kandinsky's analysis is the method of variations. By transforming this complex unity in every conceivable way, the dominant tonalities of these elements are eventually able to appear, such as the point, the diagonal, vertical and horizontal line, the circle, the triangle, yellow, blue, black, grey or green. Each one of them, in turn, gains the upper hand over the others. To be dominant here means to be completely full of life—a life that cannot be divided or separated from itself—to give it a particular but unitary tone that runs throughout it and completely characterizes it, because it is nothing but the way in which this life is experienced at that very moment.

How should we designate this very particular method of variations in a more precise way? Let us call it by its true name—composition. From the outset, this method is already composition: the conjoined positioning of the point and the plane as well as the composition of their tonalities. Composition is employed by moving the point over the various regions of the plane, by painting a triangle yellow, a circle blue or a triangle blue or a circle yellow, etc. All these minute experiments that seek to disclose the tones of the elements are elementary compositions, such that the analysis of the elements is the theory of composition. In the course of its own development, the analysis gradually constitutes this theory. But, we have focused entirely on the consideration of each one of these elements or rather the complex unities—both objective and pathetic—that they form in their original pairings: point/P.P., straight/curve, yellow/triangle, blue/circle, etc. We have not yet seen the organic whole formed by all of these analyses together, an organic whole that is nothing but painting itself—composition. We should now offer a systematic overview of composition, this time taking into account all the elements whose mutual resonances produce it.

Composition

Up to now we have provided some indications about three elements: colours, linear forms and the P.P. Two other elements must be added in order to end up with a complete composition: the object and the matter of the P.P. A brief allusion was already made to this. It concerns the substance forming the Plane's material reality—canvas, wood, various metals, stucco, cement, glass, ivory, etc.—on which the colours are placed. This seemingly simple distinction between the Plane and its 'physical' reality is difficult to grasp, and it alone would require extensive analyses. One could imagine, for example, that the substance providing the material support of the artwork is a real object belonging to the world of perception, while the Plane is an imaginary being and thereby homogenous with the artwork. The work of art is no longer situated in the world but in a radical elsewhere to which it introduces us. Concerning this elsewhere, abstraction has taught us at least one thing: it does not belong to the realm of the visible but to the Invisible. It is Life.

To affirm that the matter out of which the Plane is made is an element of composition is to imply a number of essential theses. As an element, its reality is double; it has an external aspect—this canvas or this wood that we perceive and that the colour covers—as well as an internal aspect, its revelation in a definite tonality. From the latter point of view, it should be said that *matter is invisible*. It is a pathos. This is truly how it enters into the composition, inasmuch as its tone is composed with the tones of colours, forms and the various regions of the Plane. Kandinsky designates matter as an element of composition, because it changes the tonalities of colours and forms as well as their impact on us. A colour will not have the same

radiance or luminosity, depending on whether it is applied to canvas, jute, metal, or stucco and depending on whether its surface is flat or granular, scratched or carved by knife. Contemporary art will use multiple types of material and give them a variety of treatments. These innovations belong to the theory of elements, and their use marks an enrichment of the factors of composition. To the extent that the Plane's matter belongs to the composition, it is torn away from its natural site and cast into a properly aesthetic dimension. This projection accomplishes a kind of magical transubstantiation of things to which we will return later.

All the more strange is Kandinsky's reference to the object as the final element of composition. Wasn't this eliminated from the domain of painting and replaced by the abstract content? This exclusion is so radical that the object cannot even be a 'form' for the abstract content, a form serving to express it and providing a sort of objective equivalent to it. We know that the form is just as abstract as the content. Having become purely pictorial elements, drawings and colours no longer represent objects and only enter into the composition in virtue of their tonality and not through their ability to represent objects. Yet, Kandinsky is categorical: the object can play a role, indeed an essential role, in composition. This is not a provisional concession to a historical moment of painting, when neither the public nor artists were ready to conceive of a purely pictorial composition. On such a view, the objective references still legible in the paintings, for example in Kandinsky's transitional works, would serve to prepare the sensibility of the time for the subsequent completely abstract forms.

This is not the case. The perceived thing is not safeguarded through indeterminate sketches and scattered fragments giving rise to a schematic or stylized representation, its conceptual recognition. The entire, real object with its massive presence, including all of its intuitive characteristics and its full intelligibility, is no longer designated as one factor of composition among others but as its chief possibility and ultimate justification.

In formulating this new principle of composition, Kandinsky is not thinking about his own works or the series of intermediary paintings between representation and abstraction. He is thinking about Henri Rousseau. It is in reference to Rousseau's personal style that he conceives a special type of composition called 'Greater Realism'. This type of painting is timeless and worthy of counting alongside 'Greater Abstraction' among the eternal models of art. The 'Customs Officer's' importance for Kandinsky's reflection on composition does not only stem from his explicit role in the genesis of 'Greater Realism', as asserted in *On the Spiritual in Art*.[12] One

would find confirmation of this, if needed, in the *Almanac of the Blue Rider* which devotes seven reproductions to the Customs Officer, who is thereby the most represented painter in this important document. And we also know that Kandinsky had a Rousseau in his personal collection. What does the Object come to do here?

Abstraction explains this to us. For the Customs Officer, the object only acquires its strangeness and interest by first losing its characteristics in ordinary perception. In traditional painting, if not in perception itself, the embellishments added to the object were thought to be good for making it conform to some canon of beauty and harmony slowly inculcated in the public. The Customs Officer's regard strips away this 'anecdotal idealization of the objective element' and this 'external aesthetic element'. But what is left when the object is then stripped of its practical and cultural substance? What remains is its pure form as an object perceived for itself: its abstract form.

This is how the unique parallel that Kandinsky introduces between abstraction and realism can be understood. The former seems to exclude that on which the latter is based: objective reality. But the objective reality considered by 'Greater Realism' is very particular: it is withdrawn from the aesthetic forms by which we are used to understanding and trusting in the objective world, its conventional beauty and its expected proportions. The object in its nudity thereby allows its pure tone to be heard. Just like a form or a colour that no longer resembles anything, it is 'abstract'. Through processes that seem to be opposed but whose results are the same, in both cases a radical transformation of the external element releases its original tonality. The disclosure and exaltation of this tonality is the shared principle of the two arts. Kandinsky states: 'The greatest external dissimilarity becomes the greatest internal similarity' (245). Just as abstraction destroyed objective reference in order to return life to itself and the plenitude of its pathos, likewise in realism 'it is not the object itself, nor its external shell, but its inner sound, its life that are important' (244).

The object, inasmuch as it is an element whose reality is an inner resonance, gains its membership in Kandinskian composition, and it enters into composition in this way. This resonance allows it to harmonize with other elements: graphic forms, colours, P.P., its various regions and its matter. This generalized harmony is the overall composition of the work of art. The synthesis or unity of all the elements occurs in it. This synthesis is based on their tonalities and the subjective capacity of each one of them, including the object, to blend with all the others in the unity of life—in

composition. On the basis of its irreducible features, this overall composition must now be developed in its full scale and fecundity.

First of all, this composition seems to be spiritual. There is a need, according to Kandinsky, for 'construction upon a purely spiritual basis' (197). This is not the expression of a philosophical, metaphysical or religious presupposition; instead, it is merely a result of the analysis. To compose is to place a specific element in a specific relation to another one. We know that this relation is the initial given. To construct upon a purely spiritual basis means that the choice and use of each element, or primitive complex of elements (Point/Plane, Colour/Form), depend entirely on their tension. This reality is situated in absolute subjectivity. Kandinsky rightly calls this 'spirit' (esprit). The internal comprehension of painting—again, this is not an ideological choice—leads Kandinsky to reject the nineteenth century's 'materialism'. From the perspective of painting, materialism must also be understood as the attempt to base art on an 'external' touchstone, on the material world. The huge setback of this attempt—which can be seen in realism, naturalism, academicism, official art as well as in impressionism, cubism, etc.—entails a complete reorganization of the categories for thinking about art: the substitution of the invisible life for the material world as a principle of aesthetic creation. In this way, the destruction of figurative painting and its objective basis seemed for Kandinsky to be the announcement of an intellectual and spiritual revolution that would be enacted in the twentieth century.

A 'spiritual' composition is a hidden composition. Here we can see the decisive pictorial signification of what one might be tempted to regard as a mere matter of conviction or belief. As long as composition is based on the objective givenness of the world, it respects its continuous substantiality. The world is without a lacuna. It does not cease or get interrupted in any way. However neutral its components (colours, lines and figures) may be, they compose a tight fabric that does not allow any room for a void. It is a homogenous whole with no external limits or inner fissures, spreading out in all directions. This continuous, unbroken thread is reproduced by all painting whose principle of organization is the world. No form of this kind is unrelated to the other ones. The continuum of the work responds to that of the world. The huge, unfailing coherence of the world ensures that the artwork's being will never change into non-being. What a reassuring picture of the world!

On the pictorial plane, this type of composition that always wants something to be placed next to something else without a breach of the

continuum is called filling (*remplissage*). In the terminology of the workshop, it is called the sauce. Figurative painting was only able to avoid aesthetic collapse by constantly tricking representation. It did not represent the world as it was given to us, with its immediate and unfailing availability; instead, it was organized as a canvas whose elements were carefully chosen, selected and calculated to produce a specific effect. What was the nature of this effect? What was the principle behind this choice? It was never the world because the world cannot make a selection of its components or predict its results. In truth, the principle behind all aesthetic composition is identical to its effect: the tone of elements reunites and defines the tone of the composition. But, if the nature of the composition's tone is subjective in nature from the outset, it has nothing to do with the laws of the world, with the objective connection between forms and colours, and with the arrangement of the spectacle that painting was believed to represent. The most important feature of this world—the ontological plenitude of an unshakable being that never falls into nothing-ness—is of no use to it.

When the external connection of forms ceases to be the principle of composition, then this connection can disappear. In its absence, a new type of composition arises. It no longer depends on the continuity of a visible order and no longer seeks to justify its elements on the basis of this order or by its place within it. Abstract art offers the new appearance of forms attached to nothing, disconnected graphics, colours used randomly; it is painting without obligation or sanction. The disconcerted spectator believes it to be a matter of just anything whatsoever, and in the best of cases, the spectator claims just not to understand it. If one goes back to the masterpieces of the Parisian period, how can one fail to be struck by the hitherto unrivalled tone of this haughty and casual art, by its deliberate and evident disdain for all references? Pure forms move around freely, entirely preoccupied with themselves and, in being self-satisfied, they are indiffer-ent to everything that surrounds them. Where does their certitude come from? And why do we experience it, in turn? Why are we assured of their well-founded extravagances, and why do we share in their audacity and jubilation?

Here is the reason—the pathos of each one of these forms justifies it, produces it and first provides the power to do it. Inasmuch as we are this pathos that this form seeks, we form it and share in its growth or its strangulation, its weight or its excess, its sovereign magnificence. But, if the pathos of each form justifies and engenders it, then the question of

composition, having become a question of the pathetic determinations that govern a form and determine what it is, would no longer be satisfied with a general response. We noted that if forms are united in spite of their exteriority and their spatial indifference, this is due to their tonalities. But the possibility of joining all conceivable forms by referring them to the invisible site of Life where they live their true life does not yet explain why an artist chose to place one form next to another one—and why Kandinsky chose the force of this triangle to break into an invincible circle. Is it not due to the tonality of each one of its elements?

We should be aware here of an enigmatic remark in the 'Cologne Lecture'. Speaking about the danger of the experimental use of abstract forms, Kandinsky states: 'Every form has an inner sound which falsely simulates an inner necessity' (399; tr. mod.). In what way does inner necessity differ from the inner sound? Is not the inner necessity leading the artist to select a form the form's tone? What is construction upon a purely spiritual basis besides the use of pictorial elements in terms of their pathos? Does Kandinsky's major thesis about aesthetic creation—the radical determination of the artwork's form by its abstract content, that is, the principle of Inner Necessity—signify anything but this?

But, if each form is brought into light by its pathetic value, the question is whether or not a form belongs in the place where the artist's hand pauses to trace its contours. Its value for life and its attractiveness to the eyes of the artist are certainly due to the fact that it is always justified by the emotive power with which it is invested. In this sense, one can say that every form has its own pertinence and its own law. The more the form is abstract and freed from every extrinsic meaning, the more its tone resonates in its depth and purity, and the more its own value and lawfulness become evident. Forms are thereby entities that 'have their own existence, their own influence and effect' (165). For this reason, Kandinsky writes magnificently and will illustrate in a striking way in the Parisian period that 'all these forms are citizens of equal status in the realm of expression' (166). That is why 'the artist may utilize every form as a means of expression' (175).

This is the case so long as it is dictated by Inner Necessity. Every form is good and justified on its own: by the pathos which it expresses. According to Kandinsky's general thesis, form is the expression of content. But this content is only the content of the form. Between a specific form and content, there is a tautological relationship. The artist does not want to express this specific content of the form but a much more general pathos that is the artwork's theme. And the artist does this by recourse to the

arrangement of a group of forms—by composition. Every form placed in the composition maintains a double relation: first, with its own pathos that allows it to be used; second, with all the other forms that objectively compose the work that we see and subjectively its abstract content, whose overall pathetic unity and invisible reality is conferred by the artwork. Inner Necessity summons the pathos of each one of the forms in virtue of its ability to submit to and contribute to the arrival of the overall unity's pathos. Inner Necessity requires this pathetic compossibility of forms in their submission and suitability to the theme of the work.

To trust the tone of a particular form, instead, and to be duped by its beauty and value, is to invert the order of things. It is to establish as a principle of painting what is actually dependent on it. It is to fall prey to the illusion whereby every form's inner resonance 'falsely simulates an inner necessity'. This is why, in spite of the resonance that gives every form its eternal value and in spite of its membership in the abstract realm, no form is good or bad in itself but only in virtue of its relation to a larger aim and higher unity.

Kandinsky studied the relationships among forms in a systematic way. Each form has its own value, a consubstantial tone. But this tone can vary. The first change is tied to internal conditions. Since every form is composed of parts, the variation of one part reverberates on the tone of the whole. It is thus possible to act on the whole through very small changes. In addition to these organic changes, other changes can result from changing the form's orientation, either in relation to other forms or the P.P. The form thus has a flexible nature, making it 'as fragile as a puff of smoke' (170). Having established that composition begins with each form's organic internal structure as well as its placement on the P.P., we can now turn to the overall relations of formal configurations.

From this point of view, composition consists of the subordination of all the forms to a principle form that communicates its own tone to the entire work. Two cases should be distinguished here: simple and complex composition. In simple or melodic composition, the dominant form is clear and simple. *On the Spiritual in Art* provides the examples of the mosaic 'Empress Theodora and her retinue' in Ravenna's St. Vitale Church and Cézanne's 'The Bathers' in Philadelphia. In these two artworks, the ascendancy of one single, simple form is marked by its repetition. Echoing throughout the entire work, the tone of the privileged form becomes more audible at the same time as it grants a rhythmic quality to the whole. Kandinsky calls this type of composition with a repetitive and obvious formal construction

'rhythmic', even though the concept of rhythm has much broader applications.

In complex or symphonic composition, a number of dominant forms are mixed and combined, creating a subtle network of similarities and differences. In contrast with the legibility of a simple composition—of which there are abundant examples in classical painting—a complex composition can only show the complicated network of structures on which it is constructed little by little. This complexity gives the spectator the enjoyment of carrying out an endless quest. In spite of their abundance and differences, all of these forms in turn submit to a single dominant form, whose affective recognition demands the unfolding of a certain temporality. This latter form will either be called clear or concealed, depending on whether it is felt as the tone of a visible graphic or only as the result of fitting them together into a configuration. The echo of this configuration is experienced within us before we can follow the thread that seems to tie them together and where we think that we have discovered the secret behind their power.

In order to understand why symphonic composition is more fecund, here one should recall Kandinsky's remark that what is concealed acts more strongly than what is clear. This is not just due to its complexity, which is synonymous with its wealth. An easily spotted form that is more evident, for example, due to its repetition, leads us to believe that it, as it is given to us in its objective appearing, is what captivates us. However, as long as one is limited to their sensible beauty, forms of this kind quickly lead to boredom or even disgust. Their organization does not avoid the gratuity of everything external and leaves us 'cold', as does exteriority itself. A form only acts through its resonance. Symphonic composition destroys the illusion of simplicity that visible things so easily produce. It requires us to return to the site of this resonance, and in the case at hand, to the concealed tone of the overall invisible form.

In an impressive synthesis, Kandinsky summed up the results of his investigations of formal composition, which he calls the purely graphic counterpoint: 'Thus, on the one hand, the flexibility of the individual forms, the so-to-speak internal-organic changes they undergo, their direction within the picture (movement), and the emphasis upon the juxtaposition of forms that together constitute the larger formal patterns, built up out of groups of forms; the juxtaposition of individual forms with these larger groups of forms, which makes up the overall composition of the whole picture; further, the principles of consonance or dissonance of all those parts mentioned, i.e., the meeting of individual forms, the limitation

of one form by another, likewise the jostling, the confluence or dis-memberment of the individual forms; similar treatment of different groups of forms, the combination of the hidden and the revealed, of the rhythmic and the arhythmic upon the same surface, of abstract forms—on the one hand purely geometrical (simple or more complex), on the other, indescribable in geometrical terms, combinations of delimitations of forms one from one another (more/less strongly), etc., etc.—all these are the elements that constitute the possibility of a purely graphic "counterpoint" and will give rise to it' (171).

The graphic counterpoint is immediately followed by the counterpoint of colours, and this counterpoint is itself double. It involves the com-position of colours and their tones, on the one hand, and the composition of the colours and the forms to which they are always joined, on the other hand. The composition of colours finds its necessary and sufficient basis in the theory of colours. Again, we must emphasize that this knowledge which has always been practiced spontaneously cannot continue to rely on the agreement of complementary colours. The new harmony that Kandinsky has in mind and that, to him, best corresponds to the spirit of modernity is a harmony of contrasts. This is more suited to increasing the energies of Life. The juxtaposition of red and blue favored by the German and Italian primitives and also found in popular sculpture indicates an investigation that goes beyond the 'physical' basis of complementarity and the traditional harmony of colours. It is attentive to their spiritual reson-ance and the new laws that only take these resonances into account. These laws are the basis of the pictorial counterpoint. They are ultimately equiva-lent to the laws of life, as direct expressions of its passion, creative violence and exaltation. The pictorial counterpoint is the strict parallel of the graphic counterpoint, and Kandinsky celebrates its lyrical and dramatic power in the same way: '"Permitted" and "forbidden" combinations, the clash of different colours, the overriding of one colour by another, of many colours by a single colour, the emergence of one colour from the depths of another, the precise delimitation of an area of colour, the dissolution of simple or complex colours, the retention of the flowing colour area by linear bound-aries, the bubbling over of the colour beyond these boundaries, the inter-mingling [of colours] or [their] sharp division, etc., etc.—all this opens up purely pictorial (=painterly) possibilities in an infinite series stretching into the unattainable distance' (194).

All that remains, then, is to associate this counterpoint of colours to the counterpoint of graphics ('the counterpoint of the art of White and Black')

in order to discover the 'purely pictorial counterpoint' that defines painting in terms of the possibilities of composition. The unity of these two counter-points—forms and colours—shows that the principle of Kandinskian composition is purely abstract composition. As long as one is limited to the unity between colours and forms, one could easily imagine that this unity should be understood on the basis of the objective appearances to which these elements are commonly reduced, in short, a visible unity. This naïve external unity ultimately means that each form can be attached to any other form and that colours are arranged on their own. But, it can no longer function when it comes to heterogeneous and irreducible elements. Only the similitude or identity of their resonance can tell us that the acute angle and the yellow *are subjectively the Same*, in spite of their objective differences. What allows for the unity between pictorial and formal coun-terpoint also ensures the inner unity of each one of them. It is through their tone, as we have already shown, that graphics enter into a true, internal relation, and the same holds for colours. The unity of every par-ticular type of composition belongs to the same order as the unity of the whole composition; it is an 'abstract', subjective unity. We are now in a position to understand Kandinsky's ultimate and huge ambition.

If elements as objectively different as formal configurations and colours are nevertheless identical or homogenous in their subjective reality, the following question should be raised: Is not this situation that makes painting possible and that we have explored largely within the domain of painting capable of being extended to all the arts and the relations between them? These various arts rely on a variety of means: sounds in the case of music, coloured forms for painting, words for literature, poetry and drama, movements for dance, etc. But these different means are elements in each case. Let us suppose that the theory of elements demonstrated with respect to pictorial elements is also valid for the elements of the other arts: for sounds, words, movements, sculptural and architectural forms as well as for those of painting. Then, we would have to say that these elements, however different they may appear externally, all have a subjective reality—a tone—that makes them, if not identical, at least similar and homogenous. And Kandinsky does say this: 'The means belonging to the different arts are externally quite different. Sound, colour, words! . . . In the last essentials, these means are wholly alike' (257).

The consequences of this thesis are immense. The subjectivity of the pictorial elements was the basis of their unity—the unity of colours was the colour counterpoint, the unity of forms was the graphic counterpoint and the unity between forms and colours was the purely pictorial counterpoint. In the same way, the subjectivity of the heterogeneous elements from the different arts can establish their similarity in spite of this external heterogeneity. The synthesis of all the arts is the ultimate counterpoint in which

all of these energies will converge in order to constitute the entire creative activity of human beings: monumental art.

Kandinsky's main idea, even his obsession, was monumental art. Before examining the concrete realizations of it that he was able to procure—including the ones that he found around him and took as realizations of this vast project—some theoretical considerations should be added to its definition. By affirming a shared, subjective content for the different arts, abstraction ensures both the unity and synthesis of the arts, for Kandinsky. This ontological unity does not suppress the reality of their differences in any way. These differences are conveyed externally through the diversity of elements used, differing from one another as a colour differs from a sound, a drawing or a movement. At the same time, the inner reality of these elements is diversified as well, because this inner reality is nothing but the way in which each one of them is experienced. This 'way' is different in each case. Just as each colour is separated from all the others through its tone, the same holds for each form, sound, movement, or word. In order to constitute the unity of all these elements, subjectivity can be nothing less than the principle of their diversity and individuality as well.

Kandinsky says that there is an essential element within each colour that no word will ever be able to express due to the absolute particularity of this colour within the spectrum of neighbouring tones. The possibility of obtaining this particular resonance by means of another art is what makes monumental Art possible. It is the rigorous, expressive transfer from one art to another one. The recourse to a second means of expression borrowed from a different art—a musical sound, a movement or a word—adds 'something more' to the colour's primitive resonance due to the nature of this complementary element: its nature as a sound, a movement or a word. That is why it is doubtful that there is one identical resonance from one art to the other; instead, a more general resonance continually enriches itself as it brings about the synthesis of heterogeneous elements from different arts. Through this synthesis of ever more diverse and refined tones, Kandinsky's insight is that it is possible to obtain 'more subtle and immaterial inner vibrations' (257; tr. mod.).

Without a doubt, the idea of monumental Art was suggested to Kandinsky by Wagnerian opera. The grandiose conception of a *Gesamtkunstwerk* involving all the registers of sensibility had to fascinate an artist whose main preoccupation was to multiply and to deepen the forms of expression that art can offer to humanity. It is precisely this demand concerning the meaning of art for the individual's life that led Kandinsky to return to his

youthful admiration for Wagner but to be severely critical of it. In Wagner's conception, opera is a synthesis of the arts. By bringing together drama (which is expressed either in words or else poetry), music and dance—not to mention the forms of the decorations, the colours of the clothes, etc.— into one single spectacle, it aims to end up with a more significant and powerful effect through the addition of all these means. But this 'addition' is precisely what Kandinsky challenges, and the source of his reluctance leads us back to the principle of abstract art. The synthesis that abstraction seeks would only be an inner synthesis, but neither opera nor classical ballet produces this.

Let us consider movement, for example. It can be a representation, such as the representation of a real event occurring in the world like a difficult project accomplished together, a battle or an erotic scene. It can also be offered as an illustration of a psychic state: effort, violence, love, despair, etc. In all of these cases, the content of the work is not the tone of the movement as a movement or as it is accomplished; instead, it is the tone of what the work is supposed to represent: this collective work, this battle, this erotic scene, this despair. In keeping with Kandinsky's rigorous terminology, one should say that the meaning of this type of ballet is external. It is external to the abstract reality of the work—its means—and external to the subjective relation of the movement—its tone.

The representation of a battle or a feeling of despair also has its own tone. Such tones are usually awakened in us when these events take place around us and can be experienced by reading a newspaper article relating these facts. As long as the meaning of a ballet remains external in this sense, its choreography teaches us nothing. The tones accompanying it within us are the tones provided in the ordinary course of things. A strictly representational art would have no creative power; it would not even be an art. A ballet can only be creative, if the source of its tones is the tones of the movements themselves—the abstract movements—that lack any objective meaning and are reduced to their pure subjectivity, that is, to their tone. Because the emotions tied to the performance of a ballet are the tones of the movements out of which it is composed, aesthetic creation is the creation of these movements. It only concerns them and not the theme, motifs, situations or feelings that this ballet is said to represent. This is also the reason why the motor tonalities of a dance can unite immediately with the tonalities of words, colours and musical sounds. Like them, motor tonalities are invisible and are capable of producing one single emotion in a purely subjective composition: in life.

An 'external' ballet would not be strictly limited to its abstract content and could only maintain an 'external' relation with the other aesthetic elements (sounds, words, etc.). But, such a relation would no longer entail what the synthesis of the arts seeks: a 'more', the growth of what was obtained hitherto by only one of them alone. That is Kandinsky's reproach against classical opera. To join the representation of an extreme situation with the *fortissimo* of music underscoring this pathos is to find a type of addition that defies the ordinary laws of arithmetic. Here one should not say that $1 + 1 = 2$ but that $1 + 1 = 0$. The relation introduced between the heterogeneous elements of different arts should not be an external relation between the external aspects of these elements—for example, between the *meaning* of a heroine's gesture representing her despair before the cadaver of her lover and the *meaning* of an orchestra's *fortissimo* aiming to amplify this same despair. There must be an inner relation between the tones, in this case between the movements and the musical sounds. Abstraction is not only the condition of the possibility for the synthesis of the arts; it alone can keep it from succumbing to the search for artificial effects, of which the history of lyrical art provides all too many examples.

We can now understand better that the monumentality of art is a call for help from all its traditional forms, which up to then played their parts in a dispersed order. By adding the powers of music to those of words or dance, one wants to arrive at increasingly complex modes of expression. Kandinsky dreamed of a theatre that would be an 'abstract stage synthesis' encompassing painting, sculpture, music, poetry, dance and in which architecture would also play its part. From this dream came 'Yellow Sound'. This 'stage composition' is a sort of ballet where the unusual characters—Five Giants, some 'Indistinct Beings', A Child, A Man, 'People in flowing garb', 'People in tights', a Chorus 'behind the stage'—move about senselessly, are dressed in bright colours, are placed under harsh lights, and hear the sound of voices (which pass quickly from high to low) coming from who knows where. This revolutionary show is consistent with the constant aim that motivated a whole series of creations: *The Almanac of the Blue Rider*, the décor of Modest Mussorgsky's 'Pictures at an Exposition', the large mural compositions, in particular, for the music hall for the 1931 International Exposition of Architecture in Berlin whose walls were covered with abstract ceramics in an effort to produce a pictorial equivalent to music. All these attempts, which were usually overwhelming successes, are joined to the broad historical project of the Bauhaus: to join the different arts through an architecture that integrates them all and, more broadly, to produce a

group of collective works capable of renewing the social, economic and cultural life of the epoch.

Yet, we have shown that Kandinsky's dream for the monumentality of synthetic art does not rely on a mere increase of the number of means used. The Bauhaus programme was that the distribution of light and the use of space in a building with mural paintings and sculptures added to the mere functionality of the architecture. It gave the architecture an ability to respond to the multi-faceted call of human sensibility and allowed it to exercise its potential richness. But, as the result of overturning the grand-iloquence illustrated by the Neo-classicism of the 1830s, Kandinsky under-stood that the synthesis of the arts could only be subjective. It draws the single but differentiated principle of its constructions from the force of pathos, its inner conflicts and its fate. Kandinsky's abstraction works dir-ectly on the affective tonalities; it defines, discloses, sharpens, overlaps and combines them; it scrutinizes and brings out their history together with the secret transformations that they make. The monumentality it builds is the monumentality of life whose full powers are restored. Aesthetic creation is nothing but the construction of this inner monumentality.

In each one of the investigations in which he sought to give a concrete formulation of the synthesis of the arts, Kandinsky puts this process of the total development of life to work. This effort is not directed towards a visible solution. The magnitude of an artwork only results from subjec-tive forces. If these forces happen to be lacking, the edifice will crumble. The colossal works of fascism, socialist gigantism, and, in our eyes, the syncretism of the post-modern era are all the unfortunate testimony to this inner void. Because the exaltation of the powers of life can only be produced in life, life can do without these pretentious manifestations. The size of the material means does nothing for it. This can most surely be found in the small but very precise experiments where Kandinsky puts the elements of one single art or two different arts into relations of belonging or internal reciprocity. This is how he illustrated the stories of the poet Remizov and composed his 'Sounds' collection, an admirable example of 'synthetic' work in which he decorated some of his own poems with coloured wood and other ones in black and white.

With the subjective unity of objectively different elements, we are brought back to the sources and principles of abstraction. We should indi-cate briefly how these principles develop a monumentality infinitely more monumental than the one that realistic art would seek to attain, and, frankly speaking, could not even conceive. Every objective construction

emerges in exteriority and is submitted to its laws. The concrete laws of the world of perception place restrictive conditions on their existence: their spatio-temporality, their 'physical' properties, their causality, their purpose and their utility. Under the effect of these constraints, the natural world seems repetitive and dull. In such a world, even the most ambitious project, one which challenges its laws, remains prisoner to them. By pushing their limits, it only renders the imperatives that it seeks to break more apparent prior to collapsing under them. If the representations of the tower of Babel move us, this is ultimately because they symbolize the metaphysical condition of a life that is foreign to this world and that would like to be released from it.

This is the miracle of abstract painting: it constructs the unlimited monumentality of a work that no longer has a foothold in the visible world, that ignores its rules and does not seek anything from it, neither aid nor sanction, and that emerges with the pure force and infinite certainty of life. Withdrawn from the weight of things and from the inertial systems in which things are held and have their limited possibilities circumscribed, the work of art proceeds from the imagination. To imagine is to posit something other than what is and what is there right in front of us—something other than the world. To imagine is to posit life. Inasmuch as it proceeds from the imagination, is not the work of art an image, the image of things, a copy or reproduction of them? Or, if this conception seems altogether too trivial, instead of being the image of this or that particular object, is it not the image of the world: the *Imago Mundi*? This *Imago* is the appearing of the World, its emergence into the light, its ecstatic explosion, in short, the World as such. By returning to its Greek origin in its effort to escape from the platitude of realism, the objectivist interpretation of art still has nothing to do with life or with 'abstraction'.

It is the nature of great revolutions not to be limited to the sphere of the phenomena from which they are born. Their effects spread over everything that exists. Such is the case with Kandinskian imagination: it overturns our concept of the imagination. Is not the product of the imagination an image, and is not the art stemming from it imaginary? The incredible response to this question in the article 'On Stage Composition' is negative. The imagination belongs to life; it develops there entirely and does not leave it. It does not produce a world before itself with luminous images and phenomena that shine—nor does it produce images that would be the reproduction of these phenomena, copies serving to replace them. The imagination is immanent, because life experiences itself in an immediacy that is never

broken and never separates from itself; it is a pathos and the plenitude of an overflowing experience lacking nothing. What, then, does it imagine? What does it mean to imagine in this case?

The imagination brings into being what has not yet taken place in being: hitherto inexperienced tones, impressions, emotions, feelings and forces. The imagination is indeed creative, even in a radical sense that gives it a positivity that was not glimpsed by classical thought. Art's creative imagination does not give us decoys to contemplate, for example, the depth of a third dimension where there was only a flat surface. It has ceased to be, according to Kant's famous definition, the faculty of representing a thing in its absence. It has become the magical power of making something real. What type of thing is it then? Where and how does the imagination bring it into existence? We have already answered this: it gives a thing life, as a modality of life. What it creates is in fact this new modality. The movement of the imagination is thus nothing other than the movement of life, its internal becoming, the tireless process of its coming into itself, an arrival in which it is felt in ever more vast, differentiated and intense experiences.

The article 'Of Stage Composition' refers to this process as the aim of art and, in particular, as the mission of monumental art. At the same time, the prize of this analysis is that this process is described with precision and allows us to enter into the inner workings of the concrete imagination of art itself. A particular modality of life—differentiated, refined, hitherto inexperienced in this acute form—is what Kandinsky calls a 'vibration of the soul'. The various 'means' defining the different arts correspond to a series of potential modifications of the soul, each one being the tone joined to the development of one of its means—such as a graphic, a musical sound or a movement. Abstraction has established that the subjectivity of this tone allows the objective heterogeneity of the elements to be surmounted. Through them, it produces a unique effect, all the more sought after because it results from the combination of more numerous and elaborate means. The interference between the means is played out within each art—in painting, between graphics and colours—before finding its greatest degree of complexity in the synthesis of the arts. Every work is a successful, adequate group of tones, whose repercussions can be either limited or increased depending on their subjective place in the composition. Kandinsky observes: 'A certain complex of vibrations—the goal of a work of art' (257). In producing works, art thus does not aim for anything but producing this complex of vibrations, the fulfilment in and through life of its own goal. It is, according to Kandinsky, 'The progressive refinement of

the soul by means of the accumulation of different complexes—the aim of art' (ibid.).

To say that the imagination is real and subjective, that it works in and through life, and that it is the proper work of life, is to say that the work's vibrations are not the result of the external aspect of elements on the soul, as if they were the passive traces of an action coming from the world. The awakening of tones is based on the tones, each one through its own dynamism can call forth another one, summon it, change into it or make it exist. Kandinsky writes: 'This vibration of the receiving soul will cause other strings within the soul to vibrate in sympathy. This is a way of exciting the "imagination"' (258) and then 'strings of the soul that are made to vibrate frequently will, on almost every occasion other strings are touched, also vibrate in sympathy' (ibid.). Which vibration is acting now and why does it awaken this precise tone rather than another one? How can this association, which philosophy traditionally refers to the imagination, be explained (here, of course, it is a matter of explaining a particular association, the connection between this vibration and some other one)? Why, moreover, is the artwork an organic whole, a pathetic unity rather than a cacophony, an unintelligible and meaningless group of tonalities assembled by chance?

These tonalities are not separate, autonomous unities, capable of maintaining external relations between one another, as is the case in the crude conception that empiricism has about our 'psychological' consciousness, which is actually only a representation of life. The aesthetic element has a dual aspect, both external and internal. This means that the internal—the tonality—cannot be understood in terms of the external. It does not arise from a horizon and cannot be determined or identified through a horizon. It overflows the exteriority of the world. Tonalities are the vibrations of the soul, of one and the same power going where it wants and knowing where it wants to go. The associated tones, mysteriously joined in the artwork, are joined together by life; they are the pathetic modalities of the process in which life seeks itself as well as the reality of the elements of the different arts that are given externally to us. This single process runs throughout the elements, allows them to be harmonized and ultimately synthesized in monumental Art. Kandinsky explains: 'The internal, ultimately discoverable identity of the individual means of different arts has been the basis upon which the attempt has been made to support and to strengthen a particular sound of one art by the identical sound belonging to another art, thereby attaining a particularly powerful effect' (258-9).

The imagination at work in artistic creation cannot be reduced to the power to form images, just as the artwork itself cannot be reduced to images or the imaginary. Images are life in its ceaseless effort of internal self-differentiation. This calling into question of the power of artistic creation is also a calling into question of all the traditional concepts of the theory of the arts. All of the points above are affirmed with incredible concision and power in the essay currently under discussion:

'Viewing the question from the standpoint of the internal, the whole matter becomes fundamentally different.

1. Suddenly, the external appearance of each element vanishes. And its inner value takes on its full sound.
2. It becomes clear that, if one is using the inner sound, the external action can be not only incidental, but also, because it obscures our view, dangerous.
3. The worth of the external unity appears in its correct light, i.e. as unnecessarily limiting, weakening the inner effect.
4. There arises of its own accord one's feeling for the necessity of the inner unity, which is supported and even constituted by the external lack of unity.
5. The possibility is revealed for each of the elements to retain its own external life, which externally contradicts the external life of another element.' (263)

As always with Kandinsky, these bold claims are derived from very painstaking work, from a humble return to the 'things themselves'. This is what the analysis of the premises of the conception of monumental art will show.

Music and painting

The conception of monumental art issued from a reflection on music and its relations with painting. No one was more aware than Kandinsky of the specificity of each particular art, each of which has its own means and thus a content that it alone can express. As such, the matter of music is sound, whose sensory content differs from the colours and forms that are the 'content' of painting for traditional thought. Due to this ontological difference between their material substances, music and painting are different arts, with their specific means and their own development.

If, from the perspective of the synthesis of the arts and monumental art, one considers the relation of music to painting on the aesthetic plane, it is clearly a particular case of the more general problem concerning the relation between our senses. Humans are the inhabitants of this world, and our being-towards-the-world is first accomplished through the use of our senses, in particular, sight and hearing. One very general problem which the relation between the arts cannot avoid concerns how these different senses delivering different content—in the one case visual, in the other case sound—can open nonetheless onto one single and same world. On the philosophical level, this problem still remains a question but it is one that can be resolved. We relate to things through our different senses, but we only live in one single world. We do not live in one world that would be visual, another which would be sonorous, and another which would be made up of smell; instead, we live in one and the same relation to what we see, touch, feel and hear.

If, despite the diverse impressions that stitch it together into an uninterrupted framework, the world is one, it must be one because the different

senses providing our access to the world are themselves one, one and the same unique power with a plurality of modes of fulfilment. This single power is our body. What does its unity consist of? What makes seeing, hearing, touching and feeling the same, in spite of the variety of distinct experiences? It is their subjectivity. There is no seeing that does not experience its seeing, no hearing that does not experience its hearing, no touching that does not immediately experience itself and does not coincide with itself in the very act by which it touches anything whatsoever. On the basis of their radical subjectivity, all of these powers are one; one and the same force sees, hears and touches. Because our true body is a subjective body, it is the unity of all the powers and all the senses comprising it. Because all these senses that offer the world are one, the world, in turn, is only one and the same world.

There is a metaphysical answer to the question as to why the various sensory worlds are based on one single world: this one sensible world in which we live is the exact replica of the unity of our sensibility in the subjectivity of our body. This answer contains the solution to the aesthetic problem of the synthesis of the arts and, in particular, of music and painting. If the audible and visual worlds can actually be the same, it is because in sound and the visual as such there is a common element present in both of them that can put them into relation and even allow them to coincide, in spite of their specific irreducible qualities. It is not difficult, then, to understand that the phenomenology of bodily sensibility described above is the philosophical foundation of Kandinsky's theory of abstraction as well as his theory of elements.[13] If every element has an external aspect distinguishing it from all the other elements, and an inner reality revealing it to be similar or identical to the others, this is because the ultimate power of feeling contained in seeing and hearing and thus in every visual and audible sensation is the feeling in which this sensation is immediately experienced. This pathetic subjectivity defines our original Body as well as our being, our Soul.

Kandinsky did not discover the principle of the synthesis of the arts as we just did, by reflecting on the metaphysical problem of the unity of our sensations; instead, he discovered it by following his intuitions as an artist, with respect to the aesthetic problem presented by this synthesis. Abstraction is thus the possibility of this synthesis. Music played a key role in the genesis of the concept of abstraction. At the time of the great 'spiritual turn', Kandinsky was shaken by the crisis of objectivity in all the domains of knowledge and, in particular, the domain of painting, and interrogated

the new 'content' that art should aim to express. Music came to mind as the model to imitate. By following its lead, painting would escape from the impasse in which it was bogged down and discover its true purpose at last. Paradoxically, music provides the answer to the question concerning the fate of painting: 'What is its object and what reality must be painted?'

From its outset, music is characterized by the fact that it shows no interest for what we call the world, that is, the external world of ordinary perception. If one were to assign painting the task of representing the world and to define it as an imitation of nature, such a definition would immediately seem like non-sense when applied to music. In those rare occasions, as with imitative music, where it did seek to reproduce natural sounds, its results were so laughable, so superficial, so limited and vain, that their sole effect was to reawaken music's consciousness of the reality expressed in both its ordinary and extraordinary works. Like all art, music does indeed have an 'external' element, namely, the sounds that it uses. But, surprisingly, this external element that affects us from the outside like any other sensation (which, for this reason, I called 'representative') does not refer to an object; its 'content' does not belong to the world and cannot be produced by the world. Music, Kandinsky says in a striking formula, is 'the most immaterial art'. But what can it 'represent' then?

It is impossible to remain silent here about the influential role of Schopenhauer's thought on the European intelligentsia at the end of the nineteenth and early twentieth century, in particular, on its most important creators in the domains of literature, theatre, opera, music, painting and film. 'Expressionism' is unintelligible without him. As for Kandinsky, this influence exerted itself in two ways. Directly, *The World as Will and Representation* was, with the delay of a half-century, the bedside book of the cultivated public of the times.[14] Indirectly, it occurred through the intermediary of Wagner's opera and music. Schopenhauer marks a complete rupture with Western philosophy which, since Descartes, sought to provide a theory of knowledge, that is to say, an explanation of the relation between the human being and the objective world, a relation resulting in science and 'materialism'. By the latter term, Kandinsky understands the type of thought that only recognizes external being as being real. Against this view, Schopenhauer claimed that the world is only a secondary representation, an illusory double and an objectification of the true reality of Being. This non-objectifiable, inner and hidden reality is what he calls the Will, and it is only another name for life.

113

From this sharply divided metaphysics where the invisible Will is the principle of every thing and where every visible thing is devalued as unreal and reduced to a supernatural appearance, Schopenhauer deduces a theory of the arts dividing the arts into two groups. The first—comprised of most of the arts: literature, poetry, painting, sculpture, architecture, etc.— has the goal of representing the world. But, it does not represent the world in terms of the incomprehensible diversity of its changing and perishable phenomena. Those phenomena result from the refraction of Ideas through the prisms of space and time. The Ideas are their womb, and they are only a monotonous reproduction of them. The Ideas are the immediate object-ification of the Will; art allows us to see them, in and through their multiple, evanescent sensible appearances. Through this first group of arts dedicated to the visible, aesthetic experience thus provides us with mediate metaphysical knowledge (through these Ideas) of the essence of things—of the Will whose entire objective universe has now become intelligible through the initiatory regard of art.

The second group of arts is limited to music. Music differs completely from the other arts in that it has no relation to the world, either to the Heraclitean flux of the sensible world or to the world of Ideas serving as its eternal archetype. In both the sensible and intelligible worlds, the Will is objectified. It does this in order to come into the light and to show itself. Objectification is the visible becoming of what originally and in itself stands in the invisible. Literature, poetry, painting, sculpture and architecture seek the essence of things there where they can be seen. Giving themselves to be seen as either sensible or intelligible phenomena, things are never given in themselves, that is, in the radical subjectivity of invisible Life. The metaphysical power of the supreme art of music is that it immediately reveals this nocturnal Will—'immediate' means without the mediation of objectification, the visible appearing where life only displays itself by hiding its ownmost and most intimate being. Here Schopenhauer formulates a surprising proposition—one in which we can also understand what God is: 'Music could exist even if the world did not exist'.

It must be asked, 'What is this Life which does without the world, and how does music reveal it?' For Schopenhauer, life is a Desire that no object can satisfy, an endless desire that is destined to be unsatisfied and unhappy. The existence defined by the disappointment of desire is Suffering. In the phenomenal world, a series of traps arise for the human being, leading one to believe that one will engage in some sort of activity with some sort of being and find the happiness that one seeks. Because no object is suitable to

Desire, satisfaction can only occur in the negative, as a merely provisional suspension of suffering. Once the inadequacy of the object is discovered, Desire arises again along with dissatisfaction. To suppress desire would be to destroy the basis of all things, the essence of life's drives, and this is impossible. Even suicide is still an affirmation of the relentless Will.

How can music, without any reference to the world and without the means of any representation, reveal the intentions of this universal suffering? This is done through the use of sounds in an order whose aim will be to reproduce the history of our unhappy existence that, throughout the long sequence of disillusions and chagrins, aspires for a state no longer torn apart by lack, for relief. The revelation of our suffering existence occurs through melody. By distancing itself from the fundamental tone, the melody gives rise to an anxiety comparable to an awakening desire. It runs through all of the harmonic intervals marking the tribulations of an existence continually reaching out towards something that escapes its grasp. With its ultimate return to the tone on the final chord, it symbolizes either the realization or mere abolition of desire. Music has the miraculous ability to disclose the immense domain of our feelings with their many nuances. Music's expressive power consists in the infinitely varied way— fast or slow, easy or troubled—by which it allows this return to the native Soil free from trouble. Schopenhauer writes: 'As rapid transition from wish to satisfaction and from this to a new wish are happiness and well-being, so rapid melodies without great deviations are cheerful. Slow melodies that strike painful discords and wind back to the keynote only through many bars, are sad, on the analogy of delayed and hard-won satisfaction'.[15] Schopenhauer goes on to explain in detail how specific musical techniques have the power to signify our most intimate existence, for example, how the mere change from the major to the minor third is enough to give rise to a feeling of anxiety that the return to the major can then dissipate. The passage from one tonality to another is like tearing way from a world and resembles death.

One of Schopenhauer's most important theses concerns the generality of music. Music immediately expresses our life, that is, our feelings. A feeling can never be assimilated to an event in the world, to a fact individuated in space and time, which is destined to slide into the past and disappear. To confuse a feeling with its occasional cause in the world leads to the loss of its true nature. Affectivity never occurs as one content of experience among others or as a contingent, perishable content; instead, it is the *a priori* condition for the possibility of experience. It is thus the original

mode in which everything that can be given to us is revealed and given to us. The prioritization of affectivity within experience results from the fact that everything that can be experienced by us is conditioned by life, that is, by an absolute subjectivity whose immediate self-experience is affective.

As for Schopenhauer, he conceives the affective *a priori* in the following way. Desire, which is the core of our being, is usually disappointed by the course of the world and only very rarely satisfied by it. It is necessarily spelled out as suffering but sometimes as pleasure. Suffering and pleasure are the inevitable categories of our grasp of things, depending on whether they comply with or frustrate our desire. They can only come to us through these two fundamental ontological tonalities that are the matrices of our experience of being. It is clear, however, that the nature of these things matters little, such as the obstacles they set up for our desire or the circumstances in which things happens. In every case, the result is one and the same suffering. A similar sadness thus responds to multiple different situations; it is their common denominator, the substance in which they are all united. Music formulates the generality of the affective tonality within a plurality of distinct experiences. Its universal power of expression comes from copying pleasure and pain through the greater or lesser overcoming of the clash between dissonances. It represents the totality of situations lived by human beings, which are lived in terms of the two fundamental affective tonalities governing our relation to being.

One single tonality, through its gradual change into an opposite tonality, can thus correspond to an infinite variety of circumstances or 'histories' that exemplify it. Because music expresses this affective life in its most profound generality, one single song can be suitable for multiple episodes of individual or collective existence. In the case of opera, various librettos recounting different dramas from different epochs can provide equivalent incarnations of it. Schopenhauer observes: 'In opera, music shows its heterogeneous nature and its superior intrinsic virtue by its complete indifference to everything material in the incidents; and in consequence of this, it expresses the storm of the passions and the pathos of the feelings everywhere in the same way, and accompanies these with the same pomp of its tones, whether Agamemnon and Achilles or the dissensions of an ordinary family furnish the material of the piece. For only the passions, the movements of the will, exist for it, and like God, it sees only the heart'.[16]

Should music's complete indifference 'to everything material in the incidents', towards all the natural and social facts be extended to painting in order to find the definition of abstract painting? Kandinsky writes,

'It became, however, quite clear to me that art in general was far more powerful than I had thought, and on the other hand, *that painting could develop just such powers as music possesses*' (364; Henry's emphasis). It is thus no longer a matter of finding some mysterious correspondence between sounds and colours, thereby following a long tradition going back to alchemy and ending with famous literary formulations in the nineteenth century. So long as we take sounds and colours as contents representing the objective world and consider them as external elements that are signs or parts of the objective world, no path will ever lead from sounds to colours or break down the wall that their heterogeneity—the one separating sound from the visual—sets up for us. But if this reference to the objective world were abolished, as music 'the most immaterial of the arts' does with great effect, if sounds were no longer the sounds of things but were heard as movements of the soul, like the cry of pain arising from wounded Desire or the slow change of suffering need into its satisfaction, then the same meaning and purpose could be attributed to painting. Would not this ability to express life immediately, which is the essence of art and which finds its most compelling example in music, also be the essence of painting?

This could only be the case on one condition: colours and graphic forms must cease to be identified with objects in and of the world, or in other words, their essence must cease to be confused with their objective appearance. What is their essence? What are its powers? Kandinsky answered this question above: 'just such powers as music possesses' (ibid.). These are the powers of life: willing, loving and suffering—and the greatest of all—growth. In their shared reference to the internal development of pathetic subjectivity with its indifference to the world, painting and music are the Same. The entire development of abstract painting, taking music as its model, has shown us exactly how forms and colours are released from their adherence to the external appearances of things and are reinscribed within the pathos of life. The theory of abstraction—the theory of the elements—was the theory of this inscription. With the proof of this Sameness to which music guided painting, the synthesis of the arts, the ultimate possibility of monumental Art, has become altogether clear for us.

A question arises, however, that quickly takes on the air of an objection. Following in the footsteps of music, painting was led to the following great revolution: instead of depicting the world, it expresses Life. But what, in the end, does this word 'express' really mean, this word which, like Kandinsky, we have employed so often? In what way does its meaning differ from the meaning of an imitation? To think about this in a very

simple way, let us put it like this. After having represented the world of things, painting, like music, would henceforth seek to simulate the only world that truly matters: the invisible world of Desire and its history. One referent would give way to another one—the External to the Internal—but in both cases *the structure of art would remain the same: it would be a referential structure*. Through its reference to something other than itself—in the one case the world and in the other case Life—art would be the 'expression' of a foreign reality, a means. That is, it would be a means for expressing a content with which it would enter into agreement. This is how music, according to Schopenhauer's conception that has been explained in detail due to its own importance as well as its influence on Kandinsky, would seek to 'reproduce' the course of our feelings. In carrying out this task, music would indeed seem to be a means for a prior content—not, of course, the trivial content of the world but the essential and more interesting content of our own life. Art would be a means—the means include sounds, colours, forms, movements, etc.—in the service of a different content, a content whose meaning is external to it: our life, our soul. In this context, one of the brief claims with which the 'Cologne Lecture' ends might surprise us: 'I do not want to paint states of mind [*Seelenzustände*]' (400).

The essence of art

It would be a grave error to conceive art and painting in particular as the means for expressing a different content from themselves. When this content has become life instead of objects, the content still precedes its artistic expression, thus rendering it as useless as when it simply copied a world already there. It is true that our life matters to us and is of more interest to us than the world, even if only in virtue of the fact that it possesses the extraordinary property of feeling itself and experiencing itself, while things are so cruelly deprived of this *happiness*. They stand silent and unsatisfied under the human regard, awaiting the presence that they seem to possess on their own but which is actually due to subjectivity. Each thing is experienced and becomes alive only through experiencing oneself.

But if this extraordinary and abundant life grants life to each thing as well as to ourselves and if it has already deployed its essence in the entire cycle of feelings it engenders as the modes of its entrance into the self, what good then does it do to express them and to say them a second time? Reduced to this second saying, art would indeed seem to be superfluous, and this would be so for at least two reasons. The first, mentioned above, is that an activity lacking all creative character and incapable of being something that human beings did not already possess, would not be necessary and would have no reason to interest us. The second is that this saying, simply repeating a pre-existing reality, does not just turn out to be useless; it accomplishes a reduction and falsification of the original reality—*the original reality no longer reveals itself in this saying in the same way as it reveals itself on its own.*

How, then, does the copy differ from the model? It differs in that it is only the representation of the model. With respect to life, such a representation signifies the destruction of its inner essence—which is not external at all— by the exteriority into which representation casts everything that it represents and places before itself. In being represented, life thus loses what it is: the pathetic immediacy where it finds its happiness. If art, and painting in particular, is delivered over to the realm of the visible, this is not just because it has gotten the wrong object. This happens because, given the task of expressing this object, it has no other means of expression than to put it before our regard and to display it in the light, where humans have thought they could find everything that could be found ever since the Greeks.

The following point must be stated with complete clarity: *art is no more a mimesis of life than it is of nature*. If it were a mimesis of life, it would don the characteristics of a mimesis of nature. It would set life outside and before itself, as something opaque and indifferent—like nature. If one looks at David's 'Oath of the Horatii' in the Louvre, one can see that the theme of this famous painting is life. It is a representation of feelings, even of great feelings: the love of county leads the father to make a gift of his sons, each one of whom must be sacrificed, while, the women—the wife and the sister—are pressed up against one another and collapse under the weight of grief. If these feelings barely touch us, one might say that this is due to their grandiloquence or their archaism. This scene in ancient style, with the rhythmic distribution of the characters whose profiles are on one single line in the style of a bas relief, takes us too far way from our familiar world for us to be to still believe in it, one might say. But just the opposite hypothesis could also be formulated. The science of composition, the forward placement of the figures and the centreing of the action detached from the somber basis of the three Doric arches, the irrealism of the cold colours shining on the armor, the splendour of the drawing—they are what makes this conventional painting a work of art in spite of its pathos and in spite of its representation of life about which we should no longer be preoccupied.

How can we not think here of one of Kandinsky's critiques of figurative painting: the subject of figurative painting, instead of being an integral part of the aesthetic experience and helping to bring it about, actually disrupts and can even prevent it. When life takes the place of the objective world and, in turn, becomes the theme of representation, the same thing occurs. As an object of representation, life is an equally powerful obstacle to art as the objective world. This is the case for the same reason: having

become an object, the content of a spectacle, life is no longer life but its contrary—death; it becomes a thing like the other things that populate the world. One must return to this fact: art can only exist, inasmuch as life is never offered as an art object. And that is Kandinsky's basic intuition: *it is because life is never an object that it can and must be the only content of art and painting—inasmuch as this content is abstract, it is invisible.*

How then is life present in art? Abstraction's answer to this question is that life is never present in terms of what we see or seem to see in a painting but only in terms of what we feel within ourselves when this seeing happens: the painting's composition of the tones and tonalities of colours and forms. Composition, as we have shown in detail, is the composition of these tones and tonalities; their invisible unity is the pathos and theme of the work. The theme of a work is not what it represents; it is not an objective given, either of nature or life, events or feelings. The theme of a work is indeed its pathos, but this pathos belongs to the colours and forms; it is their own pathos. It is produced by them, by the painting itself. Here these forms and colours are understood in their immediate subjectivity, not by some meaning external to them (objective, emotive or aesthetic meaning, for example, a 'beautiful form') that would be joined to them and give them a sense, a reference, an intention that they do not have and that they would merely convey. The theme does not precede the work, and it does not result from the work, either. It is never separated from the pure pictoriality of the artwork but rather merges with it. The theme is its real, invisible content, its abstract content. The ultimate implication of Kandinsky's extreme view is that form is abstract and, moreover, that it is the abstract content of the work. Painting is not absorbed into form—graphics and colours, instead form is absorbed into life. This is because no sensation of form or colour is possible without an auto-affect or auto-impression—without life.

One has to get used to the idea that art does not represent anything—not a world, a force, an affect or life. A pictorial representation, as it is so improperly called, can happen to represent force, such as a powerful anatomy with bulging muscles. This representation can also make one nearly laugh. The force of the representation has no relation to the represented force. The only force or weakness involved in painting is that of the forms and colours as such—independently from what they do or do not represent. This force only follows from their combination, from the composition of their tonalities, and from the ability of the tonalities of this composition to produce a force.

But our question arises again. If the content of art is life, what good is art since life exists without and before art? But, art cannot be on the one side and life on the other side, *if life provides art with its sole conceivable reality and its sole content*. Art is a mode of life, and for this reason, a way of life. One should ask, instead, 'How is life present in art as opposed to ordinary existence? The answer to this question justifies art and establishes it as one of the highest human activities: life's own essence is present in art.

What is the essence of life? It is not only the experience of oneself but also, as its direct result, the growth of the self. To experience oneself, in the way of life, is to enter into oneself, to enter into possession of one's own being, to grow oneself and to be affected by something 'more' which is 'more of oneself'. This something more is not the object of a regard or a quantitative measurement. As the growth of the self and the experience of its own being, it is a way of enjoying oneself; it is enjoyment. For this reason, life is a movement: it is the eternal movement of the passage from Suffering to Joy. Inasmuch as life's experience of itself is a primal Suffering, this feeling of oneself that brings life to itself is enjoyment and the exaltation of oneself.

What, then, is art if not the carrying out of this eternal movement? Because life *is* not—it is not a state, as Kandinsky reminds us, 'I do not want to paint states of mind'—but becomes through the tireless process of coming into itself, it stands in need of art (400). Art is the becoming of life, the way in which this becoming is carried out. Because it is alive and has the will to live and grow, each eye wants to see more and each force desires more force. In painting, these two desires are satisfied. The painting does not show what one has never before seen, like the surface of the moon as one finds in illustrated magazines for childish adults. It shows by leading vision to itself. It increases vision's ability to see in and through the intensification of its pathos. Through the experience and exaltation of its power, vision takes hold of itself and can see. Along with vision, the pathos of painting also gives force a licence to grow and reveal itself. These are the major themes of abstraction that we will investigate one last time.

The theory of elements has interpreted the reality of the elements—their invisible reality is the abstract content of painting—as a force and at the same time as a 'tonality'. These two determinations—the dynamic and the pathetic determinations—always either go together or pass into one another, to the point of seeming interchangeable or even equivalent. The real being of a line is the force that creates it and that moves the point from which it is engendered. As long as this force remains single, it gives the line

its lyricism. But the conflict between two forces gives the resulting line a dramatic character. As for colours, three passages from 'Reminiscences' noted with astonishment the 'staggering force' (361) and the 'power of the palette' (363), while the fascinated contemplation on Rembrandt at the Hermitage revealed 'the superhuman power of colour in its own right, and in particular, the intensification of that power achieved by combinations, i.e. contrasts' (366). But, as we have seen, the fundamental colours are defined and related to one another through their pathos. The pathos of these colours and graphic forms are the basis of composition. How should this primordial pair 'Force/Affect' be understood in the mutual relation between these two terms? How do they define the true, abstract essence of pictoriality?

In our brief presentation of his theory of music, we saw that Schopenhauer makes the affective tonalities depend on a prior *conatus*, that is, on a Desire that runs throughout the noumenal bodily existence of human beings. Depending on whether or not this desire is satisfied, the dichotomy of affectivity—satisfaction or dissatisfaction—follows. Psychology recognizes this dichotomy without ever being able to explain it. The affect, however, cannot be the result of desire, if desire is itself affective or if in its flesh it is already Suffering. This is indeed the case, since desire is here only another name for Force. Force is affective not due to the vicissitudes of its history, its failures or successes, but due to its experience of itself in the embrace in which it grows from its own power. This pathetic embrace is the strongest force; it is the prior force situated within every force and power; it is the hyper-power through which force takes hold of itself in order to be what it is and to do what it does. And the greater the violence of this embrace in which being is gathered in oneself and is initially given to oneself in the flesh of one's suffering, the greater the force in everything that exists as well. Instead of being the result of Force and its deployment, affectivity is the presupposition of force. This pathos is the basis of every force. It is what painting 'expresses'. It is present in every colour and form and their agency pushes it to its paroxysm. Art is thereby the fulfilment of the essence of life. In this respect, it differs from ordinary existence where the pathetic force of life remains unspent and changes into anxiety, leading to the monstrous behaviours of denial and self-destruction that are currently killing our world.

Time and time again, Kandinsky presented Inner Necessity as the principle of abstract painting. This means the radical determination of the form—colours and graphic forms—by its content, that is, by life. *On the*

Spiritual in Art presents this determination in three ways: first, the artwork is determined by the characteristics of each artist's personality; second, by what is proper to the epoch, its style and its aesthetic postulates and third, by what is proper to art. Concerning the latter, Kandinsky observes that it is the 'element of the pure and eternally artistic, which pervades every individual, every people, every age, and which is to be seen in the works of every artist, of every nation, and of every period, and which, being the principle element of art, knows neither time nor space' (173).

According to the third determination, the determining power is a 'mystical necessity', or life in its eternal essence. But, as the artwork's form is abstract and ultimately identical to its content, this is no longer the determination of the form by the content, instead it pertains to the determination of life by its own inner essence; it is the Inner Necessity of Life itself. We just explained what this necessity is: it is the necessity according to which Force is delivered to itself by its own pathos and is forced to act. It is the radical passivity of life to itself. Through this impossibility not to be itself, life cannot separate from itself, put itself at a distance, or escape from itself. It is forever and always obligated to be what it is, to exhaust all its possibilities and to live. Art is life's response to the requirements of its own nature, its own prescriptions—its Inner Necessity.

In this respect, art is a fact of culture. Culture is the process by which life realizes its own eternal essence. Through its tireless arrival in itself, life's essence is to grow and to push each one of its powers to its end. Art takes charge of the powers of sensibility. All great artworks through the ages indicate this to us; there we see the powers of sensibility carried to their utmost degree of intensity and force. Along with this, the aesthetic emotion—the pathos of this force—is also at its peak. More than anyone else, Kandinsky is able to evoke these emotions, because he knows the dynamic and pathetic virtualities of each formal and pictorial complex and the countless relations between them. He is thus able set the most profound virtualities of life into motion.

The imagination, whose unsuspected meaning we have already discovered, is the source of this overall movement of our being. It is the source of the creation of forms with their endless renewal, their superb independence and their capacity to create new worlds (see the dizzying series of 'Small Worlds'), a new gallery of 'geometrical characters' have become the protagonists of a comedy outside the human scale. It is also source of the discovery of colours (Nina Kandinsky recalls that in Paris her husband created special colours for each painting and that he then threw away after

the work was completed), the extraordinary refinement of 'these colours from the Oriental bazaar' or this 'eccentric and Russian' palette in the words of the clear-sighted critics of the time. It is the source as well of the eruption of a new space that does not submit to the laws of space but to those of Desire and the thrill of creation. All of these cosmic explosions produced in, or better, producing the ek-stasis of the visible are painstakingly governed by the real imagination whose function can only be understood in its proper setting. Prior to being the luminous dream of worlds yet unborn and their striking emergence, the imagination is the proper history of subjectivity. The imagination is the expansion of its pathos, the movement by which each tone awakens another tone and then another within itself. One by one, the imagination accomplishes the cultural process by giving rise to all the potentialities buried in the human soul—the treasure of its innate ideas, the infinity of its power of feeling—in order to arrive at happiness.

But this process belongs to all the arts, especially painting, throughout all times and places; it is the eternal essence of life, its Inner Necessity. This process is more easily recognized in painting, when it is no longer concealed by the personality traits of the artist or by the traits of the epoch. This is why we can understand artworks from a distant, even totally unknown, past where the power that created them is laid bare better than those that are overloaded with considerations borrowed from the proliferation of developments in the human sciences. Abstraction is this pure power, and that is why abstract painting reveals the essence of all painting to us.

All painting is abstract

Among the terse statements at the end of the Cologne Lecture, another one can be mentioned: 'I do not want to alter, contest or overthrow any single point in the harmony of the masterpieces of the past. I do not want to show the future its true path' (400). With these words, Kandinsky situates the object of his theoretical reflection outside of history: the eternal essence of life is the principle behind all art and painting. It is precisely because this essence is eternal that it is indifferent to history (even if it founds history at each instant) and that the artworks proceeding from it also exceed the historical categories and mental habits through which they are customarily approached.

Today we are poorly positioned to understand painting. We understand it poorly, partly because we understand it on the basis of our own historical time that values history as a mode of access to the true sense of works of art, and partly because this history presents a very specific sequence of the development of painting. This sequence—schematically, extending from the end of the nineteenth and beginning of the twentieth centuries—is characterized by realism and gives us a very false impression of the means and ends of art. In all of its seemingly different forms, it actually assigns art one single referent: external reality. Art, if one really reflects on it and makes an exception of the Greeks, has only rarely been concerned with external reality. The world becomes the aim of an activity that ceases to be creative and lapses into representation and imitation only after its initial theme and true interest has been lost. The initial theme of art and its true interest is life. At its outset, all art is sacred, and its sole concern is the supernatural. This means that it is concerned with life—not with the visible

but the invisible. Why is life sacred? Because we experience it within our-selves as something we have neither posited nor willed, as something that passes through us without ourselves as its cause—we can only be and do anything whatsoever because we are carried by it. This passivity of life to itself is our pathetic subjectivity—this is the invisible, abstract content of eternal art and painting.

Today, we can appreciate how and why the sacred essence of life—which is the content of all true art and explains the original connection everywhere between art and religion—has become distant from us. When, in the times of Galileo and Descartes, the emergent modern sci-ence sought to arrive at a rigorous knowledge of the material world, it deemed it necessary to set aside the world's sensible qualities in order to retain only its ideal forms. These were justified by a geometrical and mathematical knowledge, which is to say a 'rigorous', 'objective' and 'sci-entific' knowledge.[17] In the present context, the Galilean project can be given another sense apart from its purely methodological sense. It implies nothing less than the suppression of painting, whose elements are all sensible qualities. At the same time, life—where forms and colours ori-ginally exist as sensations—is also eliminated. By contrast, the objectivist project only allows the sensible qualities and consequently the elements of painting to function as indices of objects. The objects alone are said to provide a complete definition of reality. Reality becomes external reality. Representation, the use of coloured forms to represent the world of things, does not convey the initial state or essence of painting; it is a recent ideology transposing the presuppositions of the sciences onto the domain of art.

Thus, for Kandinsky the critique of 'realism' and its impressionist, cubist and other offspring of this kind goes together with a true distrust of science, even in spite of his admiration for the speculative renewal of physics and his interest in some of its consequences for the aesthetic point of view. He felt the need to replace the entirety of this 'materialist' world with another one where life would regain its membership in the world. Today we should be inspired by his ingenious foresight, if we want to see what surrounds us clearly and recognize, from the aesthetic point of view, a number of paradoxes there. One example is the view that representation is the norm of all painting, while abstraction in the Kandinskian sense seems like an incomprehensible abnormality. Yet, it is the opposite presupposition that has always constituted the 'norm', the presupposition of the invisible as the principle of art and culture.

Yet, one might ask, 'Is not the entire development of Western painting guided by a preoccupation with exhibition? What is painting about, if not showing and thereby showing something in the world'? Ever since the rise of Christianity, the Greek *telos* of representation has undergone an important shift. The world is no longer really what is represented; instead, it is explicitly, deliberately and continually life—the invisible life—that is represented. As a result, the tonalities of life—force, joy, love, forgiveness, purification and gift—and the affirmation of life against death—faith, certainty and self-confidence—are represented. The affects of their 'contraries'—fear, doubt, envy, boredom, pride, cruelty, neglect, luxury, gluttony and suffering—are represented. To be sure, we do not perceive these feelings directly and in themselves, because a feeling is invisible, like the life that inhabits it and brings it into being. Instead, we see a deposition and a lamentation on the body of Christ here, and a baptism, a washing of the feet, a Last Supper there. From opposite sides, we see a Madonna in adoration before the Child and two genuflected saints resembling pyramids or columns whose force suddenly overwhelms us and makes us tremble with an unforgettable joy. We see the Seven Works of Mercy, Annunciations, Visitations, Temptations, Martyrs and Resurrections. One after another, we see all the scenes from the Old and New Testament. (Someone who does not know the Bible at all, such as a child in our schools, would understand nothing about almost all of the masterpieces of Western painting, if they were placed in front of him or her—such a person thus lacks, through his or her own education, a huge part of his or her own culture.)

But, one might go on to ask: 'How was this life—whether our own, God's or both at the same time—given to us by spiritual painting? Wasn't it really represented, placed before us as a theme, with its particular themes such as the joy of birth, the sorrow of death and the happiness of the gift?' Like the Roman glory of the Horatii's father or the courage of his sons! Like these 'states of the soul' that Kandinsky explicitly banished from his art. His art is not guided by some foreign patron—whether it is the external world or psychic reality—this unfortunate objectification of what we are, this shadow of life from which all life has fled.

Yet, great painting, such as Renaissance or Pre-Renaissance painting, never provides 'representations' of this kind. It certainly does have to do with a Virgin birth, an escape from Egypt, a conversion of Saint Paul, the mystical marriage of Saint Catherine, or a sacred conversation where, in a silence that has replaced all speech and with their eyes lost in the distance, the saints 'converse' about something we have no idea of and which is

perhaps nothing more than, in this silent petrified silence, the rustling of the force that gives them their being. The fact that each one of these oft-reproduced scenes are designated by what they represent can only mislead the attentive viewer for an instant. Is it possible to define or explain any one of these paintings on the basis of a model in the world?

With respect to the resurrection of Christ, nobody ever truly witnessed this event. In Dirk Bouts' famous composition in Munich's *Alte Pinakothek* or in its reprise by Pleydenwurf's huge triptych at the same museum, the angel placed at the sides of the triumphant figure and bearing witness to the Resurrection does not belong to the reality of this world any more. The angel does not discover this scene as we do today, in a huge room without tourists. The same observation holds for all those artworks whose content is a sacred theme. Whoever saw the angel restrain Abraham's hand holding the knife, Jonah escaping the whale, Moses and his companions cross the Red Sea with dry feet while it closes over the Pharaoh and swallows up his entire army, Joseph and Anne at the Golden Gate, the Assumption of the Virgin or the Spirit's tongues of fire?

One might say that this is because all these productions are imaginary. This is indeed true. But, we can now understand how far this imagination can go and how it can lead this so-called figurative painting into the domain of the purest abstraction. When an artist has chosen to represent the Adoration of the Magi or has received this request from some prince or prelate, the problems of composition immediately raised are all abstract problems, in the Kandinskian sense. Supposing that the nature of the support is determined by the place and time (oak in Flanders, walnut in France, fir in Italy), the choice of the form is determined—we have demonstrated this with respect to Dürer and Michelangelo—by each great artist's intuition of the dynamic and pathetic structure of the P.P. These invisible determinations of subjectivity thus serve as the guiding principles for the construction of the artwork from the outset.

Yet, the size, placement, and general arrangement of the painting can be imposed on the artist as well. This is quite commonly the case with large altarpieces, because they were initially sculpted together with a structure defined either by tradition or by the fact that the altarpiece was supposed to be placed in a precise location of the church and thus had to suit the requirements of the architecture, etc. If one thinks of the most beautiful work ever painted—the famous Issenheim Altarpiece at the Colmar museum—it is a well-known fact that Grünewald did not make it from scratch. He was dealing with a sculpted altarpiece completed ten years

earlier whose overall conception was late Gothic (notably, it was the work of the Strasburg sculptor Niclas Hagnower). He had to take this restrictive architecture as the basis of his work and integrate it with his own work in order to end up with such a perfect work. The work is so homogenous and so striking that today one can hardly imagine that it was the fruit of two times and two different minds. Grünewald knew how to use the powerful tonalities of the P.P. that was given to him—the Gothic imagination—and he was able to harmonize its frenzied pathos with his own mystical conceptions. The composition before our eyes—with the subjective unity of its double expressionism—is absolutely consistent with the principles and laws of Kandinskian composition. In fact, it could pass as one of its most elaborate and successful examples.

But one does not have to stand at these great heights in order to see the principles and laws of abstraction put to work. All great classical painting, we said, is the illustration of abstraction. Let us return to the Adoration of the Magi, which is one of the most common themes of Christian iconography. It is a representation of a particular event (one that nobody ever saw, either). Caspar, Melchior and Balthazar came from their faraway lands in order to offer gifts to the Child around whom the Mother and Joseph stand in prayer. One might wonder how this single scene has been able to give rise to so many different creations that are so original and surprising. And, one could raise this same question with respect to all other masterpieces, since they are actually only the repetition of a very limited number of religious *topoi*. This is possible because, in spite of all appearances, these paintings escape from the sphere of representation. First of all, the painter does not seek to reproduce Caspar's unseen gesture of giving the precious vase or his deferential attitude. It must be created; one must imagine the angle in which the character is presented, the curve of the shoulder and arm, the tilting of the face, in short, *choose the forms* that will be the composition's fundamental forms. These forms are imposed by nothing and are not prescribed by any archetype (if there is one, it would be precisely a pictorial archetype obeying the imperatives that we are describing). These forms have no other motivation than their tone, their inner resonance.

But these Kings, these characters who are not in human memory—these leaning forms, the forces which bow and whose entire reality is the pathos of their bowing, adoration—also wear clothes. They wear extraordinary clothes, with sumptuous stuff: brocades and leotards in bright tones. Whoever saw these tones—these surprising, refined and dazzling colours—in so-called external reality? They do not come from the external world any

more than do the forms of the bending profiles of Caspar, Melchior and Balthazar. They are not real colours, belonging to real objects, inscribed in them by objectively identifiable links. The colours are also chosen for themselves, without any relation to the clothing—which could be in other colours—or to the form of real clothing. It only has a relation to the extravagant form of this extravagant clothing, a form which was used solely in virtue of its own value, just like the colour covering it. Both the extraordinary colours and the unseen form were created for their tone and for their suitability to the pathos resulting from their subjective combination. One must agree on this point: all these paintings are abstract paintings.

Let us consider again the right section of the inner face of the Issenheim Altarpiece: the Resurrection. The idea that it is a representation of some external reality is so absurd that it no longer needs to be discussed. Who, it must be asked again, would have been able to see such a spectacle? One might say that we who are in the Unterlinden Museum standing before the panel would. But what is the nature of this vision and what does it really see? Objects in the real world are defined on the level of sensibility by their colours and their sensible forms. This long green rectangle is a prairie; this snake that shimmers and zigzags through its surroundings is a river; this whitish section, pierced with regular openings, is the façade of a house. On the altarpiece, if one looks at how the shroud of Christ climbs with him against the law of gravity, this shroud is at any rate not definable by its colour. Its colour changes magically before our eyes, sliding above the tomb with a white-blue whose shades still obey the relations of the local tone, to an increasingly intense violet as it rises in aerial scrolls, to a red fire when it wraps up Christ and finally to a sort of yellow that seems to be destroyed by its own excess when, as it falls onto the shoulders and torso of the glorious body, it merges with the body and becomes nothing more than pure light.

For Kandinsky, white was the colour prior to all things; it was the place of the possible, where everything can and will be born. Blue marks a retreat, the curve of the shroud that is hollowed out in front of us distances itself a bit before straightening up quickly and being snatched up above us by the aspiration of the victorious Body. This body is Red, a bright red. Red is the colour of Life. Kandinsky says that it bears witness to 'an immense, almost purposeful strength', 'which is principally within itself and very little directed towards the external, we find, so to speak, a kind of masculine maturity' (186). This auto-affirmation of life in its exaltation and in the certainty of its force is thus the auto-affirmation of this red rushing forward like a flame. This is what we see on the panel of the Resurrection.

We raised the question above: 'What does it mean to see and what exactly is seen?' To this, we might also add the question: 'How can one see life, when life is invisible'? According to the principles of abstraction, to see is to experience the pathos of the colour that is seen, to be the reality of this pathos and to be Life. The Issenheim Altarpiece does not represent life; instead, it allows life to be felt within ourselves. Life always sleeps within us, while the Red of the Resurrection always burns, burns on its own, within us. Yet, when the shroud is torn apart and allows the nude body of the Resurrected Christ to appear, this Red lightens and becomes yellow. Kandinsky observes: 'Bright, warm red (minium) has a certain affinity with mid-yellow (it also contains quite a large amount of yellow as a pigment), and evokes feelings of power, energy, striving, determination, joy, triumph (pure), etc. In musical terms, it reminds once again of the sound of a fanfare, in which the tuba can also be heard—a determined, insistent, powerful sound' (187). Surrounding this glorious explosion, all that remains of the world is a few objects: soldiers thrown up by the blast and rocks swept up by it, like the rock of the tomb that was broken apart in order to clear the passage of the Saviour. They have lost all identifiable colours, only being a reflection of this bright Red of life, and are scattered debris carried away by its whirlwind force.

Shouldn't forms also be mentioned? The tremendous vertical that crosses the composition from above to below reduces the P.P. to two regions. There are four horizontal bars: the confused mass of two over-turned soldiers and stones in the foreground, the extraordinary profile cut out by the third fallen warrior whose helmet is thrown down in front like a wisp of straw, the huge rectangle of the highest rock similar to Rothko's transversal, and finally, the solemn, open arms of Christ are inscribed in the circle of eternity. They only serve to emphasize the irresistible emergence and triumphant irruption of Life.

Art and the cosmos

One might ask: Is not figurative painting, taking its models from objects in the world, a kind of painting? Is it not painting at all? From the eighteenth century, after the disappearance of religious feeling, it only offers weak and, in a certain way, secondary works. The overall waning of its creative power in the realm of painting is the direct and immediate result of the subsidence of life and the loss of certainty about its invincibility. This is demonstrated by the aesthetic movement of the last three centuries, which, lacking an inner force, led it to return to the things and to seek a foothold on them that it could no longer find in its beliefs or in the belief in life itself. This movement was pursued with the support of the positivistic ideology that only recognizes the reality of what it finds at the end of microscopes and test tubes, and art does indeed have a right to be expressed in this way. But, from the perspective of abstraction, what would be the foundation of such a modest and mediocre art?

According to Kandinsky, all beings and all objects have their own inner resonance, from the most trivial things in our everyday surroundings to the most elaborate drawings with their complex combinations. A wonderful passage from 'Reminiscences' explains this to us: 'Everything "dead" trembled. Everything showed me its face, its innermost being, its secret soul, inclined more often to silence than to speech—not only the stars, moon, woods and flowers of which poets sing, but even a cigar butt lying in the ashtray, a patient white trouser-button looking up at you from a puddle on the street, a submissive piece of bark carried through the long grass in the ant's strong jaws to some uncertain and vital end, the page of a calendar, torn forcibly by one's consciously outstretched hand from the warm

companionship of the block of remaining pages. Likewise, every still and every moving point (=line) became for me just as alive and revealed to me its soul' (361).

By listening to the inner resonance dwelling in each particular object—from pure elements like the point or the line to colours detached from every meaning external to their pure sensibility—Kandinsky was able to discover abstraction. This was the discovery of the invisible life that spreads out everywhere under the shell of things and supports their being. But, if any object whatsoever possesses a resonance, it can be integrated into a painting that is based on the tones of the elements it uses. This is why, in many texts and especially those from his 1910 turn, Kandinsky mentions objects as a factor of aesthetic composition, alongside the pictorial elements of sensible forms and colours reduced to their abstract content. The object is also endowed with an abstract content and can thereby enter into an inner relation with the other elements. From this, Kandinsky's categorical claim follows: 'It is of absolutely no significance whether the artist uses a real or an abstract form. For both forms are internally the same' (248).

One distinction should be recalled here. Ordinary objects are defined by their ideal pole with an objective identity—*a* table, *a* door, *a* house, etc.—whose inner tone is weak and concealed by the anonymous generality of practical meanings. They are different from the Object that is torn away from these meanings, becomes itself again, and can let its pure tone be heard once again once it is placed outside of the world. The first category of objects gives rise to the bland realism guiding nineteenth century painting, in the sense that even its attempts to escape from objects remained trapped within the initial givenness of this oppressive equipmentality. The object returned to its pure tone is the Object of 'Greater Realism', whose aesthetic foundation was shown by Kandinsky to be the same as that of 'Greater Abstraction'. Regardless of whether it is a common object or the giant plants, fabulous birds and wild animals wandering through Rousseau's marvellous forests, all of these figurative things ultimately belong to a world. Does the fact that they have a tonality that places them within the domain of abstraction and pure pictoriality ultimately mean that *the structure of art and the world are the same*? And does this one and the same external reality become real, however, only insofar as it is experienced inwardly in the pathos of its invisible subjectivity and is Life?

One doubt still remains: 'Wasn't the theory of abstraction in painting defined against objective representation and thus against nature'? Nature could not provide either the content or the form of art. The entire substance

of the painted work came from life and it alone. Yet this provenance should not be misinterpreted: it does not at all signify the transfer from the primal Invisible to an Outside where it would be seen. Instead, it remains in its own place, in the non-objectifiable and unrepresentable subjectivity, and leads to more alive and intense experiences. What good, then, is this extraordinary and paradoxical attempt to tear painting away from its home in light, from its world of appearances, if this world already retains within its mysterious bosom what an esoteric art alone claims to be able to reveal?

This same uncertainty seems to appear in Kandinsky's texts. It is in contrast with nature that music was thought and recognized for what is its own. But music must serve as the model and guide for painting. Its specificity is that of art in general and assigns its sole content as the real and abstract content of life. Reflection one last time on the means of painting, one sees that colours and forms derive their amazing power from their detachment from the world, for example, from the objective context of a landscape. This power is precisely their subjectivity. We have already observed this throughout the analysis of classical painting, whose compositions are never regulated by on the natural order but rather obey the injunctions of their elements' tones.

One can then understand how Kandinsky was able to write in 'Reminiscences' that 'the aims (and hence the resources too) of nature and of art were fundamentally, organically, and by the very nature of the world different' (360), and later conclude that 'for me, the province of art and the province of nature thus became more and more widely separated, until I was able to experience both as completely independent realms' (373). This difference and ultimate contrast between nature and art rests on the contrast between their laws—along with Kandinsky's somewhat personal situation with regard to them as well. While the inventor of abstraction was aware of having the main principles of pictorial activity—principles of abstraction that he was able to clearly expound from the 1910s—the rules of nature remained mysterious to him. Evoking once again his visits to the *Alte Pinakothek* in Munich—this high place of painting—in 'Reminiscences' he writes: '(I) noticed that not one of the great masters had attained the exhaustive beauty and ingenuity of natural modelling: nature herself remained untouched. Sometimes, she seemed to me to be laughing at these efforts. But more often she appeared to me, in an abstract sense, "divine": she created as she saw fit; she followed her path towards her goals, which are lost in the mists; she lived in her domain, which existed in a curious way outside myself' (375).

Yet, in the very same reflection on art considered in its specificity as 'a realm in itself, regulated by its own laws peculiar to itself', the same work adds with respect to this 'realm in itself' of art that it 'together with all other realms, will ultimately constitute that mighty kingdom which we can now only dimly conceive' (376). This concept of the Mighty Kingdom reveals Kandinsky's metaphysical ambitions and the power of his thought. This Mighty Kingdom is not just monumental art realized through the synthesis of all the existing arts; it is the unity of Art and Nature, beyond and in spite of the differences between their laws. We can arrive at the idea that such a unity exists on the deepest level, when we pay close attention to some of Kandinsky's statements about creation. The identity between aesthetic creation and the creation of the cosmos is affirmed each time. Their similarity, at any rate, is a sort of essential analogy of the aims and the steps to be taken. Let us mention just one statement, taken from the 'Cologne Lecture': 'The birth of a work of art is of cosmic character' (394).

If we seek to clarify this question of the relation between nature and art—an indispensable question for the intelligibility of abstract painting—the founding principles of abstraction ought to be applied to it. These principles tell us that 1. every pictorial element involves a dual aspect: external and internal; 2. this dualistic structure of phenomenality includes every possible manifestation, everything that is shown to us and everything that exists. It follows that the reality of the world is the same as the reality of art, exhausting the division between the visible and the invisible. That is why everything given in the light of the world also belongs to art, which possesses its inner essence. From this perspective, there is no longer any reason to distinguish the trivial purposes of simple objects in the world from the colours and pure forms of pictoriality. As the condition of their coming into being, they both contain the primal Division (*Partage*) that splits appearing into its two realms. This affirmation of the universal meaning of the principles of abstraction and their necessary application to the entirety of being and thus to the cosmos is formulated explicitly in a footnote from *Point and Line to Plane*: 'In principle, it cannot be doubted that every phenomenon in every world permits of such an expression—the expression of its inner being—whether it be a thunderstorm, J.S. Bach, fear, a cosmic event, Raphael, a toothache. . . . The only danger would be that of hanging upon the external form and ignoring the content' (619).

We have examined extensively the consequences of this thesis for painting: they are the theory of abstract painting. Moreover, we now understand better why the object also belongs to the composition, at least potentially.

The differences between this trivial object and the pictorially pure elements of colour and form—between figurative and abstract painting—are not destroyed; quite the contrary, they are based on it. Their differences cannot be traced back to the difference between the external and the internal. Instead, it concerns only the internal and is the difference between the pure tones of forms and colours as such and these same tones when concealed by objective purposes. In painting, the most important consequence of abstraction is, as we have seen, a theory of composition based explicitly on subjectivity and its own becoming. This is also what allows painting to be integrated into monumental Art.

We should now briefly indicate the consequences of abstraction for a conception of the cosmos. What is erased, first of all, is the apparent contradiction in Kandinsky's successive positions with regard to nature and its relation to art. How can this same nature, at the same time, be depreciated, as when musical is praised for completely ignoring it, and be admired for its fascinating mystery, and more precisely, for its affinity with art as their essential community is gradually recognized? It is not the same nature in these two cases. The critique bears on naturalism as well as realism, that is, on a certain conception of nature. It is not so much the fact of taking nature as a model but a very specific archetype of nature that is in question. What type of nature serves as a model for nineteenth century art?

It is the Galilean nature from which the sensible qualities have been excluded, and along with them, everything that was relative to a subject and our life. Emptied of its pathetic substance, this type of nature is offered henceforth as 'external reality'. Aesthetic realism misconstrues colours and the sensible forms of objects. What would they represent then? These properties of objects are taken as external and objective; the radical dimension of interiority that provides their impressional reality and without which they would not exist is thus ignored. It derives the laws of artistic construction from the objective order in which these properties are displayed before us and not from their tone. This type of art thereby lacks any authentic creativity.

Art will rediscover its way in a different type of nature. The sensible qualities of this nature are not reduced to external features, as mere signs that are limited to 'representing' a foreign reality. These qualities are modes of life: impressions, tones and tonalities. This is what I mean: by tearing colours and linear forms away from the ideal archetype of meanings that constitute the objective world and by taking them in their non-referential pictoriality, Kandinskian abstraction does not depart from nature but

returns to its inner essence. *This original, subjective, dynamic, impressional and pathetic nature—the true nature whose essence is Life—is the cosmos.* A dazzling claim from *The Blaue Reiter Almanac*, highlighted by Kandinsky himself, defines the *Arche* where Art and the Cosmos are identical: 'The world sounds. It is a cosmos of spiritually affective beings. Thus, dead matter is living spirit' (250).

What are these beings that constitute the cosmos? They are every thing and element of a thing, *inasmuch as they are sensible.* They only exist in this way, that is, in sensibility. In this respect, they are subjectivities. In this respect, the world is filled with resonances: all of the vibrations marking its repercussions in the soul and the spiritual action that they exert. In this respect, all matter—while seemingly dead—is a tonality and a living spirit. This much is clear: abstraction's reduction of the elements to their pure pictoriality signifies the reduction of the cosmos to its true reality. The question of abstract painting is the question of the world.

How does art differentiate itself from this cosmos with which it shares an essential community? It differs at least in two ways: though its laws and through the fact that it is a cultural process.

The laws have a bearing on elements. The elements of painting and the cosmos are the same: colours and forms. Inasmuch as they have a bearing on the same elements, the laws of painting and the laws of the cosmos partially overlap. In the study of these elements, the theory of pictorial abstraction demonstrated three fundamental pairs of opposites: the straight and the curve with respect to lines, the triangle and the circle with respect to planes, yellow and blue with respect to colours. Concerning these 'three fundamental pairs of opposites', relations of affinity are established between the straight line, the triangle and yellow as well as between the curved line, the circle and blue. At the end of this analysis, Kandinsky added: 'This abstract logical structure peculiar to one form of art, which finds in this art a constant, more or less conscious application, can be compared to the logical structure found in nature, and both cases—art and nature—offer the inner man a quite special kind of satisfaction' (601).

Insofar as the elements and the laws based on them are identical or similar, it remains to be seen how they can be used. This can be observed without raising the question of purposes. It is a matter of seeing 'how the independent realm of nature uses the basic elements: which elements are given consideration, what qualities they possess, and how they are formed into organisms' (625). Kandinsky's meditation on this confrontation between art and nature identifies the same fundamental laws of

Panpsychism

juxtaposition and opposition within these two realms. The laws of parallel and contrast are then derived from them. This is how one arrives at a general law of world composition whose ultimate basis is the 'higher synthetic order—External + Internal', that is to say, the splitting of being into two fundamental realms serving as the basis of the entire analysis (626).

In dealing with the unicity of the latter regulation, Kandinsky attempts to distinguish art from nature not in terms of their laws but their elements. The concept of the element thereby receives a particular sense, designating 'the motionless and calm' point in painting while designating the cell when applied to the universe. This difference between the elements has immediate repercussions on the level of legality. Whether it is a giraffe or a toad, a human being or a fish, an elephant or a mouse, creative forces in nature still seem to function in terms of the 'principle of concentric construction'. Art, by contrast, opens the new possibility, unknown in nature, of an uncentred construction. As we have seen, this is how abstract painting conceives free straight lines; they are detached from the plane, 'float', and no longer have a relation to it or any of its points. Every constraining objective context has disappeared, and in place of the natural concentric layout, the sole remaining principle of construction is the subjectivity of the elements. Only their tone will determine their distribution and their assemblage. Kandinsky thereby concludes that the elements from the various domains of creation are always the same, while their differences are due to construction.

Construction in art, and especially in painting, is composition. There is indeed a composition in nature, given that each one of its elements also has a tone. A passage in *Point and Line to Plane* explicitly states that 'the entire "world" can be regarded as a self-contained, cosmic composition, which itself consists of innumerable, independent, hermetic compositions' (554). Because each cosmic element has its own tone—its experience of itself in an impression that is its life—the whole cosmos is alive: an immense subjective composition. As such, there can be no world without an affection and without the sensations that are the Whole of our sensibility and that continually make it vibrate like the flesh of the universe. Kandinsky writes: ' "Nature", i.e. the ever-changing external environment of man, continually sets the strings of the piano (the soul) in vibration, by means of the keys (objects)' (169). The context of this passage clarifies that nature's constant action on the soul (the cosmos is this action as such; it is nature in its subjectivity) is the action of the colour and form of the object as well as the object itself.

In the course of this analysis of the cosmos, a brief remark situates art—or rather the artist—in its relation to this invisible nature: '*Now, however, in the place of nature we have the artist who has the same three elements at his disposal*' (169). Thus Art and Nature occupy the same place where forms, colours and objects are felt: in our suffering and happy Night. In contrast with nature, art willingly uses the linear and coloured appearances that have become the elements of painting. It structures and puts in a new order not what would already exist outside of us but what comes only through the flux of our life, as the *feeling of nature* and as the radical interiority of all possible exteriority. Abstraction, as we have said, is not opposed to nature; it discovers nature's true essence. But why, in this silent arrival of cosmic life within us, does the artist take the place of nature? And what does the artist do after having taken this place?

All of Kandinsky's theoretical and practical work responds to this question. To bring about the revelation of life by its own accord is to analyse the elements, to move them, to isolate them, to contrast them, to combine them, to unite them and to let their tones be heard. Life is self-revelation. But it leads this revelation to its own end; life wants to feel more and to increase each one of its powers. Painting is born from life's wanting to see more. It wants more force and so other lines, marks and graphic forms appear. They are showered with these increased powers of life. In ordinary perception and the figurative art reproducing its limits, we have 'the experience of the spiritual in material things'—they are muffled resonances that are inaudible due to the fact that they have already been heard. This is succeeded by the experience 'of the spiritual in abstract things'. This experience leads us towards unforeseen configurations, overturned edifices, arborescent entities viewed from unrepresentable perspectives, metallic cones in a state of suspense, rays exploding like fireworks rockets, joined angles, enigmatic grids and diagonals launching an attack. All of these forms are armed with something more; they are self-assured, indifferent to everything and come from elsewhere.

Where do they come from? They come from a place that is prior to the world that does not have the appearance of any world, and that cannot be measured by any regard. They come from the powers of the night where every being rests prior to its birth, when space does not govern their navigation in terms of above and below or light and dark, when they know no customs or laws—because these laws, directions and space have not yet been established. Nature is only a particular case of art. It creates beings sequentially according to effective archetypes, so that perhaps one day

these beings may be more entrepreneurial and lend themselves to other possibilities.

In the Night, the unborn possibilities and unsatisfied wishes of Life are elaborated. Prior to deploying their ecstatic being in the light, they only exist in this self-absorbed power that enjoys all that it can do. These are the forces that draw lines and invent colours. Although they are not visible and are not placed alongside one another in the clearing of an Outside, they are nonetheless unmistakably what they are. Nothing here below or up above can surpass their certainty.

Kandinsky knew them well. Through his repeated exercises, he learned how to handle each one of these forces separately as well as the forms they engender—an exemplary graphic or some astounding checkered pattern. The virtuosity of his art is due to this incredible mastery. Kandinsky does exactly what he wants with the 'means' of painting, because he knows what they are, what source they mirror and what affect they depict. He is the ballet master; his canvases are marionettes whose strings he pulls. But these strings are the cords of the soul. This is expressionism like it never existed before and never will again. The all-powerful one marvels at his powers; he abandons himself to them and exercises them in every way, and like God, he is sometimes amused by what he makes. Multi-coloured stacks stand balanced on a tiny base, a mere line, on nothing at all. Lavish, Asiatic-Russian, free-floating, triangular forms revolve slowly on an immaterial point. Stunning (*étourdissant*) Kandinsky. His genius weighed heavily on the fate of abstract painting in the twentieth century. The 'Usher' possessed all the talents; he exhausted countless possibilities. After him there would only be awkward imitators.

Let us look one last time at the Parisian paintings. One might wonder how Kandinsky can escape from flat space all the while refusing the representation of depth. This is not the least of the paradoxes for a painting whose principles are no longer spatial. It creates new spaces, before and behind the canvas, just as easily as it destroys them; it abruptly interrupts space when an arrow stands at rest without any apparent reason. This is because space, including the most lavish linear edifices as well as those reduced to the purity of a bare line, is the product of a force, and force does as it pleases. Thus, each part of a plane can change into a voluminous mass, like a boa that has swallowed a gazelle or like the church of Wies. A square can become a cube, a circle some sovereign sphere extending its reign over a tangle of cruel spades, arcs and angles. This force is the force of life. Like the point that changes into a white circle in one of his 1937 poems, it

'grows in growing; in growing it grows'; life expands itself and communicates its inspiration to everything it touches (839). Instead of going past figures without seeing them, setting them aside from its path, or dispersing them on the waves of its unfurling, life stops with them now, considers them, enters them, is concerned with them. It adds some ironic swelling to them here or some fancy artery there; the growth of light increases their inner space through the delicate compartmentalization of an oneiric checkerboard.

Because it is situated in subjectivity, borne by it, and inseparable from its dynamism and emotion, every concrete object is ultimately a cosmos. The geometrical world of the Bauhaus is thus slowly transformed. The sphere is deformed, thickened, elongated and slowly balanced; it becomes a transparent jellyfish with incandescent filaments caressed by the underwater currents. In this place without heaviness, where weight changes into lightness, forms wander about without their substance—bodies of light, glorious bodies, bodies of life. They are organic forms with clear and cold colours, all kinds of protozoa, parts of insects, outlines of foliage—creatures from another world with another nature reveal the nature of all nature, every possible world, and consequently our own world.

We gaze petrified at the hieroglyphs of the invisible, as they too stand motionless or only slowly change against the background of a nocturnal sky. We watch forces that slumbered within us, waiting stubbornly and patiently for millennia, even from the beginning of time. These forces explode into the violence and gleam of colours; they open spaces and engender the forms of worlds. The forces of the cosmos are awakened within us. They lead us outside of time to join in their celebration dance and they do not let go of us. They do not stop—because not even they believed that it was possible to attain 'such happiness'. Art is the resurrection of eternal life.

Endnotes

1. An extensive bibliography can be found in Alain David and Jean Greisch, eds., *Michel Henry: L'epreuve de la Vie* (Paris: Cerf, 2001).
2. It is important to note that Henry's reading of Descartes is not entirely negative. Descartes's separation of sensible impressions from the external world paves the way for a philosophy of radical immanence. The problem, however, is that he turns in the wrong direction: he turns to the external world instead of the purely sensible impression.
3. More detailed biographical information can be found at the official Michel Henry website: www.michelhenry.com
4. Michel Henry, *Le Bonheur de Spinoza* (Paris: PUF, 2003).
5. This preoccupation extends equally to Henry's novels. For example, see Michel Henry, *L'amour les yeux fermés* (Paris: Gallimard, 1976).
6. His subsequent work in the 1990s might be described as a theological turn, insofar as the religious becomes the focus of the major works of that period: *C'est moi la vérité* (1996), *Incarnation: Une philosophie de la chair* (2000), and *Paroles du Christ* (2002).
7. In addition to this study of Kandinsky, Henry's aesthetic theory is developed further in a group of essays published posthumously in Michel Henry, *Phenoménologie de la vie: De l'art et du politique* (Paris: PUF, 2004). The volume includes essays on Kandinsky and on music as well as two interviews on art, 'Art et phénoménologie de la vie' and 'Narrer le pathos'.
8. This is noted in the insightful interview with Anne Henry entitled 'Vivre avec Michel Henry: Entretien avec Anne Henry' in Michel

Henry, *Auto-Donation: Entretiens et conferences*, ed. Magali Uhl (Paris: Beauchesne, 2004).

9. Wassily Kandinsky, *Kandinsky: Complete Writings on Art*, eds. Kenneth C. Lindsay and Peter Vergo (Boston: Da Capo Press, 1982), 532. All subsequent citations of Kandinsky's writings appear in the text and refer to the above volume.

10. A more detailed reply to this objection, along with a more extended account of his conception of the community of the living, can be found in Chapter 3 of Michel Henry, *Material Phenomenology*, trans. Scott Davidson (New York: Fordham University Press, 2008).

11. *XXe siècle*, special edition, *Hommage a Vassili Kandinsky*, 1974: 110.

12. Translator's note: The 'Customs Officer' (*Le Douanier*) is the nickname of the painter, Henri Rousseau.

13. On this point, see Michel Henry, *Philosophy and Phenomenology of the Body*, trans. Girard Etzkorn (The Hague: Nijhoff, 1975).

14. Arthur Schopenhauer, *The World As Will and Representation*, 2 Volumes, trans. E.F.J. Payne. (New York: Dover, 1969).

15. Arthur Schopenhauer, *The World As Will and Representation*, vol. 1: 260.

16. Arthur Schopenhauer, *The World As Will and Representation*, vol. 2: 449.

17. See Michel Henry, *Barbarisme* (Paris: Grasset, 1987).

Index

CPSIA information can be obtained
at www.ICGtesting.com
Printed in the USA
LVHW080749071221
705492LV00011B/838